SEE YOU IN THE STREETS

HUMANITIES AND PUBLIC LIFE

Teresa Mangum and Anne Valk, Series Editors

University of Iowa Press, Iowa City

SEE YOU IN THE STREETS

Art, Action, and

Remembering the Triangle

Shirtwaist Factory Fire

RUTH SERGEL

University of Iowa Press, Iowa City 52242
Copyright © 2016 by the University of Iowa Press
www.uiowapress.org
Printed in the United States of America

Design by Ashley Muehlbauer

The University of Iowa Press is a member of Green Press Initiative
and is committed to preserving natural resources.

Printed on acid-free paper

Library of Congress Cataloging-in-Publication Data
Sergel, Ruth, author.
See you in the streets : art, action, and remembering the
Triangle Shirtwaist Factory Fire / Ruth Sergel.
pages cm. — (Humanities and public life)
Includes bibliographical references and index.
ISBN 978-1-60938-417-3 (pbk), ISBN 978-1-60938-418-0 (ebk)
1. Triangle Shirtwaist Company—Fire, 1911. 2. New York
(N.Y.)—History—1898–1951. 3. Clothing factories—New York
(State—New York—Safety measures—History—20th century.
4. Memorialization—Social aspects. 5. Community arts projects—
New York (State)—New York. I. Title. II. Title: Art, action,
and remembering the Triangle Shirtwaist Factory Fire.
F128.5.S47 2016
974.7'1041—dc23 2015035317

For my mother, Judith Treesberg

Daughter of an immigrant mother,
she made sure I got to the promised land.

CONTENTS

FOREWORD

ANNA ALTMAN, 16 YEARS OLD

The most searingly memorable history sometimes arises not from intentions but from accidents. Consider the workers at the Triangle Waist Company in 1911. Marginalized by who they were and the nature of their labor, these workers made history after a devastating fire sparked a national struggle for workplace safety. The avoidable deaths of nearly 150 textile workers, most of them low-paid immigrant women, mobilized activists to find ways to prevent similar tragedies. Nearly one hundred years later, the story of the Triangle factory fire inspired Ruth Sergel and a dedicated band of activists, archivists, artists, Triangle family members, and workers to memorialize the tragedy and the place where it occurred. In the process, using tools provided by art and the humanities, they also made history.

That is the story captured here, in *See You in the Streets*.

History has no singular or static meaning, as *See You in the Streets* demonstrates. Historians, artists, and people affected by the disaster at the Triangle Waist Company have told the story of the factory fire repeatedly since 1911. They have offered a multiplicity of perspectives and emphasized a range of lessons we can learn from the horrific event. Families of victims have kept their outrage and sorrow alive by saving mementoes and passing down stories of deceased relatives. In 1912, New York City charitable groups erected a headstone for victims in Brooklyn's Evergreen Cemetery, marking a burial site and vividly reminding visitors of the catastrophe. The International Ladies' Garment Workers' Union and the Women's Trade Union League gathered thousands for a funeral procession immediately after the fire, denouncing corporate practices that endangered workers' lives.

To this day, labor groups hold annual commemorations and rally the memory of the Triangle fire to honor the protections won by unions and to celebrate worker solidarity. Numerous poets, painters, playwrights, composers, and novelists have penned and painted tributes to the victims; this creative work continues to move audiences emotionally and politically. At the factory building, three plaques mark the site's historical significance to the city of New York. In addition, several research archives have collected and maintain materials related to the fire. In all these ways and more, the story of the fire—its causes

and aftermath and its connection to women's and immigrant history and to labor and workplace reform—has been preserved and passed on to subsequent generations. The commemorations present distinct versions of the past; and, as Ellen Wiley Todd and other scholars have shown, unions, reformers, and other stakeholders have sometimes competed to control the forms of remembrance and to claim the meaning and legacy of the disaster. The driving motivation all these groups share is the search for a "usable past." Separately and together, they seek to make history meaningful and relevant to present-day audiences by preserving and retelling Triangle fire stories, even when they differ in their understanding of the significance of the disaster.

Today that history lives in and through the present, thanks to the Chalk project. Started by Sergel in 2004, Chalk invites people to inscribe the names and ages of those who died in 1911 on sidewalks in front of the workers' former homes. This annual event, held on the fire's anniversary, gives visibility to the victims and calls attention to their presence as former residents of New York City. It also offers a reminder of the city's industrial past and highlights the sacrifices made by the many individuals who have fought for jobs that guarantee safety, dignity, and adequate pay for workers. A living memorial, Chalk urges the active participation of individuals who believe that this history matters. The Remember the Triangle Fire Coalition built on the success of Chalk. In 2008, the Coalition began to plan activities in New York City and to connect with events around the world to mark the passage of one hundred years since the original fire. Both these initiatives used remembrance to mobilize a new generation to confront ongoing workplace safety concerns and global economic inequalities. Or, as Sergel puts it in *See You in the Streets*, by invoking the "necessity of civic engagement," the projects summon participants to make history not through death (as the Triangle workers did) but through energetic advocacy for social justice.

Ruth Sergel's work demonstrates the transformational impact of public history on the people who participate in civic life and on the communities they address. When we learned of the Chalk Project, we knew that others could learn from Ruth's collaborative, applied memorialization and enthusiastically invited her to write about her work for the Humanities and Public Life series. The book series aims to document and critically assess projects like Chalk and the Remember the Triangle Fire Coalition that use history, art, and culture both to engage and to transform communities. We ask our authors to share the

serendipitous, imaginative, and often challenging aspects of publicly engaged processes and partnerships and to document the complex outcomes of such projects. We believe that books in the series can help establish best practices for collaboration; offer measures for evaluating the impact of such endeavors; and inspire students, practitioners, and others who are developing their own publicly engaged research and teaching projects. This book, *See You in the Streets*, contains vivid insights of value to historians, artists, and people engaged in carrying out public humanities and commemorative initiatives, whether as scholars, teachers, artists, students, and professionals affiliated with public history organizations or simply as people who love cities and want to share their history in creative ways.

A multimedia artist motivated by the pursuit of social justice, Ruth Sergel proclaims several times in *See You in the Streets* that she is not a historian. Despite Sergel's disavowals, Chalk and the Remember the Triangle Fire Coalition represent impressive forms of public history as a practice. Along with the earlier efforts to preserve and tell the history of the Triangle fire, these commemorations address questions that motivate public historians employed in museums and other historical and community organizations: Why do people continue to care about the past? What functions does history play in the present? How do we engage the public in past events barbed with controversy? And what are the consequences of forgetting the past?

For Sergel and her collaborators, the history of Triangle speaks both sternly and poignantly to many twenty-first-century concerns. If the act of telling history always represents an attempt to make the past relevant in the present, then the 2011 commemorations revealed New York's deep immigrant and activist roots and made visible the threads that tie together workers and consumers from around the world. In the immediate aftermath of the fire, activists, artists, journalists, and families had highlighted the story of Jewish American workers. Coalition participants helped uncover new stories, including those of workers from Italy, who have been overlooked among the Triangle dead. Women who went on strike against garment manufacturers in Chinatown in 1982 were invited to publicly share their story at Coalition programs, thereby demonstrating how textile work—and textile workers—changed from the 1910s to the 1980s. Materials about both the Italian American and Chinese American workers have been contributed to a new archive created by Coalition partners that will expand the ways that future audiences understand the 1911 fire.

In her book, Sergel also relates the 1911 disaster to recent industrial work-place accidents, including a devastating building collapse in 2013—two years after the 2011 Triangle centennial—at a clothing manufacturer in Bangladesh. Linking the 1911 fire with the disaster that killed more than one thousand workers at the Rana Plaza factory, Sergel reminds us that history can teach us how those before us have provoked change. By connecting past and present, she also shows us the terrible consequences of disregarding the fragility of workplace safety measures in a world where capital is constantly on the move.

Along with illuminating the significance of public history for a new genera-tion of New Yorkers, Sergel's account describes many of the challenges that con-front practitioners. Whose version of history gets passed on? Public historians (like all historians) must interpret archives of memory and historical evidence to compose a narrative of the past; such interpretations differ depending on the identity and interests of the interpreter. In Sergel's account, the collapse of the World Trade Center Towers played an enormous role in determining how Chalk and the Remember the Triangle Fire Coalition took shape. Within a local context, the collective grief that followed the terrorist attacks of September 11, 2001, influenced how coalition members understood the variety of tangible forms memorials could take and the emotional impact they could evoke.

Moreover, Sergel's earlier efforts to document the impact of the events of 2001 impelled her to develop inclusive ways to remember the Triangle fire. Sergel created Chalk and convened the Coalition's meetings, but she invited many people to shape and participate in memorial activities. Both initiatives actively welcomed participation by an unlimited number of organizations and individuals—those who had not taken part before, as well as those who wanted to connect their ongoing or recurring commemorations with this local, national, and international effort. The fire's commemoration would not be owned by any one distinct constituency or group. Dedication mattered more than historical expertise; and dedication to the activist legacy of the fire—to the lessons of the necessity of fighting to prevent the economic exploitation of industrial workers—mattered above all. As a result, the coalition's partners were diverse. People came from arts, labor, historical, faith-based, and educational organizations and from the many families who lost loved ones on that terrible day in 1911. By incorporating diverse perspectives and approaches to relaying the fire's history, the Coalition enlarged the historical narrative, broadened the audience for history, and made the discipline of history broadly relevant.

See You in the Streets also addresses the challenges historians and communities face when they must decide what means of commemoration best honors those who are lost and best holds the attention of those who remain. What tangible—or intangible—form does, or should, public history take? How does form relate to message? Two permanent memorial sites are associated with the fire: the grave in Evergreen Cemetery, where unidentified victims are buried, and the former factory building, now part of the campus of New York University. Each place keeps the memory of the fire alive. The cemetery offers a space for private grieving, and the historical markers on the university campus highlight the significance of what now is an academic building. Each site also serves as the location for organized memorial activities; but the cemetery's remoteness and the building's current uses largely confine their power as memory sites to those already aware of the fire. In contrast, Chalk offers a memorial that focuses more on workers' lives than on their deaths and that visually connects those lives to the places where they resided throughout the city. In this way, Chalk resembles the Stolpersteine (stumbling stones) project created by Gunter Demnig in Berlin and other European cities to mark the homes of Jewish families and other victims of the Nazis. These memorials help people see places in new ways by giving them a past. For participants in Chalk and others who encounter the writing on the sidewalk, the streets of the city are forever populated by these past residents.

But Chalk goes beyond the Stolpersteine project and calls on—indeed requires—participants to create the memorial through the act of writing on the sidewalk. Turning spectators into actors, Chalk transforms memorialization into an embodied activity that is open to all who remember the lost workers or want to protect workers in the present and future. As Sergel explains, she intended for Chalk to entail active remembering: the memorial doesn't happen if we don't remember. And she sees chalking as only the first step, since she hopes that participation will inspire chalkers to take action in myriad ways to strengthen occupational safety and otherwise advocate for workers around the world. Using history to connect people to places and to connect the past and the present, Chalk is a brilliant expression of engaged public humanities.

In other ways, the projects described here model processes that public historians and others will appreciate and, we hope, be moved to emulate. *See You in the Streets* describes how the coalition developed and sustained collaborative processes and the democratic values that drove them. As Sergel demonstrates,

such efforts to share authority can be complex and time consuming—and the time, labor, and sacrifices entailed often go unrecognized. But collaboration is essential for projects that aim to engage a broad public. The Coalition encompassed historians, artists, activists, and a wide range of other people; together they coordinated programs and assembled an interested public in ways no one could have done alone. In the end, the Coalition's activities were more expansive, inclusive, and inviting because the collaboration brought together people who possessed diverse skills and approaches and who represented far-flung professional and institutional affiliations.

We are honored to include this book in our series. We were moved by Sergel's accounts of Chalk and the Remember the Triangle Fire Coalition and are grateful for her careful documentation—through words and images—of the events organized to mark the anniversaries of the Triangle fire. These projects now have become part of the history of the Triangle Factory fire and part of the history of New York City. As *See You in the Streets* shows, publicly engaged humanities projects have the power to inform, incite, and connect thousands of people to each other, to the past, and to their communities. We hope that you find this history as inspiring as we do. We also hope the text will embolden us all to enter into our communities in new and meaningful ways—to use our own histories to make our marks on the future.

—Anne M. Valk and Teresa Mangum
Humanities and Public Life Series Editors

SEE YOU IN THE STREETS

I WOULD BE A TRAITOR TO THOSE
POOR BURNED BODIES

I would be a traitor to those poor burned bodies, if I were to come here to talk good fellowship. We have tried you good people of the public—and we have found you wanting. The old Inquisition had its rack and its thumbscrews and its instruments of torture with iron teeth. We know what these things are to-day: the iron teeth are our necessities, the thumbscrews are the high-powered and swift machinery close to which we must work, and the rack is here in the firetrap structures that will destroy us the minute they catch fire.

This is not the first time girls have been burned alive in this city. Every week I must learn of the untimely death of one of my sister workers. Every year thousands of us are maimed. The life of men and women is so cheap and property is so sacred! There are so many of us for one job, it matters little if 140-odd are burned to death.

We have tried you, citizens! We are trying you now and you have a couple of dollars for the sorrowing mothers and brothers and sisters by way of a charity gift. But every time the workers come out in the only way they know to protest against conditions which are unbearable, the strong hand of the law is allowed to press down heavily upon us.

Public officials have only words of warning for us—warning that we must be intensely orderly and must be intensely peaceable, and they have the workhouse just back of all their warnings. The strong hand of the law beats us back when we rise—back into the conditions that make life unbearable.

I can't talk fellowship to you who are gathered here. Too much blood has been spilled. I know from experience it is up to the working people to save themselves. And the only way is through a strong working-class movement.

—Rose Schneiderman, 1911, quoted in Leon Stein, *The Triangle Fire*

Rose Schneiderman was a renowned labor organizer, socialist, and feminist. Over decades of activism, she was the president of the Women's Trade Union League and a founder of the American Civil Liberties Union. She is credited with coining the phrase "Bread and Roses."

WHAT WE CELEBRATE, WHY WE CELEBRATE

JACOB BERNSTEIN, 38 YEARS OLD

What We Celebrate
Why We Celebrate
We firefighters artists labor organizers
religious non-religious people
any age possible we became everyone in order
to honor to remember to understand and know,
revere and recognize, dissect and acknowledge, and use what we knew
 and know
to move forward understanding that we can't move forward if we don't
 truly know
what came before us who stood before us stands with us now.
Some people died because they didn't have to
in a fire that shouldn't have happened in a tragic fire
over 100 years ago and that fire is no less
important because of those years still we
all of us we quickly became we,
not just a one time we but we forever
united because we want to remember
we should remember that fire because
no life should be lost, just lost, and because
we don't want other fires to happen and we
are committed to knowing the memory
using the memory every way we can create
every way we imagine, to honor and celebrate,
to prevent and heal and know.

Esther Cohen writes, teaches, and is a cultural activist.

WELCOME

Every so often it happens. A trigger jolts us out of our day-to-day lives. Drawing on outrageous energy from one past injustice after another, we cast off the world as it is presented to us and surge forth. Trusting in our own instincts and possibilities, we boldly assert our presence, our voice, our will.

In 1911 the Triangle Shirtwaist Factory fire was such a trigger. Many witnessed the inferno in the heart of New York's Greenwich Village. Helplessly watching as 146 garment workers, most of them young immigrant women and girls, burned or came out the windows to plummet to the pavement below. The bosses ran a defiantly nonunion shop, but many of the dead were secretly members of the fledgling International Ladies' Garment Workers' Union. They had bravely gone on strike just over a year earlier. Each Triangle worker who perished served as an indictment of a public that had not stood up when the call for solidarity was made. In the wake of the fire, a movement for social and economic justice was galvanized. People from wildly different walks of life stepped forward to insist that the lives of these workers could not be simply erased. The specter of the Triangle dead became an impetus to a progressive movement that created many of the laws that protect us to

this day. Even decades later, the Triangle fire retains the power to outrage and incite.

See You in the Streets is the story of how, nearly one hundred years later, the activist legacy of the fire was reimagined with the creation of Chalk, an annual community intervention, which in turn inspired the founding of the Remember the Triangle Fire Coalition, uniting artists and activists, universities and unions—in all, 250 partners nationwide—for the 2011 centennial of the infamous blaze. With political actions and academic symposia, theater, music and fine art, poetry, and film, the Coalition framed the centennial as a collective act of memory and resistance.

I believe deeply in the capacity of people as the experts of their own lives and communities. In creating Chalk and the Coalition, I am driven by an exploration of what makes it possible for us to move from the inner realm of thought, dream, or feeling to the exterior world of public action. Through films made with communities, public interventions, and new media, my projects explode out traditional mediums. Aligning content and form, the work investigates experiences of agency, teasing out the delicate mix of vulnerability and unexpected strength as we cycle from a frozen state, vibrating between personal and political distress, to moments when we burst forth to act on our own truth.

See You in the Streets is my attempt to translate years of creative experimentation and learning from radical pedagogues, artists, and activists into language. It is not a set number of stages or a three-part plan. It is diving, twirling, biting to draw a little blood, sinking back, punching through, and a lot of dreaming. What worked for me will be different from what works for you. This text is only part of an ongoing exchange. Throughout the book you will find "postcards," short essays contributed by partners in the Coalition. These essays are a small taste of the diversity of the group, to whet your appetite for further investigation. I hope you find something here that is useful to you.

At the time Chalk and the Remember the Triangle Fire Coalition were being realized, we were a country at war in two nations with another more amorphous war on terror steadily expanding. The economic divide was the worst it had been since the Gilded Age. The gross negligence that created the Triangle fire had been shipped overseas, where our cheap goods are paid for with the lives of unprotected workers. Greed is organized. Across the globe people continue to be treated as if they are of so little value they could disappear from the face of the earth and their absence not be noted. It is a kind

of daily terrorism unleashed on workers in environments where there is no living wage, no physical safety, and where—like the Triangle owners of one hundred years ago—no one faces accountability.

Our own lives seemed oddly blinkered in response. Forms of dissent that had been successful in the past were no longer proving to be effective, while new models had yet to coalesce. There was a sense of unease as we continued old rituals of protest but no longer had any faith in their actual efficacy. In this environment, art, with its unique capacity to break free from convention, has a central role to play.

In 2011, the year of the Triangle fire centennial, seventeen people in the United States were killed by terrorism, while 4,609 died in workplace accidents.[1] Between economic distress, the hysteria over terrorism, and a growing realization of the breadth of the surveillance state, there was little sustenance to conceive bold possibilities. Our imagination colonized, there was no need for official censorship. The dream is cut off before it even reaches the surface. Yet if a lesson is to be learned from the Triangle fire, it's the hard knowledge that if we don't stand up for ourselves, they will let us burn.

The story that I would like to tell is about the necessity of civic engagement. It begins with an uprising, then a tragedy. It culminates in a lasting sense of purpose deeply held by members of a broadly diverse set of communities. The heartfelt fervor inspired by the Triangle fire mirrors something larger—our hunger for meaning, connection, and effective engagement. I share the story of Chalk and the Coalition as part of a larger conversation about the exuberant joy of inhabiting a passionate life.

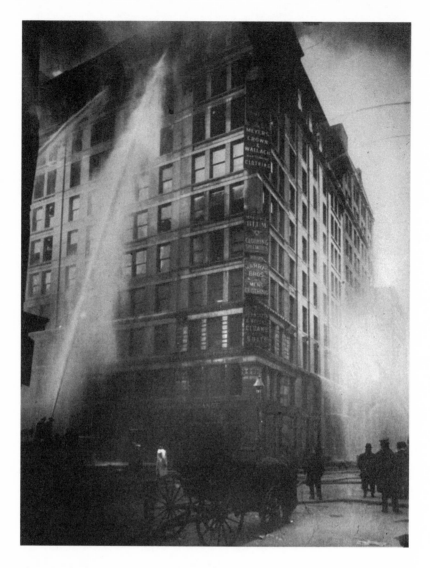

The Triangle Shirtwaist Factory fire, March 25, 1911. Photographer unknown. Courtesy of the Kheel Center, Cornell University.

THE FIRE

The "Triangle" company . . . With blood this name will be written in the history of the American workers' movement, and with feeling will this history recall the names of the strikers of this shop—of the crusaders.

—*Jewish Daily Forward*, January 10, 1910[1]

Growing up in 1970s lower Manhattan, I first learned of the Triangle Shirtwaist Factory fire from the pages of a book. I was stunned by the story of the workers, most of them girls just slightly older than myself, Jewish like me, who raced to get out of the burning factory only to find the exit locked by rapacious owners more concerned with profit than human lives. Leon Stein's *The Triangle Fire* vividly brought to life the story of a great injustice. It was through his pen that the voices of survivors and witnesses were passed down to me. For many years this is how I remembered the story of the Triangle fire.[2]

The Triangle Waist Company[3] was located in the top three floors of the Asch Building,[4] just one block east of Washington Square Park, at the corner of Greene Street and Washington Place. By the standards of the day it was quite

modern. Instead of farming out work to individual sweatshops, the company set up a central facility within which independent contractors hired and paid small clusters of workers. The eighth and ninth floors housed the manufacturing while the tenth floor was for management and shipping. In this way the Triangle owners were both physically and contractually one step removed from engaging with their employees.

Each day hundreds of garment workers were densely packed within long rows of machinery. These immigrant sisters and brothers, neighbors and friends were connected through an intricate web of relationships. Most of them were young women and girls from the Jewish and Italian American families in the surrounding neighborhoods. They worked long backbreaking hours together but also had the advantage of all the New World had to offer.

While the factory was required to have a certain amount of square footage per worker, this was commonly achieved by high ceilings rather than actual floor space. There were two sets of stairs—one on the Washington Place side, the other on Greene Street. A fire escape on an inside court ended inexplicably over a skylight to the basement. There were passenger and freight elevators. At closing each day the workers would line up to pass through a narrow partition at the Greene Street side exit to have their bags checked, part of a larger system of social control. The doors on the Washington Place side of the floor were regularly locked, ostensibly to prevent stealing but also to conveniently keep out unannounced inspectors or union organizers.

Despite several previous fires, the bosses of the Triangle Waist Company had no difficulty in securing insurance for well over the actual value of the goods and equipment in their factory. When the insurance inspector visited the Triangle factory, he noted several points of concern. The long rows of sewing machines created narrow aisles that were cluttered by seating and wicker baskets of fabric. Machine oil soaked the wood. Highly combustible light cotton fabric scraps were collected in bins built into the base of the cutters' tables. Uneasy, the inspector recommended that the company schedule fire drills. A fire safety expert duly contacted the owners to set up the exercise. Despite the regularity of garment factory fires, including in their own facilities, the Triangle owners never responded.

On March 25, 1911, several hundred workers were crowded into the Triangle Waist Company. On the eighth floor a fire broke out and spread with alarming speed. Because no fire drills had been conducted, no one knew what to do.

Precious time was lost as people made well-meant but tragically misguided efforts to contain the situation. A call to the tenth floor alerted the owners, and all but one on the executive level survived. On the eighth floor, seeing the start of the fire, most of the workers had the advantage of a few extra moments that made it possible for them to escape. Many opted for their usual exit and pushed through the narrow passage and down the Greene Street staircase. Others ran for the Washington Place exit but found it locked. After a moment of panic, the key was found, and the door opened a path to safety. A few knew about or found the fire escape. They quickly climbed down and reentered on a lower floor. Behind them the narrow walkway clogged with fleeing workers, as more and more desperate Triangle employees pushed out. Suddenly the fire escape twisted and gave way, dropping them to their death.

The hundreds of workers on the ninth floor had no warning. The fire had spread below, then seemingly in an instant engulfed them in flames. Survivors described a chaotic scene. With so many family members working together, some naturally sought their loved ones, even as the possibilities for finding a route to safety rapidly diminished. Sisters Rose and Katie Weiner never found each other. We don't know if Caterina Maltese was with her two daughters, known as Sara and Lucy, or if sixteen-year-old Annie Miller turned back to try to save her sister-in-law. Some escaped through the Greene Street exit. Others raced for the Washington Place door only to find it locked. Many later testified to their growing desperation while they tried but were unable to open the door.[5] As the wall of flames and smoke drew closer they were trapped. No survivor from the ninth floor escaped by the Washington Place side.

The elevators provided a slim possibility of rescue. Terrified workers rushed into the small cars. The operators, Joey Zito[6] and Gaspar Mortillalo, bravely returned to the floor again and again, but they were no match for the speed of the fire. When the elevators could no longer make the climb, workers jumped or fell down the shaft in a last desperate attempt to escape the flames. A barrel of oil stored by the Greene Street door exploded. Soon the fire inexorably pushed the remaining workers toward the windows.

From the street, witnesses saw the first worker come out the window. The sight was so disorienting that there was a moment of confusion. It seemed it was only fabric being tossed out to be saved, until a rush of air revealed a pair of legs just before the Triangle worker smashed into the sidewalk. Framed within each window, intimate scenes of the workers' final moments played

out. Girls holding hands as they leapt together, a man helping his friends over the ledge before going himself. A reporter described the horrifying sound as each person crashed into and sometimes through the pavement. The crowd on the street grew. Some grabbed horse blankets to try to catch the workers, but the force of the falling bodies only sent the would-be rescuers somersaulting. Hope surged when the fire truck arrived and the ladder uncoiled up toward the building until it came to rest at the sixth floor, well below the fire. The fire ladders of the day could go no higher. A few of the Triangle workers made desperate attempts to leap for the ladder, but the distance was too great, and they fell to the street. Witnesses watched helplessly as now not individuals but groups of workers tumbled out the windows, many already in flames. One locked door—and in fewer than twenty minutes, 146 workers lay dead or dying.

The anguish and outrage that leapt off each page of Leon Stein's book seemed a perfect mirror to the world I was growing up in. It was a heady time of active civic engagement. My family took me along to anti-war and civil rights demonstrations. Art was everywhere: in galleries, in the streets, and in our home. Dinner table discussions revolved around creativity, politics, and relationships. I was intently listening to the adult conversations, trying to discern the unspoken rules that govern human interaction. Photography, poetry, and music all seethed with an immediacy fueled by love and politics.

What was for my parents a rebellion seemed to us, their children, the normal way of things. My mother was increasingly involved in the women's movement. The political was intimately entwined with the personal as the adults around me were experimenting with sexuality, drugs, and consciousness. It seemed that day by day, year by year we were forcefully moving forward. I fully believed that I was growing up into a society just on the brink of social justice and equality.

People seemed to take for granted a sense of personal responsibility for the actions of their government. I understood that one of the lessons of the Holocaust was the cost of complicity. I was taught to judge harshly those who had simply "kept the trains running" while conveniently not noticing they were heading for Auschwitz. It seemed that if people only knew about injustice, then it would necessarily be put right. If the United States was wrongly engaged in Vietnam or failing on civil rights, then we as individuals were culpable. Surrounded by protest and creative direct action and sometimes violence, it was clear that to be a moral citizen we had an obligation to speak out, stand up, and be counted.

From the vantage point of my middle years, the view is quite different. As I came of age, Reagan was elected president; and what seemed like an inexorable march forward began, inexplicably to me, to quickly slide backward. Civil rights, reproductive rights, even simple compassion seemed to recede into a fog of greedy individualism. Despite the efforts of many deeply committed individuals, the overall tide was pushing back. I was living in one age but seeing and thinking from another. What I had thought was inevitable progress had been only a moment of a much larger and more complex engagement.

Professionally I began working in the film industry as a proud union member of IATSE 600 (Cinematographers Guild). Camera is great because you're always at the center of the action on set. It's fascinating to see how a production with dozens, if not hundreds, of people can work in a modular but efficient fashion. Each department works independently but for a common vision led by the director. How that works (or doesn't) on any given film is endlessly compelling.

As I began to make my own films, I kept returning to Leon Stein's book, but every idea I had for a film about the fire sank into sentimentality. It was too easy to go cheap and emotionally manipulative. There was something deeper in the story that I could not yet reach.

Many artists had created works in response to Triangle. Just days after the fire the *Jewish Daily Forward* printed Morris Rosenfeld's brilliant and brutal poem on its front page. At least two Yiddish songs commemorating the fire were quickly in circulation. In 1940 artist Ernest Fiene, hired by the WPA, painted a three-panel mural. In 1950 the ILGWU commissioned the Academy-Award-winning film, *With These Hands*, which depicted the Triangle fire and contrasted contemporary working conditions. The Triangle fire can be found in the poems of Chris Llewellyn and Robert Pinsky and in novels by Kevin Baker, Katherine Weber, and now Alice Hoffman. The play *The Triangle Fire Project* uses historical texts as dialogue. There are many children and young adult books, including Al Marrin's *Flesh and Blood So Cheap: The Triangle Fire and Its Legacy*. The story was included in a segment of Ric Burns's epic *New York* TV series.

I began to sporadically attend the annual union commemoration of the Triangle fire. Each year the dignitaries sit on the dais in the shadow of the Brown (formerly Asch) Building. The structure, which was fireproof, looms overhead. In the street there is a ladder truck from the fire department. Usually there are not a lot of people, but still a respectable showing. Union members,

city schoolchildren, neighborhood folks, and a few relatives of the Triangle dead are in the street. A tenderness always underlies the ceremony—a sense that despite everything, here we all are. The politicians make their boilerplate speeches, but the workers and labor organizers always spark the crowd. Calling out current labor struggles, those on the front line are our most direct link to the legacy of the fire.

Each year the story of the Triangle fire is recounted. As the fire truck raises its ladder up the side of the building, the crowd is suddenly hushed as we watch the ladder rise up and up, then tip, bounce, and lightly come to rest at the sixth floor. We witness the gap to the eighth, ninth, and tenth floors where the Triangle Factory burned. The sensation is visceral, as one can't help but imagine standing in the window, the fire behind, the pavement below. Often I would run into Vincent Maltese, who lost both of his aunts and a grandmother in the fire. In those early days, he had pieced together a xeroxed collection of articles and remembrances that he would generously share with anyone who expressed an interest.

At the end of the ceremony, schoolchildren line up alongside of the building. They step up to the microphone, read the name of one of the Triangle dead, and place a flower on the pavement where the bodies once lay. The fire bell is rung, and the next child comes forward. Through the retelling of the story, the fire truck with its ladder, the children reciting the names, there is a sense of ritual. This is how we remember our own.

The annual union commemoration at the site began in earnest around the fiftieth anniversary of the fire. The ILGWU, which had sought to organize the Triangle Waist Company, held a large ceremony that was attended by Triangle survivors, Frances Perkins, Eleanor Roosevelt, and Dave Dubinsky, president of the ILGWU. It was around this time that Leon Stein, editor of ILGWU's *Justice*, began to doggedly seek out the testimonies of survivors and witnesses. His sense of outrage vibrates off every page of the brutal tale as he passionately evokes the stories of the young workers.

Today, the Kheel Center for Labor-Management Documentation and Archives at Cornell University's ILR School is the home for the archives of the ILGWU and Leon Stein. Paging through Stein's correspondence, one can trace the tender thread as one survivor led him to the next. There is a touching humility as they honor his questions by being as specific and clear as possible. Sometimes the survivor had never spoken about the fire until Stein sought

out the story. Others have questions of their own. A woman who survived but lost her sister and is searching for more relatives. An adoptee who thinks her birth mother may have died in the conflagration. There are charts and lists, retyped again and again, covered in handwritten notes. Sifting through the delicate onionskin papers, one gets a sense of the magnitude of the task. If it were not for Stein's intrepid dedication to preserving the workers' stories, the history of the fire would have remained impersonal and murky. His commitment and the honor he gave to the survivors by insisting that their testimony mattered resulted in a passionate and deeply felt work. It is on his shoulders that the rest of us stand.

Growing up with Stein's book planted the seed, but it would be many years before I would have the tools to make the work. Only in retrospect do I understand that there were other skills I needed to develop before I was ready to create a piece that would fully share the sense of sorrow and defiance that the story held for me. When I did, it turned out not to be a film at all but a public action taking us into the streets.

LEON STEIN AND *THE TRIANGLE FIRE*

The Triangle fire may never have been a distant memory for those closest to it—survivors of the fire, the families of victims, and workers in New York City's garment industry. However, when Leon Stein published *The Triangle Fire* in 1962, the general public was compelled to recall the deadliest workplace tragedy in American history. And since that time, the research that went into the writing of the book has made new forms of remembrance possible in more recent years and into the future.

Published in the year after the fire's fiftieth anniversary, *The Triangle Fire* provided the first extensive account of that industrial disaster. It was based on newspaper articles, court documents, and interviews with survivors, families of victims of the fire, and others who had been close to it. Critically acclaimed in 1962, the book was also reissued in paperback in 1985 and again in 2001 and 2011.

Leon Stein's long career with the International Ladies' Garment Workers' Union (ILGWU) began in the shops. He later worked as an organizer, before joining the staff and eventually becoming editor of the union's newspaper, *Justice*. In addition to writing *The Triangle Fire*, Stein translated, with Abraham Conan and Lynn Davison, *The Education of Abraham Cahan* (1969) and edited *Out of the Sweatshop* (1977). Thus, Stein's writing about the Triangle fire may be rightly understood within the context of these complementary accomplishments—organizing for the union, writing about issues affecting workers, and publishing books that provided in-depth views of lives and events of significance to working people.

Since 1987, Leon Stein's papers have been housed in the ILGWU archives at Cornell University's Kheel Center. They contain materials relating to Stein's work on *The Triangle Fire*, *Justice*, and other publishing projects. Drawing on the manuscripts and photographs from Stein's papers, the Kheel Center designed a web exhibit on the Triangle fire and its legacy. First launched in 1997, the site has millions of hits and hundreds of thousands of visitors annually. Whether for a National History Day project, professional training in workplace safety, or personal interest, all who learn about the fire through the website have Leon Stein to thank in large part. Without his efforts to gather news accounts, court documents, and interviews with people who lived through the fire and

the events surrounding it, we would not have the rich and significant archive about the Triangle fire to share with the public today.

Cheryl Beredo is the director of the Kheel Center for Labor-Management Documentation and Archives at Cornell University's ILR School. The Kheel Center maintains the archives of the International Ladies' Garment Workers' Union (ILGWU), which include historical materials on the Triangle fire and the papers of Leon Stein (http://www.ilr.cornell.edu/library/kheel/).

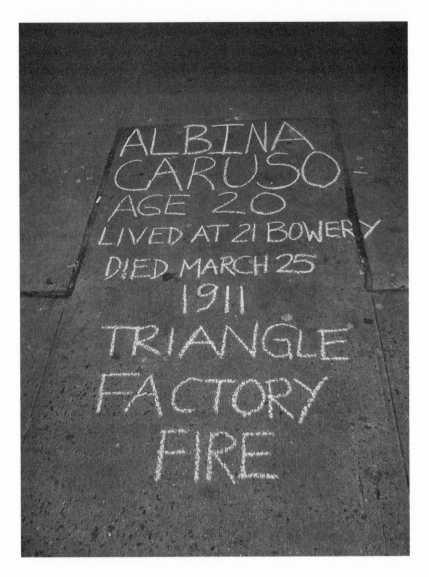

Chalk. © 2005 by Roy Campolongo. Reproduced by permission.

CHALK

We found them. You could find them by the flowers of mourning nailed to the doors of tenements. You could find them by the wailing in the streets of relatives and friends gathered for the funerals. But sometimes you climbed floor after floor up an old tenement, went down the long, dark hall, knocked on the door and after it was opened found them sitting there—a father and his children or an old mother who had lost her daughter—sitting there silent, crushed.

—Rose Schneiderman, quoted in Leon Stein, *The Triangle Fire*

Each year on the March 25 anniversary of the Triangle fire, someone steps outside her home into the streets of New York. She might cross the Lower East Side or head uptown to East Harlem or the Bronx. Perhaps she pushes out to Brownsville or to the small buildings in the West Village. Arriving at the home of one of the Triangle Shirtwaist Factory fire dead, she bends to the pavement and with thick sidewalk chalk inscribes a name:

Civia Eisenberg
17 years old
Lived at 14 East 1st Street
Died March 25, 1911
Triangle Shirtwaist Factory Fire

She posts a flier nearby to share the story of the fire, then moves on to another home, another name. Across the city more people are moving into the streets. Each of the 146 names will be remembered. Building after building, block after block, the human cost of the Triangle fire is marked across a city.

Chalk is based on a premise of active collective memory. It is an annual memorial that exists only if people do in fact remember the Triangle fire and are willing to perform a public act of commemoration. Each year the chalk washes away; but the following anniversary we return, revealing a community of resistance as we insist on making the lives of the Triangle workers visible.

I blame David Von Drehle.

His book, *Triangle: The Fire That Changed America*, built on Stein's work to create an expansive narrative that contextualized the Triangle fire within the broader social and political Progressive Era. The book was a popular best-seller and brought the fire back into the public eye. In the last pages Von Drehle included the first modern list of the Triangle dead with the age, home address, cause of death, and name of the person who identified each body. With that list Von Drehle made the Triangle workers more than their deaths. He insisted on their lives. In an instant, my own project became clear.

I launched Chalk in 2004 by emailing about thirty friends who I hoped might be willing to take a chance and hit the streets with me. I wasn't sure if the Triangle fire was something anyone felt strongly about or if it was simply a sentimental childhood memory that I stubbornly refused to release. I was startled and pleased to find that the word spread quickly. I was soon hearing from friends of those friends, then their friends. In all the years since, the mechanics of the project have remained essentially the same. I send out a general call for participation. Each volunteer gets a list of a few names and addresses and a version of that year's flier. On the March 25 anniversary of the fire, the chalkers are on their own to fan out across the city to the assigned addresses. On the pavement they write the name and age of the worker, that she or he lived at this particular address and died March

25, 1911, in the Triangle Shirtwaist Factory fire. The flier, which provides a short history of the Triangle fire, is taped up in a visible spot close by.

The first time one chalks, it can be a bit awkward juggling chalk, fliers, tape. Seeking the home of the Triangle worker, one begins to experience a vibration between past and present. As the body bends toward the pavement, there is a flood of childhood sense memory in the smell and texture of the sidewalks and an unexpected physical connection to the life of the Triangle worker. Looking up at a window, the steps, a door, we can imagine her here. It was in this street that she also walked. By this route she went to work or to meet friends. In those rooms she dreamt a future. Through physical proximity we experience the Triangle workers not as victims but as vibrant young strivers. We touch not simply her unexpected death, but her life. This was her home; she was part of a family, a community, a neighborhood.

Sometimes the act of chalking provokes a conversation. Someone stops to watch. They might have heard of the fire but didn't know that one of the workers lived here. Often they have their own story of workplace struggle to share. Sometimes they will accept a flier or even take a stick of chalk and join in.

The center of the project is the trust placed directly with the chalker. There is no organizational meeting. In fact, I've never met most of the chalkers, many of whom have been participating for years. Through word of mouth or reading the press or by simply seeing the project in the streets, somehow the pool of participants replenishes, and each year the community grows. There are the girl and her mother who annually chalk one of the youngest victims; the family who chalks the woman who lived in their building; a group of Italian American artists and historians who chalk; a lifelong East Harlem resident who ensures that all the Triangle workers in her neighborhood are covered.

While on the surface Chalk appears simple, the creative decisions that make it successful are quite specific. To participate, one is engaged not just through intellect or emotion but physically; and this makes possible a very different kind of experience. There is an element of risk. It's impossible to know what will happen in the uncontrolled environment of the streets. Taking the leap is a kind of heady joy. It is an intervention, a transgressive act that suggests a different story seeping up from the pavement. The chalker is a cartographer revealing a hidden history of our streets. Only by taking public action is the community that we weren't even sure existed made visible.

Chalk mirrors the experience of coming to political consciousness. There is a rhythm that builds as the chalker moves from an interior world, where the story of the Triangle fire resides, to the act of chalking, to seeing the traces of other chalkers and interacting with the public. Joining the union commemoration at the foot of the Brown Building, one becomes part of a movement. It is how we fight politically. Any individual may not be here tomorrow, but others will step forward and then others will replace them. It is the strength of collective action.

Simplicity of design is key to creating space for people to bring their own invention. The experience is explicitly not technology based. No specialized skills are needed to participate. It is human in scale. Over time many of the chalkers have created wildly imaginative ephemeral memorials with depictions of the fire or colorful flowers, decorations, and messages. In the early years little was documented. Now people often record not just the chalk inscription but also themselves and the rituals they have built around it. Teachers from the neighborhoods where the Triangle workers lived or where new immigrants now reside bring their classes to participate. A local shul researches its Triangle worker's name each year and invites the community to chalk messages and artwork.

As Chalk matured, I became more conscious of the experience I was choreographing. I began to experiment, creating routes that purposely led the chalkers to cross paths with each other or to chalk different names at the same location. I often pass on traces of the worker's story: who was a union member or had a relative who testified at the trial. Sometimes these strategies work, and other times they don't amount to much; but each year I get to try something new.

To facilitate making the Chalk assignments, I created an online map on which I plotted the homes of all the Triangle dead.[1] To see the visual density of markers in the Lower East Side is startling. The female and male figures that dot the surface make graphically clear the impact of the fire on a neighborhood. The map also illustrated old public transportation routes, where Jewish and Italian immigrants did and did not mix. Picking through the map, one can imagine possible relationships. If two Triangle workers lived in the same building, did they know each other? Could one have gotten the other the job? Did the families console each other after the fire? Each year I revisit the map to update it with information gleaned from the chalkers, independent researchers, and Triangle family members.

In this kind of historical investigation nothing is written in stone, and this is most evident with the names of the Triangle dead. These young workers were often known by several names, which reveal the complicated history of immigrants traveling to a distant land and language. Daughters of the Old World, strivers in the New. Family members might still use a childhood or religious name, while legal names might be upended by Ellis Island mishaps. Friends, sharing assimilation hopes, often Americanized, so Lucia becomes Lucy and Velya becomes Violet. All these appellations true in their own environments and pointing to the way in which these young workers wove the different facets of their identities. The malleability of the names provides an inviting gateway for independent investigation. In 2011 Michael Hirsch shared his research into the names of the previously unidentified buried in Evergreen Cemetery. Currently, people who are fluent in Italian and Yiddish are finding new resources. For Chalk I generally use names as they are listed on the Kheel Center website, but if a Triangle family member feels strongly that their relative was known by a different name, I defer to their choice.

Through Chalk I began to meet relatives of the Triangle workers. I soon realized that although they might share the story of the Triangle fire within their family, they remained isolated with no connection to other families with the same legacy. In 2006 I organized a panel of Triangle family members to share their experiences in a public forum at Judson Church. Suzanne Pred Bass told the story of siblings. Her grandmother who had never worked at the Triangle Waist Company, her great-aunt Katie, who survived, older sister Rosie, who had perished, and David, their brother, who sought justice for his sisters. Diane Fortuna had used her formidable academic skills to research her great-aunt Daisy Lopez Fitze, who was newly married and pregnant at the time of her death. The entire Kestenbaum family had a quiet and heartfelt dedication to the Triangle fire. Phyllis Kestenbaum represented her two great-aunts, Bessie and Civia Eisenberg. Vincent Maltese described March 25 as always a very silent day in his grandfather's home. He handed out framed pictures of his grandmother and aunts who died in the fire. I wanted everyone to have something tangible to carry home so I created a small booklet of photographs and short descriptions of the Triangle workers' lives written by their families.

Over the past decade, Chalk has evolved in response to the times. In the first years of the project the city was still reeling from September 11. Prior to that day, the Triangle Shirtwaist Factory fire was the largest workplace loss of

life in New York City history. While the two events are vastly different, they are most closely linked in the experience of the witnesses. In 2001 many New Yorkers experienced the same sense of helplessness as they watched people come out the windows and fall to their death. As the 2008 economic crisis took hold, Chalk provided a mirror to contextualize what was happening within a historical framework. There is a nostalgia for the immigrant workers of the past. Their pursuit of the American dream is broadly viewed sympathetically and provides a different lens for how we might consider the plight of workers today.

In recent times, other communities have taken on Chalk and reshaped it for their own purposes. In New York at the Fashion Institute of Technology, students chalk the names of the Triangle dead in front of their school. In San Francisco and Ohio, without the physical Triangle sites, groups have gathered to chalk all the names on the Triangle anniversary. I was delighted to find out that during the large strikes in Wisconsin in 2011, firefighters chalked the names of the Triangle dead on the steps of the state capitol. I don't really know how most of these folks found out about Chalk, but I'm thrilled to see the project take on a life of its own. In recent years a number of chalkers have reported that they are now welcomed on the street by Triangle neighbors calling out "Oh, it's that time of year again, the Triangle fire!"

Today's Triangle fires continue to burn with heartbreaking regularity. The garment industry has been largely shipped overseas, any place where the workers can be coerced into conditions not so dissimilar from those at the Triangle Waist Company. In response, a new tradition has become a part of Chalk. Now after the union commemoration, we chalk at the Brown Building, listing all the names of garment workers from Bangladesh or elsewhere killed in workplace fires during the past year.

My background was in filmmaking, so when I wanted to create a piece about the Triangle fire, I naturally assumed that it would be a movie. For a long time I thought I was struggling to find the right perspective on the story of the fire, but it turned out that was only a small part of the block. The bigger challenge was to recognize that I had to find a way to expand the boundaries of the medium. Only after a lot of experimentation working with communities to create films was I ready to take the creative leap from the cinema to the streets.

CHALK'S VISUAL HISTORIES

SARAH COOPER, 16 YEARS OLD

When we chalk victims' names to commemorate the Triangle fire, our community draws upon a heritage of two activist visual traditions, both of which arose in the immediate aftermath of the tragic blaze. The first resides in the public act of mark making as an expression of opinion or protest. Contemporary chalkers join 1911 editorial cartoonists who drew their outrage on the pages of New York City newspapers. Adding to the dramatic rhetoric more typical of period journalism, the cartoonists rejected refined styles of book illustration that featured clean precise lines, high levels of descriptive detail, and smooth finish. Instead, these visual commentators used a rough crayon style, originating in the work of nineteenth-century satiric lithographers. Over time, this rougher style came to signify a forceful mode of production and a direct simplicity of address appropriate to a "people's art."[2] Chalking names against coarse pavement requires bold strokes that signify our commitments to the social justice and labor equality that lie behind the names. Public mark-makers attract passersby with inventive designs. Our annual chalking renews our convictions and transmits them to new communities of viewers and potential participants.

Typically viewers look at the subject of such cartoons—what they say. But passionate meaning resides in the how of that saying: the mark making. John Sloan's "Here Is the Real Triangle," the most well known of the editorial drawings, is unusual in the relentless scrutiny of its victim, positioned between the skeleton of death and the fat capitalist so familiar to cartoonists' economic critique. With a highly descriptive variety of crayon marks he spares us nothing of her destruction. Flesh and muscle are burned away from her right forearm, but the artist leaves a carefully delineated hand with its accusatory pointing finger intact. Finally, Sloan positions the figure to face us, her sightless left eye darkened and confrontational. And he leaves her full mouth intact, preserving her site of speech. As we mark names on pavement, we give renewed voice to these long silent victims, bringing them to present needs and issues in Labor's constituencies.

If our first tradition resides in the marks themselves, the second emerges from the performative memorial practices surrounding the fire. At the on-site ritual, when we place flowers and hear the fireman's bell with each spoken

name, brilliantly colored chalk proclamations add additional adornment to our wreaths and flowers. Chalk on site initiates the outreach that spreads victims' names and ages throughout New York. As the longstanding implement of school-time instruction, Chalk connects to local schoolchildren, who read these names, imprinting the lessons of the fire in their minds and hearts.

When we move away from the site to perform the chalking ritual, we become a community of friends, who recall the massive mourning procession of April 5, 2011. Walking around the city, like long-ago marchers, we make chalking an activist memory ritual. This connects us to both victims and their shirtwaisted mourners, whose banners are mirrored today in the shirtwaist kites. Floating on tall poles and festooned with sashes naming individual victims, these ephemeral bodily surrogates dance in the breeze above the crowds, companions in our annual procession. Along with our connection to earlier mourners, we perform in a wider association of contemporary activism. Thanks to social media and internet connectivity, chalkers everywhere make the chalking rite a malleable one. In Berkeley, for example, chalkers lack victims' home sites, so they place names in ranks along a single block. This gesture recalls not only the tragic sight of fallen victims but the power of their—and our—collective voices, a network widened across one country, extended to others. Chalked marks on pavement. Gestures made with friends. These simple acts unite us with the histories of protest and memorializing constituted in the moment of the fire and perpetuated by us now—in the streets.

Ellen Wiley Todd is associate professor of art history, cultural studies, and women and gender studies in the Department of History and Art History at George Mason University. She is the author of The "New Woman" Revised: Painting and Gender Politics on Fourteenth Street *(1993). Todd has been writing and presenting on a long-term project,* The "Infamous Blaze": Visual Imagery, Cultural Memory, and the Triangle Shirtwaist Fire; *and her most recent project examines Ernest Fiene's murals, the* History of the Needlecraft Industry in New York's High School of Fashion Industries.

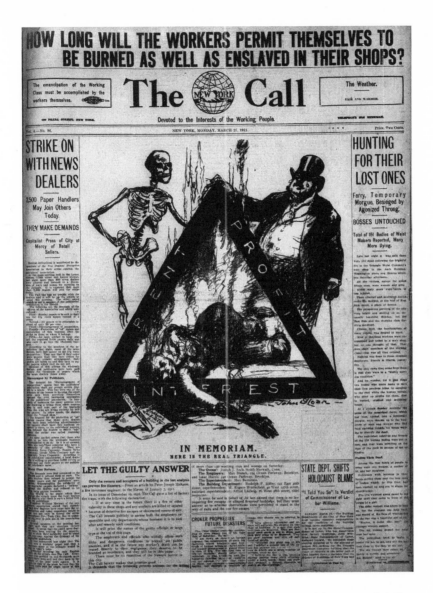

Here Is the Real Triangle. Graphic by John Sloan on the cover of the *New York Call*, March 27, 1911. © 2015 by Delaware Art Museum/Artists Rights Society (ARS), New York. Reproduced by permission.

CRAFT

Will you stay at your machines and see a fellow worker treated this way?

—Jacob Klein, Triangle worker, 1908[1]

There are moments in our lives when we are most fully ourselves. It's an electrifying feeling. Constraints that felt immutable—we step right out of them. Fully present in our bodies, they're loose and sexy. We can spin on a dime to face any adversity and blaze right through. It is not that we are fearless—it is often terrifying—but the motion that is propelling us forward has so much joy, so much life force that our demons become tiny in comparison. With crackling energy, we find ourselves whole.

My work is directed at what makes those moments possible for me and for others. The crooked path from blown-out distress, when we lack the energy to tackle even the simplest tasks, to gathering our resources to march forward once again. There is a delicate peeling apart of the layers of personal struggle from political despair.[2] To emancipate ourselves we have to exorcise internalized self-censorship and seek communion with others to find brash hope. My work

across film, public works, and new media seeks out what makes individual and social transformation possible.

The art that has fundamentally changed my life shifts how I exist in the world. It broadens what I thought possible or names something I could not fully grasp. These works have revealed not simply the complexity of human relations but also the contradictions of my own interior world. Many times the experience arrives in a medium that is not particularly comprehensible to me. My first response is often fiercely negative. I don't understand what is being presented. Often I am bored or become physically uncomfortable. The maker is forcing me to work. I have to pay close attention, read faces, think. I often have a strong urge to run away. Then, if I'm lucky, something clicks in. Out of this tangle an opening is created, and I am hooked into a deeply nurturing source. The medium is unimportant. It could be a film by Cassavetes, a theater piece by Mnouchkine, Mingus on bass, a painting by Philip Guston. I've read Audre Lorde's essay "The Transformation of Silence into Language and Action" dozens of times or the writing of Adrienne Rich or James Baldwin. Suddenly the noise of daily life goes still before something much more powerful and clean and true.

Making my own work came slowly. My stepfather, the photographer Nathan Farb, used to tell me that we make art because we think we have something important to say. I felt sure I had nothing grand to communicate. I was working in film production and hoping to become a cinematographer. On my days off, I was obsessively going to life drawing classes.[3] Day after day I toiled at sketching the figure in charcoal. I was a bit embarrassed, worried that I didn't seem to fit what I thought a camera person ought to be. It was finally the practical need to build up my show reel to get hired as a cinematographer that led me to create my first film, *Bruce*.[4]

The first time I saw Bruce Jackson dance I was riveted. He is a performer with great charisma, beautiful to watch, specializing in contact improv. He agreed to collaborate with me on what became a 35mm black-and-white short film. The fugue-like duet was constructed specifically for Bruce and the camera. The film did well at festivals, eventually being picked up for distribution and broadcast on PBS. When my drawing teacher saw it, she laughed and claimed that the black-and-white film was just a giant moving charcoal drawing. Looking back, I realized she was exactly right. As so often happens, we understand what we are doing only in retrospect. Through the daily practice of working shadow, composition, and perspective, I had taught myself to see light.

A funny thing happened when I began submitting the film to festivals. Bruce has cerebral palsy and uses a wheelchair. Several times programmers called to ask if he wasn't an actor playing someone who was disabled. At first I was taken aback by the question because it is completely clear in the film that he is a performer with a disability. I mentioned my bewilderment in a conversation with Dr. Ysaye Barnwell of Sweet Honey in the Rock, whose song "We Are . . ." is featured in the film. She wasn't surprised in the least. She pointed out that most people have one compartment for disability and a different compartment for grace and beauty. When you show them someone who is both, they short-circuit. It doesn't fit into their scheme of things. Bruce being both charismatic and disabled blew the fuse. The scope of what we are used to seeing in popular culture is so extraordinarily narrow. Tell the truth about most anything and you immediately jump the bounds of convention.

The positive response to *Bruce* emboldened me to take on more complex projects and clued me into something that has been the basis of all my work since. It is not interesting to me to make a film in which a character changes or finds redemption. The audience is only reassured in their fantasy that they don't need to engage in the difficult process of growth. The character has done the work for them. What is much more compelling is to challenge the viewers. To create an experience in which they are confronted by their own mismatched beliefs.

My interior fantasy world is pretty boisterous. Usually I am obsessing about all kinds of things. I could be trying to understand what happens to girls when they hit the wall of early adolescence (*Cusp*)[5] or pondering the false comfort of a culture that tells us that tolerance is easy (*Belle*).[6] In the company of others, I often find myself a step outside. Sometimes it seems that I don't quite get what the norms are. But as I begin to devise a project, my unquiet mind becomes focused. Creating these works gives me a language that is formed from what I sense around me and the possibilities for living unbound. For me art is dissent. I don't know if the work actually does anything in the world, but it helps me a lot. Through the action of creating, I have something concrete with which to engage with other people. The project forms the basis of a kind of conversation I know how to have. It's my best effort at being a part of things.

I am fascinated by large-scale projects by artists who work with the public. Peter Watkins, who created the nearly six-hour film *La Commune (Paris, 1871)* by taking two hundred people to a warehouse on the outskirts of Paris, where

they built their own version of the commune. Choreographer Bill T. Jones, who used movement workshops with people who had terminal illnesses as the basis for *Still/Here*. Or Maryat Lee, who moved on from her acclaimed street theater productions in New York City to rural Appalachia, where she developed Eco Theater. These diverse works don't share a medium or worldview or even a set work process, but they all engaged with communities in innovative ways.

My next film, *Cusp*, developed out of research into the fraught moment for girls when they leave behind the bold egoism of girlhood for the shaky dislocations of adolescence. There is a brief window when the disconnect between retaining one's own voice and fulfilling expected social norms is blatantly exposed. Girls are left to be anthropologists of their own culture, trying to understand what is expected of them. It is a particular coming of age when they stop acting on instinct alone but begin to censor their own voice and actions.

The story for *Cusp* came quickly; but when writing the screenplay, I found my dialogue was stilted and false. I realized that the solution might be to work with the experts: the girls the film purported to represent. I never have auditions. The casting is almost instinctual. There is a hit you get from people who have strong interior lives. I asked friends to loan me their eleven-year-old daughters to workshop the themes of the film. As we began to work together, I shared the story of the film but not the actual screenplay. Over many weeks using theater games, improvisation, and conversation, we investigated what their experiences were and the intricate relationships of the characters.

There was an extraordinary afternoon with the girls of *Cusp* and the actress playing the mother. Through improvisation, they roared and gnashed out the searing language of a mother-daughter battle—the intimate ways in which only family can reach into your most raw and vulnerable parts to rip you apart. Their fierce honesty formed the basis for the central scene of the film. Listening closely to their living language, I was able to rework the dialogue of the screenplay to match their cadence.

For *Belle*, I was fortunate to find a group of women already engaged in an oral history theater project organized by Elders Share the Arts at the Penn South Senior Center. Marsha Gildin's sensitive work with the women, ages eighty to ninety-two years old, had already created a warm sense of community. When I asked if I might borrow the group for *Belle*, Marsha generously agreed. At a reading organized by the Lower Eastside Girls Club, I found two young poets, who took on roles in the film.[7] Theater artist Jude Calder was my

collaborator in running the workshop. Her insight and theater expertise were an invaluable gift to the project. The participation of the new performers as actors and advisors shaped the heart of the film.

Sometimes looking back through videos of our work together, I am surprised at how rough things started out. The performers are self-conscious and stiff, but I always seem to remember the time really joyfully. One can see them progress from early self-consciousness to heartfelt work. A lot of what happens in the workshop comes from modeling behavior. If I am honest, precise, and open, then the new actors are that way too. A space is made for their truth, and that becomes the currency of our interactions. People are happy to be listened to. It's revolutionary. All of this takes a lot of time to develop organically. You can't rush the process without imploding it in some way.

Going from the intimacy of our workshop to the film set was like being blasted out of a cannon. Suddenly, the actors were in a roiling ocean of strangers and technical equipment. What I have come to understand is that this discomfort works to the advantage of the film. Often one sees actors acting the reality of the film rather than their characters' truths. Adrift on set, the new performers hunkered down and held on tightly to the one thing they were sure of—their intimate knowledge of their character.

A few strategically placed professional actors and a strong technical crew gave the performers a sense of safety. All my films were shot on 35mm film. While as an audience member I can thoroughly enjoy works made on the rough, technical flaws can jump the audience out of a film. There is a beauty to the physical medium of film, how it breathes and ages as it passes through the projector; the composed shot that is required when shooting expensive film stock fits with my aesthetic. By keeping production standards high I ensure that the voices of my collaborators cannot be dismissed on technical grounds. It is part of a fair exchange and a way I can honor their contribution.

After the intensity of the workshop and the shoot, the actors experience a lull while we are in postproduction. When we meet again, it is to see the film projected for the first time. I always sit toward the front on the side. As the theater darkens, I slide round to watch the audience. I pick out a few people and watch their body language and facial expressions lit by the screen. All the actors, young and old, attended the premiere of *Belle*. In one scene, new performer eighty-five-year-old Ethel Greenbaum appears full frontal naked. The audience is often a bit shocked to see a body that old projected large. One

man bellowed his disgust. But then there is the double take. We don't think twice about seeing a naked twenty-year-old body. It's commonplace. Why is it outside the norm to see an old body? By the end of the film the man who had groaned cheered louder than anyone. At the Q&A session, Ethel commandeered the microphone to tell the audience, "It doesn't matter how old or young you are, what race or religion, the human body is a beautiful thing!" She got a standing ovation.

As I gained experience as a filmmaker, I became more fully aware that, whatever the plot of the film, there is always another conversation going on directly between me as the maker and the audience. It is the nature of this conversation that actually determines a lot about the experience for the viewer. Are they being invited to an interaction that treats them as a person of intelligence and agency, or are they being spoon-fed like a child? I had a growing sense of unease at an inherent contradiction that was starting to become apparent to me. I wanted to create an emancipating experience for the viewer, yet the model for traditional film viewing required the audience to sit silent and still in the dark. Regardless of the content of the film, I was rewarding them for passivity. I was thoughtful about how I could expand the sense of agency for people participating in my work. All these ruminations were about to be challenged by an unexpected event that propelled my work out of the cinema and into the art of collective memory.

LESSONS TO BE LEARNED FROM THE TRIANGLE SHIRTWAIST FACTORY FIRE

DORA EVANS, 18 YEARS OLD

Greetings from New York City, where in 1911 the Triangle Shirtwaist Factory fire tragedy triggered grief and anger over sweatshop working conditions, enabling passage of progressive labor laws and inspiring workers to this day. To commemorate the centennial anniversary in 2011, people gathered at the site of the Triangle fire, where, as each victim's name was read aloud, relatives and schoolchildren placed 146 carnations beside the building's cornerstone. For educators, the Triangle fire serves as a prominent entry point to empowering students to help themselves through learning about labor's history, the origins and fragility of power, and why it is vital to advocate for workplace rights today. In learning about the labor conditions in the Triangle factory from both fictional and nonfiction sources, students find out that the immigrants who found work in the garment factories of the early twentieth century struggled against great odds for decent working conditions and that the events that followed the Triangle fire offer exemplars of how activism and solidarity have changed the world for the better. While labor and unionism as broad topics are politically fraught and few textbooks adequately tell labor's story, teachers can meet academic goals through selections from a wealth of teaching materials about the Triangle fire, including contemporaneous photos and artistic renderings of the tragedy, poetry, oratory, music, and literature, particularly high-interest, relatable, grade-level-appropriate novels in which the protagonists are the youthful immigrants who worked at the factory. The Triangle fire serves as a motivating and comprehensible topic for students to carry out historical research projects, with primary sources available at Cornell University's Kheel Center website or from resources listed on the Remember the Triangle Fire Coalition website. As they and their families feel the effects of income inequality, or when they listen to news of strikes against clothing retailers and fast food companies, or as they learn of workplace tragedies in sweatshops overseas, students who have studied labor history are better able to make the connections between the historical events of 1911 and the issues workers face today and will be better able to enact improvements as they gain the power that comes with maturity.

Adrienne Andi Sosin, Ed.D., chairs the education committee of the Remember the Triangle Fire Coalition. She is a retired professor of literacy education. Andi coauthored Arcadia's The New York City Triangle Factory Fire *and has written extensively about teaching labor history.*

Joel Sosinsky, J.D., M.P.A., is secretary of the board of directors of the Remember the Triangle Fire Coalition. He is a retired New York City attorney and labor union official. Joel coauthored Arcadia's The New York City Triangle Factory Fire *and is now coordinating the Coalition's efforts to erect a permanent Triangle fire memorial.*

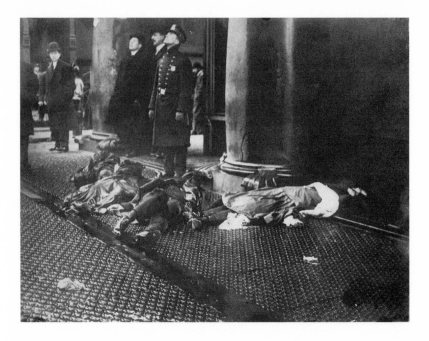

Looking up. The Triangle fire, March 25, 1911. Reproduced by permission of Brown Brothers, Sterling, Pennsylvania.

VOICES OF 9.11

Magistrate Olmstead, sentencing a striker, had lectured her: "You are on strike against God." The Women's Trade Union League wrote to the noted British socialist and playwright George Bernard Shaw, asking for a comment. Back came the reply: "Delightful. Medieval America always in the intimate personal confidence of the Almighty."

—Leon Stein, *The Triangle Fire*

It sometimes happens that you know you are living in a moment that is historic. Suddenly your fantasy of who you would have been in some iconic past hits up against the hyper reality of the immediate now. You're faced with having to quickly come up with a way to take action that is in keeping with who you thought you were.

As a native New Yorker, I was stunned and saddened on September 11, 2001. It felt as if the city was punched twice then rolled back slowly like a giant wave. The atmosphere was an almost surreal sense of living out of time. My neighborhood was shut off from traffic. We were on our own to determine

how we wanted to live. There was a tenderness in the air. A recognition of our human fragility. As the military vehicles rumbled down Canal Street and a heliport was drawn in Battery Park, people exchanged small kindnesses. Like many others, I sought something constructive I could do. The day after the attack I ran into a group of guys I knew from film production. They had spent the night setting up lighting for the rescue workers at the site. I could think of nothing as practical that I had to contribute.

In early October, my friend Pamela Griffiths introduced me to Here Is New York: A Democracy of Photographs.[1] The groundbreaking project, founded by Alice Rose George, Gilles Peress, Michael Shulan, and Charles Traub, collected September 11–related images donated by the public, which were scanned, printed, and exhibited in an empty storefront in SoHo. The prints could be bought at a modest price with the proceeds donated to charity. The lines around the block leading up to the gallery testified to the widespread desire for a safe haven for a city grappling with the repercussions of the attack.

I joined the team at the photo editors' desk. The people who brought us their photographs would often share their experience of September 11.[2] In those early days the narratives were shattered and not necessarily making a logical sense. Sometimes the photographer would return days or weeks later to repeat the story, adjusting it slightly as it came into focus. The delicacy of this endeavor was made clear as I heard the language begin to shift. One could discern very clearly the difference between their searching descriptions of what they had experienced and the set phrases dropped in from the media.

The television version of events included an almost ritualistic vision of plane, plane, building down, building down. Repeat. But as one astute contributor noted, September 11 is not about planes and buildings, it's about the people.[3] There was no oxygen for more challenging questions as to why this had happened, what it meant to us, and what we might do in healing response. We were cut off from connecting with other communities who regularly live with this kind of violence and who might have had useful guidance. Instead, a powerful machine immediately kicked in to dictate the terms of the conversation. We were inundated with stories of heroes, noble widows, and American Exceptionalism. It was another kind of violence, as we were enjoined from honestly translating our experiences into language.

One day, listening to *This American Life* on the radio, I heard the story of a man who in the immediate aftermath of World War II went to Europe to record

the stories of Holocaust survivors.[4] From David Boder's tapes you hear people attempting to describe their experience before there is a common lexicon. One survivor mentions Auschwitz, and the interviewer asks her to repeat the name. He has never heard it before. Listening to these recordings sparked an idea for what I might create in response to September 11.

Voices of 9.11[5] was explicitly designed to provide an experience that affirmed each individual's personal account of September 11. With radical simplicity we insisted on the people's right to tell their own story. Inside a private booth from 2002 through early 2003 survivors and witnesses recorded their testimonies to video. We made over five hundred recordings in New York City, Washington, D.C., Shanksville, Pennsylvania, and in the Pentagon. Sitting inside our homemade booth, the speakers had complete control over their testimonies. With the press of a button, they triggered the start and stop of their own video recording. Absolutely no restrictions were placed on what could or could not be said. Participants could speak for as long or short a time as they liked and in whatever language they felt most comfortable. We placed full trust and control in the hands of the speakers.

The Here Is New York gallery was a natural environment to find people who wanted to be a part of *Voices of 9.11*. We created fliers promoting the project in English, Spanish, Chinese, and Arabic to encourage participation as broadly as possible. As I had learned from my film workshops, in order to create a safe space for the speaker, we had to model the kind of open presence we hoped to inspire in the participants. Despite being told that they were free to say whatever they wanted, many found it difficult to believe. People have an uncanny sense for the hidden rules. Sometimes it was necessary to demonstrate a lack of fear of graphic loss or grief. If the speaker had lost someone, we might explicitly address that fact. If they were survivors, we acknowledged what they had been through and how grateful we were to have them with us that day. It was a conscious decision not to conduct the recordings as interviews. Even the most well-intentioned questioner shifts the agenda and balance of power. Each speaker signed a release affirming that the testimony would never be edited or used out of context. We were explicit about what we were seeking to create; in contrast to the TV version of September 11, the purpose of *Voices of 9.11* was to build a people's archive of what we knew to be our own true experience of that day. It didn't matter if any one story was complete. Together we would ensure that, outside the corporate or nationalist discourse, a human record of September 11 would be preserved.

In each location the booth was run by women who nurtured and expanded the project. In New York it was Pamela Griffiths. She oversaw more than 250 recordings, and the impact of her contribution cannot be overestimated. Pam was able to create an environment that provided both the space and affirmation for the speakers to openly share their stories. Her sensitivity to the needs and comfort of the participants was a great part of the project's success. Pam brought in Andrea Star Reese, a gifted documentary photographer, who took the project to Shanksville, Pennsylvania, where she had grown up and where Flight 93 had crashed. Star captured the distinct rural voices of this kindhearted community.

For the first anniversary of September 11, Here Is New York had an exhibition that included *Voices of 9.11* at the Corcoran Gallery of Art in Washington, D.C. It would have been a simple task to edit the testimonies into an emotionally manipulative video, but that would have demolished the experience of agency we had established for the speaker. For this first major public showing of the testimonies, the challenge was to create a similarly empowering experience for the viewer. I made the decision to project the testimonies life-size or larger so that the viewer and speaker could meet as equals. Instead of editing the individual testimonies, we set up multiple screens each with a different selection of videos. The viewers become the editors, as they can choose to watch a testimony all the way through or physically move on to another screen, another story that they find more compelling. In this way both the speakers and the viewers retain power over their own participation.

Another video booth was installed as part of the exhibition at the Corcoran. Laura Doggett and Vicki Warren, the Washington, D.C., project managers, began a policy of handing a marker to whoever had made a recording. Over time the booth was covered in text and drawings. On one of the last days of the exhibition we were sitting with a couple of people who had just completed their testimonies. They were lamenting how difficult it was for Pentagon workers, with their long hours, to get to the museum to participate. It had been my dream to get *Voices of 9.11* into the Pentagon, but I had no connections to make that happen. They went over to the booth and, tracing with their fingers through the scrawled messages, found a name of someone who might be able to help us. Laura and Vicki immediately made the contact and went to the Pentagon, where they were politely turned down. Disheartened, they were being escorted to the exit when they ran into someone else who had participated in *Voices of 9.11*. Hearing the purpose of their visit, they were

quickly taken in hand and the project approved. We were inside the Pentagon with our video recording booth.

For three weeks Vicki and Laura recorded the testimonies of Pentagon survivors. Overshadowed by the events in New York and working within a constrained military culture, many people were bursting to share their stories. A woman who escaped vividly describes the sensation of wanting to make herself small so that the fire would not burn her.[6] A man has a tiff with his wife that morning. After the plane hits, he begins a nightmare journey constantly trying, but unable to reach her.[7] A child describes the men who came to her house to tell her that something bad has happened to her mother. Minute after minute passes as she sits, twisting the tie on her jacket, rubbing her eyes, unable to speak further.[8] A man testifies that on September 11 he was watching the news on a TV in a Pentagon conference room. He got up to return to his desk and gave his seat to a coworker. Moments later she was killed when the plane hit. Vicki and Laura introduced him to the colleague's surviving sisters, who had also recorded their testimony, for a heartfelt exchange.[9]

For a long time I searched for an underlying commonality to the testimonies. I wondered if one person's call to God might be equated with another's desire for peace. But I don't think that is actually correct. Some people wanted to assert the individuality of people who had been killed. To pull them from the murky haze of generic victim to an individual whose favorite color was blue, or who had been kind to someone struggling, or who cracked bad jokes. Others focused on communicating specific details that could only be known from life experience. A sister describes hearing that the north tower had been hit. She immediately knows that her brother is dead and then a moment later with absolute certainty that he is alive. Over the next thirty-six hours she jolts from one belief to the other until a rescue worker at the site forces her to see the destruction surrounding them and understand the truth: her brother is dead.[10] In the end the only thing I found that linked all the testimonies was a desire for meaning. By sharing their experience they sought to pull back from the seeming randomness of the violence to a conversation that could find a way forward.

For me the most straightforward difference between propaganda and art is that propaganda tells you the answer while art brings up the question. In propaganda the maker has a point and is going to clonk you over the head with it. It can be the evil genius of a Leni Riefenstahl or the sly humor of Mi-

chael Moore. I can be moved or outraged, but I don't really grow. It's all on the surface. A kind of junk food high. As the film critic Ray Carney says, "When you hear a baby cry, you feel something but that's not art. It's biology!" A lot of work that purports to be radical does so on the basis of its subject matter alone. But for me that isn't radical. Insisting that people think a particular way is the definition of conforming, even if it's for a point of view I believe in.

Deep harm is done to people who are not allowed the intimate space to form their stories truthfully. If only certain kinds of tales are affirmed, we find ourselves circumscribed into relying on tropes that can't bear our full weight. These false constructs—those of noble heroes and inhuman villains—are quickly twisted by institutions and individuals for their own purposes, while the more dependable supports, others who have had similar experiences with violence, are kept at a distance. Those who dive full force in the aftermath of a trauma to implement and impose only reinforce a sense of helplessness. No matter how well meant, their actions affirm the individual's lack of agency.

What expands us is if we make a work that creates space to contemplate more complicated realities. When someone we love does something truly horrific, then what do you do? Or someone you loathe commits an act of such grace it takes your breath away. Who are they? Who are you? It's in those crazy complications that we find sustenance to engage with the questions and challenges that actually come up in a life. Theater artist Maryat Lee describes it this way:

> Art is whatever lowers barriers and creates real communication across impassable barriers. To use it to create passions to fight for an issue is not art, it is the opposite of it, because it is not lowering or transcending barriers. Art is the only thing that can bridge or transcend or transform in real and lasting ways. And that is what it is. It makes connections with others very different from ourselves—including our enemies and including hidden neglected unknown parts of ourselves that are wakened and drawn forth.[11]

Voices of 9.11 is radical not because it presents a particular political viewpoint but because we insisted on the multiplicity of voices. There were survivors from the World Trade Center and the Pentagon, witnesses at all the sites, old people, young people, people testifying with their babies in their arms. Most recorded in English, but there was also a contingent of displaced workers from Chinatown, a rescue worker who came up from South America, and

someone who spoke in German. Some of the people who testified wanted peace; others craved revenge; some were terrified or damaged. Some called out in rage, others from love. The event will always be political, but for those of us who witnessed it, our personal experience has to be integrated as well. The testimonies of so many different kinds of people created a unique time capsule of this very specific moment.

Soon after our time at the Pentagon, Here Is New York closed its doors and donated the photography collection and *Voices of 9.11* to two institutions for preservation. While making the project, I hadn't really thought through ownership or credit. Everything was so of-the-moment, and my only concern was to protect the speakers. At the end of the day, despite having created the project, I did not own it. What followed was the worst experience of my professional life and an important lesson in how not to run a project. The people who had participated in *Voices of 9.11* fully expected that, like the photographs, their testimonies would appear online. In those days before YouTube it was a technical challenge, but I knew we could surmount it. Unfortunately, with no legal standing, everything was out of my hands, and I had no way to fulfill the promises made to the participants. The institutions that now held *Voices of 9.11* were well-meaning, but for them it was a preservation effort, not an ongoing concern. Many years followed during which I heard regularly from participants who wanted to know what had become of their testimonies, but I didn't have the recordings. There was nothing I could do.

On September 11, 2001, I saw many people in anguish. A girl in the street quietly answering her phone, then screaming and crying. A firefighter uncontrollably shaking, covered in dust as though he'd been dipped in flour. No one could reach him—until the office worker, also powdered, came over and touched his shoulder. The day after, the line of family members wrapped around the New School. Everyone so quiet and patient and good. Entering one door slowly as can be, then exploding out the other door, wailing at the news they had received.

We need space for an honest discussion. I don't want to be attacked. I don't want to be the excuse for violence or abuse of others. But I can't find a way forward when the air is sucked out by false comfort and tropes of patriotism. I need a harder, more honest conversation in order to understand how this came to happen, how to respond to the pain I saw and the violence our nation committed in response. I don't have peace about what happened on September

11, 2001. Not for those killed and their loved ones. Not for what happened to my beloved city, and not for my country's response. I know that the attack was used as an excuse for the US to invade a country that had nothing to do with it. I know the United States uses the fear of terrorism to torture and to surveil. I know that people should be in jail for their crimes, and instead they're on TV. The rise in Islamophobia seems so archaic. It would be laughable if the cost weren't so horribly high.

The purpose of *Voices of 9.11* was not only to make the recordings but to honor the act of giving testimony. At each step we sought to uphold the speakers' right to construct their own story. Before justice, before everything else, one has to define the narrative for oneself. There has to be room to repeat the story again and again and again—often many more times than those close to us, who might have their own trauma, can bear. Over time the story begins to shape itself into something that might be possible to live with.

The heartbreak I experienced through losing *Voices of 9.11* spurred the creation of Chalk. The new work was the only way I could find to combat the helplessness I felt as my authorship was being erased. Sometimes the only way forward is to fail up and make something even bigger. Chalk was the start of exploring physical participation in my work. Once I entered this line of inquiry it seemed obvious and in keeping with feminist thought, which rejects an artificial separation between body and mind. If I wanted to create a transformative experience, surely it had to include the whole person. I was gaining skills in how to choreograph an experience rather than simply to create a product.

I began to have some confidence that if I set up a healthy working process, I didn't need to know the full outcome, or even the final medium. Instead I could trust in the work to lead the way into uncharted waters far more compelling than anything I could have preconceived. As Chalk continued to grow each year and I saw the centennial looming up ahead, I began to consider how I might challenge myself to something even bolder.

REFORM FROM TRAGEDY

New York City's Triangle Factory fire forever lives in our memory as an industrial accident, one that killed 146 mostly young immigrant women. Triangle was a notorious firm, known for its abuses and terrible treatment of workers. Rather than become yet another in a long line of quickly forgotten tragedies, Triangle was seared into our collective memory by a coalition of working-class activists who pushed a reform agenda on a waffling reform movement and a teetering political machine. That tragedy led to a new era of industrial safety regulation—more than thirty pieces of legislation—that briefly made New York the model for the country.

March 25, 1911, started as any Saturday for the five hundred or so workers at Triangle: a work day, in a week of long hours, harsh conditions, and miserable pay. The fire started on the eighth floor of the ten-story building. As workers fled, management, on the tenth floor, were notified and escaped to a neighboring building via the roof. No one told the workers on the ninth floor, who were trapped behind locked doors in what can only be described as an inferno. There was little hope, as a crowd watched helpless women jump to their death rather than face the fire. The image of young women leaping to certain death haunted a generation.

After the fire, many called it an accident, an act of God—sad, but the sort of thing that happens—and answered with charity. But, as Rabbi Stephen Wise said, "It is not the act of God but the inaction of man that is responsible." Workers and reformers agreed with Wise. The fire and the tragic deaths were avoidable. Something needed to be done.

Immediately after the fire, activists in the ILGWU pressed for action, holding a series of large protests that focused continued attention on the issue. The fire united workers and reformers throughout the state, who pressured Al Smith and Robert Wagner, assembly speaker and majority leader of the senate, into creating the Factory Investigating Committee (FIC), which the two congressmen cochaired. During its duration, 1911–1915, they rewrote New York's labor, building, safety, and industrial code, creating better working conditions for the state's millions of workers and making New York a model for the nation. Rather than turn away from responsibility, that generation met it head on, becoming

champions of the common man. But, unfortunately, we have unlearned that important lesson. How many workers need to die before we realize it?

Richard A. Greenwald is a professor of history and dean of the School of Humanities and Social Sciences at Brooklyn College, City University of New York. His most recent book is Labor Rising: The Past and Future of Working People in America. *For more information visit www.richardgreenwald.net.*

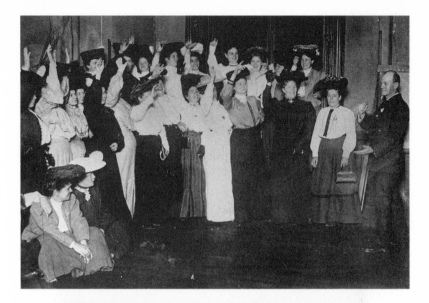

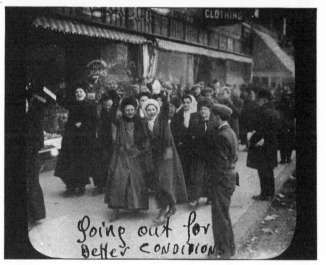

Joy in action. The Uprising of 20,000. Photographer unknown. Courtesy of the
Kheel Center, Cornell University.

START YOUR ENGINES

It is the most astonishing strike I ever knew.

—David Hurwitz, factory owner[1]

Three years before the centennial, I convened the first meeting of what was to become the Remember the Triangle Fire Coalition. Chalk had introduced me to a broad mix of people who were passionate about the fire. In an hodgepodge fashion I invited about a dozen educators, artists, activists, union members, and representatives of neighborhood organizations to gather for a conversation about the centennial. Everyone was enthusiastic. We brainstormed ideas on whiteboards, and it all seemed possible.

Over the next year our group quickly dwindled. Meetings were sporadic, and even organizations that wished us well didn't quite know what to make of us. Often it seemed we simply replayed our initial gathering as we talked about the Triangle fire and the importance of the centennial but took no action. I would not have been able to name it at the time, but I later understood that these early conversations were our first collaborative act. We were breaking

ourselves free from self-censorship to dream large what we actually wanted for the centennial.

It is a common mistake to start a project and squish it small and "doable." We think that by being what others might call "realistic" we will have a better chance of realizing our goal. But in my experience, what most often dooms an endeavor is not asking for too much—but for too little. We are so used to subsisting on crumbs that it is surprisingly difficult to simply name what we desire. The most radical change can be internal, as we break free of self-censorship so acute that we've ceased even to feel its full weight. Writer Christa Wolf describes the force with which we hold onto these constraints:

> I have known for a long time that the real transgressions are the ones that happen on the inside, not out in the open. And that you can deny these silent transgressions to yourself for a very long time, and hide them, and never speak about them out loud. We cling tight to this innermost secret and keep it and keep it.[2]

My stepfather has another saying—you'd better like what you're doing because you're gonna end up doing a lot of it! Any project worth its salt will take an enormous amount of time and effort. Superficial commitment to grand themes won't get you far in the challenges and drudgery ahead. It has to be personal. Our group was diverse. All of us had very different ideas on just about everything, from how to run a meeting, reach decisions, even what kinds of actions hold value. Before we could engage with the public, we had to begin with ourselves, modeling what we hoped to see in the communities we planned to collaborate with. Each of us had to dig down to some more intimate sense of purpose. Have our ideas challenged and expanded by hashing it out with others who genuinely see the world differently.

Over time as our connection to each other deepened, we were able to create an environment where it was safe to be uncertain and grapple, even change one's mind. It is easy to be lulled by clever language, but often our deepest tendencies need nurturance before they are ready for words. We have to create a space where people who don't use language well are free to follow a feeling or instinct. Forced into the world of intellect too soon, dreams can collapse at the point of translation. Sometimes you have to say stuff out loud in order to realize it's not actually what you believe. It is not important that we all agree at this or any stage. What is critical is to explore from as many

angles as possible. Often it is in the messy parts of our contradictions, not just between individuals but within ourselves, where we find fodder for the real work that needs to be done.

It's absolutely fine not to know the outcome or how to move forward the "big picture"—just move forward the piece that you can. The noise in our lives is so loud that often when going public we falter. We need some practice before taking that leap. I once took a writing class with Ntozake Shange. She exhorted us to write every single day, even if only for a few minutes. "Write the grocery list!" she would exclaim. "Eventually even you will get bored of that and get to what you actually have to say." If we practice speaking from the heart, we become clearer, stronger, and more generous in the present moment.

It takes a lot of fortitude not to slip into convention. When we tire, we naturally drift toward what seems safe. It can feel disarmingly comfortable. Suddenly what has been frustratingly opaque becomes crystal clear, and the road ahead is defined. But this is only because we are going the same way everyone else has gone. If too many people like what you're doing early on, be suspicious. You are probably making something that simply reaffirms people's fantasy of themselves, and that is pretty useless. If you are really doing something that will change the world, then people should be profoundly uncomfortable. When even the maker starts to shiver and wants to pull away because what is being revealed was not expected or even desired, you're onto something. This is the moment to plunge forward to question yet again not if our attempt is good or bad, but if it is as truthful as we can make it. What is the one layer more we can dig beneath to reveal something fertile and alive.

In the early days of the Coalition I often mulled what specific goal we should be working toward. After each meeting I grappled with demons. It was deeply tempting to jump for something conventional. I couldn't know until much later, but it would have greatly diminished what we were later to accomplish if we had allowed ourselves to skip the important work we were already engaged in. By clinging to a conventional project, we might have gained a short-term bang, but it would have greatly narrowed our impact. For me the fundamental question was how participation in the Coalition might give people an experience of going from the private/individual to a public/collective sphere to build the muscles of civic engagement. Discovering what might make that possible in this particular circumstance took time and collective vision.

Our conversations built common ground and taught us how people from many different perspectives responded to the Triangle fire and what kinds of change they were passionate about. Some felt strongly about educating the youth about labor history; others had familial ties to the fire. As each person articulated and expanded a dream for the centennial, we began to draw energy and ideas from each other. Each time someone asserted a bold idea or unearthed an unspoken truth, every one of us felt a piece of our own shell crack. It is initially a much slower process but in the end a highly efficient and effective one. Between us we built toward a vision worth fighting for. This work developed the foundation of the Coalition and formed the basis of a rough steering group with a clear from-the-ground-up sensibility that came to define the entire effort.

As the Coalition was coming into being, I had to think more explicitly about how we would share the story of the Triangle fire. How the tale of a factory fire with a locked door and many dead could be made resonant for the moment we were living in. As the 2008 economic crisis took hold, I sought the part of the Triangle fire story that taught us about resistance.

It begins with an uprising.

During the Progressive Era, New York's Lower East Side was teeming with theater and music, political meetings and educational opportunities. Most of the Triangle workers were Jewish or Italian immigrant women in their teens and twenties. Family members like the Goldstein sisters, Mary and Lena, and the Lehrer brothers, Sam and Max, on the Lower East Side or Sarafina and Teresina Saracino, sisters in East Harlem, often worked together. Theirs was a generation of strivers. They lived and toiled in extremely congested conditions. Many times they were the primary source of income for their families.

This hothouse bred legendary organizers Clara Lemlich, Pauline Newman, and Rose Schneiderman, working-class women who came up through the ranks of the garment industry. Labor organizing in this era was predominantly a male affair; and this included the ILGWU. Women's rights organizations, activated by the push for women's suffrage, were most often run by middle-class women with limited awareness of class issues. Lemlich, Newman, and Schneiderman each had to negotiate her own balance between her identity as a woman in the male-dominated labor movement and as working class within the class divisions of women's organizations. All of them fought for a vision that went

far beyond issues of pay and working conditions. Between them they organized for fair rent and milk prices, health care, access to education, and culture as essential requirements for the lives of workers.[3]

Pauline Newman, who went on to become the first female national organizer for the ILGWU, began working at the Triangle Waist Company as a girl of about twelve. Being employed at Triangle was considered fortunate, as such a large and successful company was less likely to lay off workers during slow periods. Working conditions there were a significant improvement from tenement sweatshops but were still quite brutal. The hours were long; the pay—for women, in particular—was low; and there were no protections against exploitation. The workers were tightly watched and controlled. One of the Triangle bosses, who was reputed to have an eye for women, sometimes asked workers to stay late. There are accounts of illegal child workers being hidden from inspectors in boxes or the bathroom. Newman spoke of being given apple pie but no overtime pay when they worked up to seven days a week in the busy season.[4]

At the Triangle Factory in 1908 Jacob Klein loudly complained that he was "sick of the slave wages."[5] Ordered to leave the premises, he was quickly joined by a second protesting worker. The manager began to beat and drag him toward the door. Klein called to his fellow workers for support. As one, they stood and walked out. The protest was short-lived, and by the following week Klein and the other workers were back on the job. Sensing the growing unrest, the Triangle owners, Max Blanck and Isaac Harris, formed the Triangle Employees Benevolent Association, a typical sham organization whose officers were family members of the Triangle bosses. In late September 1909 about a third of the Triangle workers attended a secret union meeting. The next day all work at the factory was halted as the bosses announced that the workers were prohibited from joining any union other than the in-house association. The Triangle workers began a picket line at the factory. Local thugs and prostitutes were hired to harass and beat the young strikers. The police were paid off and stepped in only after the workers had been beaten—to arrest the picketers. Sent before magistrates, they were regularly fined and sent to the workhouse. Undeterred, many of the Triangle workers joined the wildcat strikes that continued to spread throughout the garment industry.

In November 1909, a meeting was held at Cooper Union's Great Hall. Filled to overflowing, speaker after speaker hailed worker solidarity but stopped short of calling for a strike. This was in many ways a practical decision. The

ILGWU, small and underfunded, was just getting started. Despite the bravery of the women picketers, there was little faith in their ability to carry out a sustained strike. Realizing the meeting was winding down without a call to action, a voice rang out from the audience: "I have something to say!"[6] Clara Lemlich was well known for her fiery oratory and personal bravery. She had already withstood repeated physical attacks and continued to fight for the rights of garment workers. In an electrifying moment, she climbed to the stage and insisted:

> I have listened to all the speakers. I would not have further patience for talk, as I am one of those who feels and suffers from the things pictured. I move that we go on a general strike!

The crowd roared its approval.

By taking to the stage in the Great Hall, Lemlich defied the bosses but also challenged the unions to recognize the growing role of women in the labor movement. Her motion was overwhelmingly approved. Over the next days thousands of garment workers took to the streets for what became known as the Uprising of 20,000.

The strikers were wildly brave. Despite financial insecurity and the familiar tactics of violence, police corruption, and imprisonment, the strike held. Their actions caught the zeitgeist of the moment. The city was transfixed as surprising alliances formed. Middle- and upper-class women joined ranks and began to show up on picket lines challenging the police and legal system. Solidarity actions cropped up in other cities. The press flipped and began to publish stories sympathetic to the women strikers.

The strike was off to a strong start as smaller factories immediately settled with the union. Alarmed, the Triangle bosses, Blanck and Harris, quickly countered by forming an owners' association. They harnessed their considerable resources to lead the effort to put down the strike and keep the industry from being unionized.

As the winter months passed, support for the strikers began to falter. The cross-class alliance between the strikers and middle-class women frayed, and popular interest waned. Debate on the demands of the strike was heated. Some pushed for broad reform, while others were content with limited gains. By February 1910, the strikers had little choice but to settle. They had fought hard and won many important concessions on the issues of work hours and

pay. They had decisively proven that women workers could be organized to act effectively—but the Triangle Waist Company held fast and never settled. Officially they were union free, although many of the workers secretly remained members of the ILGWU.

A little over a year later the Triangle Factory burned.

If there is anything we can learn from the fire, it is the cost of complicity. The workers at the Triangle Factory did every conceivable thing right. Many of them had been bold enough to immigrate to a new land at a very young age; they worked hard in a harsh environment. They were not passive victims but stood up and fought for decent working conditions. Yet when the support of the broader community failed, their lives were sacrificed to greed.

As I took stock in 2008, the year the Coalition was founded, it seemed that we were in an oddly suspended state. Although we were a nation at war in two countries, you could roam the streets of New York City and never know it. The economic divide was the worst it had been since before the Great Depression, but in these pre–Occupy Movement[7] days, to discuss class or the problems of capitalism was outside mainstream debate. Many people I knew were swirling in shame and stress brought on by financial difficulties that were perceived as individual rather than systemic. During the period when our modest group began meeting, the situation erupted into the full-blown economic crisis.

At the end of nearly a year of conversation we chose to name our organization the Remember the Triangle Fire Coalition and created a simple mission statement. While the initial spark for the Coalition was the impending centennial, many felt strongly about creating a permanent memorial that would ensure that the lessons of the Triangle fire were ever in the public eye. Our mission statement committed us to both goals.

Centennial: Engage the community through creative educational activities in the historical implications of the fire.

Memorial: Establish a permanent memorial to commemorate the Triangle Factory fire.

The steering group had reached a limit. We couldn't progress any further through conversation and dreaming. We had discussed the history, learned a little about each other, expanded our vision from just the centennial to include the creation of a permanent memorial. Now we had to test the project in the

waters of the public, to see if our instincts were supported by the evidence. We began to organize our first public event, an evening gathering to commemorate the ninety-eighth anniversary of the fire. What the Coalition would be was still quite vague, but we had to release the comfort of sitting around a table and move into a public realm of action to find out.

Judson Church, just around the corner from the Brown Building, gave us a warm welcome and agreed to host our event. We constructed an evening that focused not on ourselves but sought to showcase the community as a whole. We filled the luminous hall with long tables and organized with everyone we could find to fill them. Because our steering group was so diverse, we had a lot of resources between us. Every corner overflowed with art, historical, and political materials related to the Triangle fire. A group from Hunter College had built a model of the Brown Building and distributed information about workers' rights. The Greenwich Village Society for Historic Preservation had culled local historical documents related to the fire and freely shared them. Katherine Weber, author of the historic novel *Triangle*, kindly signed copies of her book. LuLu LoLo was in costume from her one-woman play *Soliloquy for a Seamstress*. The public could browse books from Bluestockings, watch a film about the fire, or listen to the live musicians. Potato pancakes, Italian pastries, and beer were provided by area restaurants.[8] The Calandra Italian American Institute printed beautiful programs. Documentary filmmaker Roy Campolongo was capturing all of it with his camera. It was magical to watch as people entered and found not a lengthy didactic program, but a cornucopia of offerings on the Triangle fire. As they milled through the tables, an a cappella voice rang out calling the gathering to order with a song.

Annie Lanzillotto was our dynamic master of ceremonies. We kept our own presentation purposely brief. Leigh Benin, a relative of Triangle worker Rose Oringer, made a passionate call for the ongoing importance of the Triangle fire. I introduced the Coalition and held a mirror to the abundance that was already present and the sense of great possibility for what we might create together for the centennial. I exhorted the public to dream large and boldly. An electrifying sense of joy charged the room. With such a diversity of organizations and a great mix of people, we were surrounded by living proof of the wider community that was already coalescing around the centennial.

The success of the Coalition's first event was evident in the conversations

that organically sprang up throughout the evening. On the ninety-eighth anniversary, as the public wandered through the offerings, they naturally started to brainstorm what they might create for the centennial. By inviting people to participate two years ahead of the actual anniversary, we prompted dreams and action with time to corral the necessary resources. In an environment that invited creativity and passion, we did not tell people what to make. Instinctively and with a year's work under our belts, we were feeling our way toward what the Coalition would become: the mortar to unite our partners into a stronger whole.

POSTCARD FROM THE REVOLUTION
AND ITS SAD AFTERMATH

One of the reasons that the loss of 146 young women and men in the Triangle fire hit New Yorkers as hard as it did was because they remembered that—only a year earlier—many of the young victims had been the *farbrente maydlakh*, the fiery, idealistic young girls who had rocked the New York shirtwaist trade with the largest women's strike in US history. Sparking a massive walkout from the shops that began with 20,000 young workers and eventually embraced upward of 40,000, the shirtwaist makers had demanded shorter hours, a living wage, and safer working conditions.

The "sparkplug" of the strike, Ukrainian Jewish immigrant Clara Lemlich, had explained in the speech that launched the strike that only those who worked in the trade fully understood the dangerous and physically taxing conditions under which American women's fashions were being made. Polish Jewish immigrant Rose Schneiderman, a leader of the New York Women's Trade Union League, had repeatedly raised the issue of fire danger during and after the strike—danger from flammable fabric that clogged factory aisles, coal stoves, the cigar ash of foremen, and crumbling, inadequate fire escapes. And Lithuanian Jewish immigrant Pauline Newman, who had worked at Triangle since she was a child, had traveled through the northeastern United States explaining to affluent, native-born Christian women what it was like to work there—especially how it felt to the little children of Triangle's infamous "kindergarten" who trimmed thread from the shirts with their tiny fingers, children small enough to hide in the barrels of cloth on the rare occasions that child labor inspectors came through.

As shop after shop settled with the striking workers during the winter of 1910, owners and male union representatives alike downplayed women workers' concerns about safety and about the flammable fabric that lay piled up in most of the city's garment shops. When the Triangle fire had burned out and policemen began lowering bodies from the factory to the street, it was said that some recognized young women they had arrested, perhaps even beaten, on the picket lines of the 1909–1910 shirtwaist makers' "uprising." At a memorial for the victims, a week later, Rose Schneiderman warned New York's sympathetic

wealthy: "This is not the first time girls have been burned alive in the city. Every week I must learn of the untimely death of one of my sister workers. . . . The life of men and women is so cheap and property is so sacred. . . . I can't talk fellowship to you who are gathered here. Too much blood has been spilled. I know from my experience it is up to the working people to save themselves. The only way they can save themselves is by a strong working-class movement."[9]

Annelise Orleck is professor of history at Dartmouth College. She is the author of four books on immigration and poor women's activism, most recently Rethinking American Women's Activism *(2014). And she is now at work on a new book entitled* "Poverty Wages, We're Not Lovin' It": The Rise of a New Global Labor Movement.

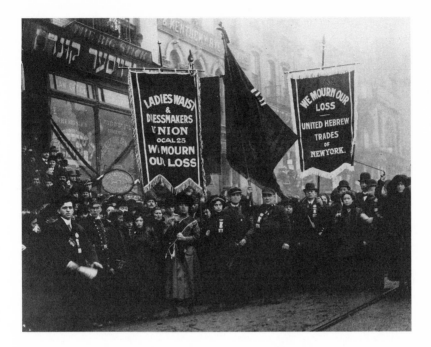

We Mourn Our Loss. Funeral procession for the Triangle dead, April 5, 1911.
Photographer unknown. Courtesy of the Kheel Center, Cornell University.

SOLIDARITY

We know that if we stick together—and we are going to stick—we will win!

—Clara Lemlich[1]

The public's joyful enthusiasm at the ninety-eighth anniversary gave our small group a wonderful jolt of energy. For the first time we had outside confirmation that our impulse for the centennial was true. There was an immediate push to build on the momentum by contacting the union to see if we could participate in the 2009 Labor Day parade.[2] It took every member of our crazy mix to pull it off.

I've been accused of being leery of working with traditional labor, and it's absolutely true. I'm cautious about collaborating with any institutionalized organization. They have their own priorities and ways of working. Unions are critical to decent working conditions, but they also have their own mixed history. The only time in my life that I had protected working conditions and decent health care was when I was a union member. But my union was also surely an old boys' club with all the attendant problems. Sharing goals is not

enough. By the time the Coalition began working with the union, we had to be strong enough to meet in an environment of mutual respect. In the end it proved to be a great partnership. I learned an enormous amount from these highly experienced organizers.

Much of the good work the Coalition was able to accomplish came through effective collaboration. It often takes having an instinct for finding the individual within an institution who has a particular passion for the subject. It's an odd intuition; but often when reaching out, if you mention the Triangle fire, folks perk up. You can hear the rhythm of their voice change. When I described what we were doing, I often found people were open and hungry to work outside the boundaries of traditional structures. They went out of their way to pitch in and became involved in the Coalition, far beyond their institutional role. We did and said what we pleased. Not asking for permission can be very addicting.

With a push from the steering group, I contacted Workers United, the union descendant of the ILGWU and coordinator of the annual Triangle commemoration at the Brown Building. I was fortunate to reach their communications director, Sherry Kane. First meetings are important; they set the groundwork for everything to come. The rule of thumb is that you have to listen more than talk. This is your best opportunity to find out what is actually driving that individual and what she might find worth fighting for. It's so simple and obvious that folks think they can skip it. But you can't. If you don't listen well, you'll be playing catch-up for the life of your project. Do it right and you'll be amazed at how generous and dedicated people can be.

I learned a lot from Sherry at that first Workers United meeting: the role of the garment industry as a stepping stone for immigrant workers; the wide disparity in pay from low-level sweatshops to the highly skilled model makers. She clued me in to the Garment District real estate battles and shared a history of the union that reached back to the venerable ILGWU. Sherry educated me to understand the union not simply as a vehicle for better working conditions but as a nexus of communal life that included education, health care, day care, and culture. Sherry welcomed and "got" us before we even knew ourselves. She warmly invited us to march with the union in the Labor Day parade.

Andi Sosin (educator) and Joel Sosinsky (Teamsters Local 237) took me along to a Central Labor Council meeting to request permission to participate in the Labor Day parade. I presented our proposal to a room full of union

representatives. I didn't know if anyone really understood what we were doing. To be honest, I'm not sure if we even knew what we were doing, but they were willing to have us along. In retrospect, I think they were much more aware of the history of artists and unions collaborating than I was. With the Central Labor Council and Workers United's support we were on our way to participate in the 2009 Labor Day parade, but we had absolutely no idea what we would actually do.

Around this time, I was fortunate to meet art historian Ellen Wiley Todd. Her writings on the early battles to control the legacy of the Triangle fire were a revelation to me.[3] Through her eyes, I began to understand the controversy over the funeral for the unidentified Triangle dead as the first round in a fight between those who would suppress the public outrage and those who fully intended to incite a call to arms.

In the wake of the fire the city was confronted with the cost of complicity. The outrage was palpable. Every possible protection had failed the Triangle workers: the factory owners, government agencies, the press, cross-class women's alliances, and the public. Frances Perkins, who went on to be US secretary of labor, was a witness to the fire. She described the sense of personal culpability:

I can't begin to tell you how disturbed the people were everywhere. It was as though we had all done something wrong. It shouldn't have been. We were sorry. Mea culpa! Mea culpa! We didn't want it that way. We hadn't intended to have 147 [sic] girls and boys killed in a factory. It was a terrible thing for the people of the City of New York and the State of New York to face.[4]

In the surge of public feeling that followed the fire, the press ran breathless stories and eyewitness accounts. A recurring theme was the call for punishment. Across the city, mass meetings were held. With 146 people dead, the disconnect between the scale of the tragedy and the usual public platitudes was laid bare. There was a discomfort in considering that perhaps more than just the owners were to blame.

The ILGWU, Red Cross, Women's Trade Union League, and many others sought to conceive an appropriate response to the tragedy. At one gathering in the packed Metropolitan Opera House, speaker after speaker intoned the usual vague handwringing until organizer Rose Schneiderman famously confronted a maudlin public with the cost of their complicity: "I would be a traitor to

those poor burned bodies, if I were to come here to talk good fellowship. We have tried you good people of the public—and we have found you wanting."

Tensions quickly focused on the handling of the unidentified Triangle dead. The unions and charitable organizations had regularly provided burial services for impoverished workers and intended to do so again. Plans for a mass funeral march were put into motion to carry the unidentified to their graves. Fearing what this public event might ignite, the city took the unusual step of refusing to release the bodies. Retreating behind a call for decorum, they carried the unidentified to the remote Evergreen Cemetery in Brooklyn to be quietly buried.

For women in the labor community, many of whom had participated in the Uprising of 20,000, the Triangle fire was a call to battle. They pushed back even their male union comrades to organize a public memorial march themselves.[5] On April 5, 1911, they took to the streets. Carriages carrying empty coffins were followed by silent marchers. The sidewalks were lined with supporters. Hundreds of thousands braved the cold driving rain. There were no speeches or political slogans. Only banner after banner that stated *We Mourn Our Loss*.

The funeral march was a collective act of solidarity. The organizers refused to let anyone dictate how their grief or rage should be expressed. United, they demanded a public reckoning. The split between the ceremony at Evergreen, which sought to use form as social control, and the public march that demonstrated collective action is not unfamiliar. Reading this history reminded me of how often paternalistic control is used as an excuse to discount emotional displays. As if anger or despair were not entirely appropriate responses to the conditions we find ourselves in.

In planning for the Labor Day parade we had to create a collective action that, like the funeral march, rejected the erasure of the Triangle workers. At the next Coalition meeting our group began to brainstorm. Leigh Benin (relative of Rose Oringer) had the brilliant idea that we should march with black umbrellas, mirroring the funeral procession of one hundred years earlier. We didn't do it after all, but I still think it's a terrific visual and somebody should. Annie Lanzillotto (artist) shared her vision of shirtwaists floating in the air. The idea was immediately supported and became the basis for what became the Procession of the 146.

A small group of us, including Carmelina Cartei (cultural worker), Rose Imperato (musician, activist), and Rob Linné (educator), met over a couple of design meetings to develop a prototype for the shirtwaists. Annie sent a

fantastic photograph of garment workers in a May Day march with a great oversized shirtwaist. Sheryl Woodruff (Greenwich Village Society for Historic Preservation), our treasurer, gave me the go-ahead to purchase a slew of bamboo poles. Rose sketched up a pattern. We experimented with shape, size, and weight, prototyping several designs. Dan Evans (writer) came up with a novel but simple way to attach the shirtwaist to the poles. Finally we found a form that worked. We stepped out in the street swinging the bamboo poles high into the air. The shirtwaists bobbed and swayed above us. Almost lifelike, as the form of the torso held but the arms swung freely. As we walked, the bamboo gently ducked and rose, the shirtwaists floating and twisting like hovering spirits.

We scheduled our first "sewing circle" to make up the 146 shirtwaists in a classroom at NYU, just around the corner from the Brown Building. Steering group members brought in relatives and friends to pitch in. It wouldn't have been a Coalition gathering if there hadn't been food. Hats off to Joel's mom, who brought along her homemade mandelbrot. Crafting something concrete and physical builds solidarity like nothing else. We wondered at the cutters' skills of a hundred years ago, as we tried to figure out how to handle the many layers of fabric. Slowly, we got our own shirtwaist factory up and operating.

Sherry had given us a box of union parade costumes, mostly made by Kathy Andrade (union member) in the 1970s and 1980s. As we sorted through the items, we found a skirt that was so long no one could possibly wear it. I was holding it in my hands as I wandered into the hall and ran into a student, Sarah Bremen (now Rabstenek). I showed her the skirt and commented that a person would need to be on stilts to be able to wear it. Sarah quietly replied that she could stilt walk. Was she free on Labor Day? Yes, she was—and she was in!

After a long afternoon in the workroom, it became clear that we were nowhere near completing all 146 shirtwaists. The next morning I was back at it. If you're the leader, the buck stops with you, and you have to be the one to ensure that no matter what, the necessary tasks get done. I knew I couldn't do it alone, so I called on my neighbors Keena Suh and Markus Waschewsky (both architects). Annie asked Audrey Kindred (cultural worker) to stop by. It took us well into the next morning, but we got the job done. One hundred and forty-six shirtwaists were ready for action.

The parade gave us an opportunity to spread the word on the centennial and the Coalition. All of us had experienced being at marches and handed dozens of fliers that quickly end up in the trash. We wanted something more personal that

would catch people's attention. Drew Durniak (designer) created a logo for the Coalition. I was startled at first. The design didn't have a hint of flame or sepia. Instead it was clean and modern. Then I realized Drew had hit on exactly what we needed to situate ourselves squarely in the present. We printed up business cards with the new logo and a call to join the Coalition. On the back of each card we placed a small sticker that Joel had printed up with the name and age of one of the Triangle dead. Before computers there was often an attempt to make things look more professional and slick. Now, with digital technology so ubiquitous, it can be more effective to illustrate the handmade quality of a project. People are impacted not simply by the artifact itself but by the obvious human time and effort that it took to create it. Placing a name on each card physically affirmed our commitment that the Triangle dead be individually recognized.

Our final prep meeting was held in a union hall that Sherry organized for us. In one corner Audrey rehearsed choreography with the shirtwaist volunteers. On the other side of the room Susanjoy Checksfeld (union costumer) fitted the newly refurbished skirt on Sarah, who was testing out her handmade stilts. We had decided that each shirtwaist should bear a sash with the name and age of one of the Triangle dead. Susanjoy and Dianna Maurer (event planner) were sewing up the sashes while Carmelina and volunteers took over tables to beautifully hand paint each name. LuLu LoLo (artist) had for years organized Chalk in East Harlem. With loving attention, she arranged the sashes so that specific names could be easily found for Triangle family members who would be marching in the parade.

When the day of the parade dawned, a pulse of excitement ran through our motley team as we arrived at our designated meeting place. Who doesn't love a parade? Workers United had a great crowd of current and retired garment workers. We had invited friends and supporters to join in. As we started to hand out the shirtwaists, everybody was posing and taking pictures together. Susan Harris (granddaughter of Triangle owner Max Blanck) brought period shirtwaists, which she generously shared. LuLu, in costume, handed out the name sashes. We had been concerned that the lengthy parade route was too arduous for many people who wanted to participate. Rose had called throughout the Northeast until she had found an open-backed antique fire truck. Diane Fortuna (great niece of Daisy Lopez Fitze), dressed to the nines, climbed in and was joined by a feisty crowd.

At last the call came. It was our turn to join the march. Sarah on stilts turned out into the avenue. The fire truck followed with Annie roaring a call on the

bullhorn. We cheered and shouted our response back. Union garment workers and members of the Coalition raised up the 146 shirtwaists. We were marching.

It was grand as we made our way up the spine of Manhattan. With the shirtwaists floating overhead, we were the most compelling visual presence in sight. People took our cards, felt the sticker, and turned them over to read the Triangle name. The shirtwaists gathered and spread, bobbing over the marchers. By the time we reached the end of the long route, we had crossed a threshold. If Chalk had made the Triangle workers' lives visible, the Procession of the 146 conjured their ghosts. With the 2009 Labor Day parade, we made ourselves large.

The Labor Day parade was our first collaborative act with the union, and it was a resounding success for all. Nobody tried to change anyone. We all worked from our strengths. From that day forward we have continued our happy collaboration. While we still maintained our independence, the union provided us stability and resources that made much of our later work possible.

I've never seen a successful community-based project that did not take a breathtaking amount of time. People often want to create holistic engagements but vastly underestimate the amount of organic give-and-take needed to make it successful. Part of the Coalition's success was simply because we started early enough, three years before the centennial, to allow the amount of time actually required. If the process is not right, the outcome never will be. This is also true on an individual level. As an organizer, I can't properly balance the community's effort if I don't meet them with my own committed example. Anything less is disrespectful to the community I am hoping to engage. As any good teacher or poet or organizer will tell you, it takes a crazy amount of work to make it all look easy. While a lot of our early workings seemed slow, they were absolutely necessary for our later success.

Today the shirtwaists are an indispensable symbol of the Coalition. After the parade LuLu LoLo took over the organizing of the Procession of the 146. Under her leadership and with the transportation genius of Joel, the shirtwaists show up regularly at rallies and exhibitions, in art galleries and government buildings. LuLu organized regular sewing circles, which built shirtwaists and solidarity.

Our usual meetings were still just a few folks sitting around a table, but together we dreamed large. Our crazy mix of artists, educators, and activists turned out to hold all the necessary ingredients for a great recipe. First moves are often clumsy, but next thing you know, you'll be marching.

THE GARMENT WORKERS' UNION AND THE REMEMBER THE TRIANGLE FIRE COALITION: WORKING TOGETHER FOR "BREAD AND ROSES"

TILLIE KUPFERSCHMIDT, 16 YEARS OLD

Perhaps because the workers who lost their lives in the Triangle factory fire were members of Local 25 of the ILGWU who went on strike two years earlier for better working conditions; perhaps because they were immigrant garment workers, members of the working class that the ILGWU's successor unions continue to represent today; or maybe because the event was so horrific—workers, young people, mostly girls, jumped to their deaths or died underfoot, trampled, overwhelmed by smoke—the union remembers.

Every year, on March 25, the garment workers' union, the teachers' union, and the New York City fire department hold a ceremony at the site of the Triangle Shirtwaist Factory fire to remember the fire's victims and honor their legacies. Along with speeches reminding us of the tragic loss of life, the ceremony focuses on the gains made in workplace safety as a result of the outrage over the fire and serves as a call to action to improve conditions for those who continue to work in dangerous conditions around the world.

The former ILGWU, today known as Workers United, has always been engaged in "social unionism," believing that the union should address workers' concerns not only at the workplace but also in their communities, with a focus on education, politics, health and welfare, and the arts. The union encouraged broad-based coalition building and personal friendships among diverse groups in an effort to support common causes in areas such as immigration, economic justice, affordable housing, health care, and civic participation. In keeping with this tradition, connecting to the Remember the Triangle Fire Coalition (RTFC) provided an opportunity for union members to work with artists and activists to broaden support for this pivotal event in American labor history.

In 2009, Ruth Sergel contacted the union about joining today's garment workers in the Labor Day parade and working together on the 2011 centennial of the fire. Artists in the Coalition made 146 shirtwaists, one for each fire victim, draped with their names on colorful sashes. Union members and RTFC activists proudly carried the shirtwaists fluttering down New York's Fifth Avenue, marking the beginning of joint efforts to raise awareness and mobilize support for the centennial.

Ruth worked closely with the union to incorporate artists and academics into this labor event. The Coalition's dynamic website became a focal point for those around the country looking for current information on the centennial and highlighted the myriad of activities that occurred around the world to remember this historic event.

Along with the union's planning meetings, the RTFC hosted open meetings that increased participation in the commemoration and ignited the passion of volunteers. The organization was housed in the union's offices, fostering a close working relationship and helping to make the centennial an event that brought thousands together to reflect on our past and to fight for a safe future for all workers.

American garment and textile workers have always fought for both "bread and roses"—to support their economic needs as well as their political and cultural well-being. The vibrant partnership that was formed between the labor movement and the RTFC produced an unforgettable centennial event as well as a long-lasting relationship that continues to work toward the creation of a permanent memorial to workers and an awareness of the need for vigilance to protect workers everywhere.

May Y. Chen enjoyed a career of more than twenty-five years with the garment workers' union in New York City. She organized and taught numerous educational programs for immigrant union members, mobilized workers to participate in labor and political action activities, and negotiated contracts to protect workers' benefits and working conditions. Chen served as manager of Local 23-25 and international union vice president until her retirement in 2009. Since 2009, Chen has remained active in labor and community projects and educational programs.

Sherry Kane is program director for the Workers United Education Program, an adult English language program for union and community members in New York City. Previously, she taught for the health care workers' union and spent several years as communications and political director for New York's garment workers' union, where she worked closely with May Chen. Sherry is active with the Remember the Triangle Fire Coalition, serving as a board member, and helps coordinate the union's Triangle fire commemoration, a ceremony that is held at the site of the original fire every year on March 25. In addition to her positions in the United States, Sherry has worked in education in Africa, China, Central America, and Europe.

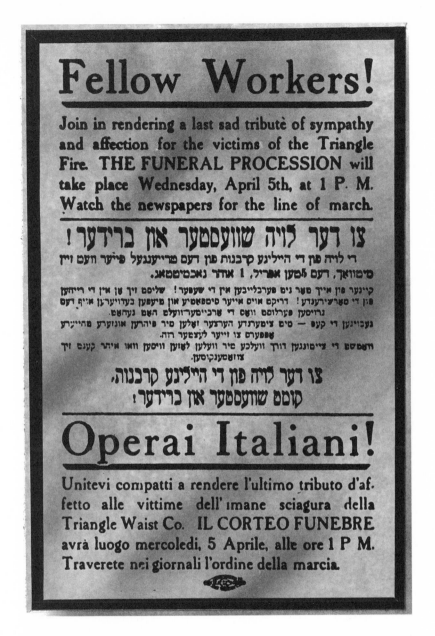

Fellow workers! Multilingual call to join the funeral procession. Photographer unknown. Courtesy of the Kheel Center, Cornell University.

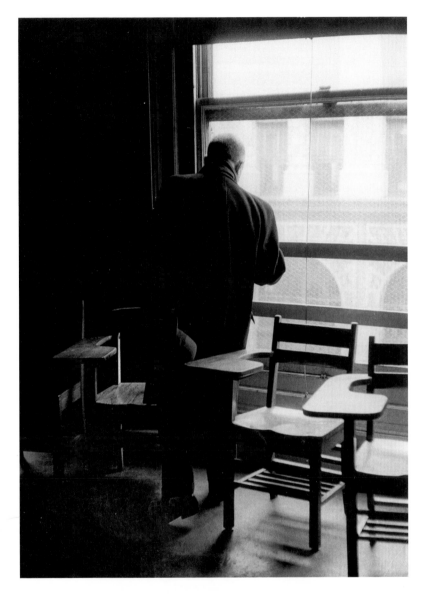

Leon Stein looking out the window of the Brown (formerly Asch) Building, photographer unknown; courtesy of the Kheel Center, Cornell University.

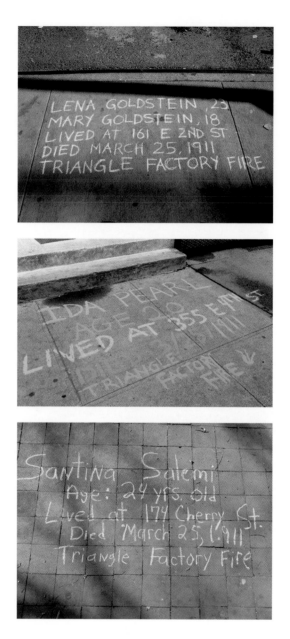

Chalk. *Top*, sisters; courtesy of chalker/photographer Kevin Walter. *Middle*, courtesy of chalker/photographer Ileana Montalvo. *Bottom*, chalked by LES Young Historians, an eighth-grade social studies program that focuses on local history, created by Alfonso Guerriero at PS 126, just around the corner from where many of the Triangle workers lived (2015); courtesy of photographer Alfonso Guerriero.

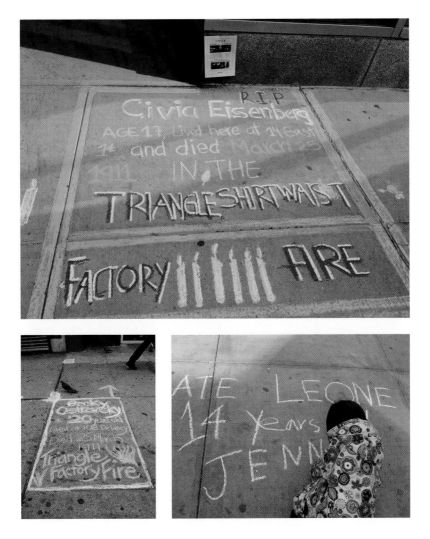

Chalk. *Top*, chalked by Scott Jackson's class from Brooklyn International High School (2015); courtesy of photographer Scott Jackson. *Bottom left*, courtesy of chalker/photographer Shelley Jacobs Mintz. *Bottom right*, Josie Ingall (pictured) has been chalking Kate, one of the youngest victims of the fire, annually since 2007; courtesy of photographer Marjorie Ingall.

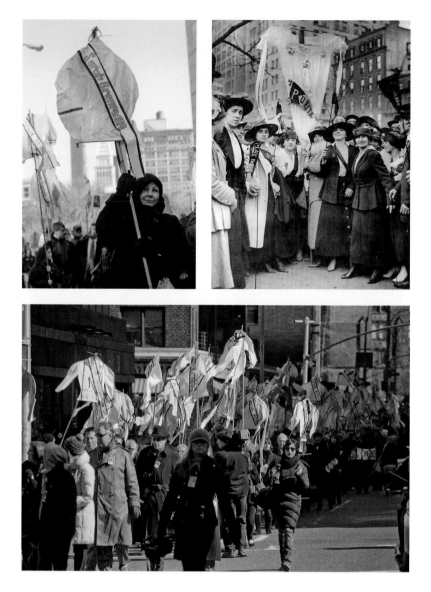

Procession. *Upper left and bottom*, Procession of the 146, photographs by RJ Mickelson; courtesy of Workers United. *Upper right*, garment workers parading on May Day, New York, 1916, photographer unknown; courtesy of the Library of Congress.

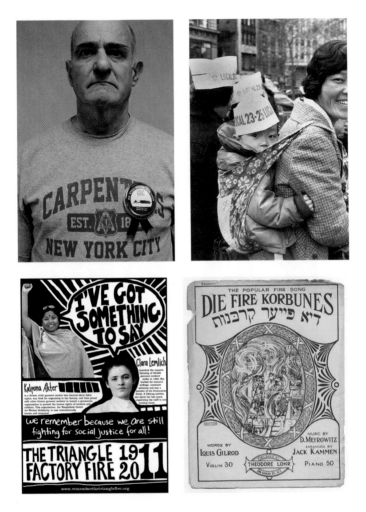

Triangle Fire Open Archive. *Upper left*, union member Norman Saul with his re-creation of the period button that reads "We still mourn our loss"; courtesy of photographer Gabrielle Bendiner-Viani/Buscada. *Upper right*, We are One! 1982 ILGWU Local 23-25 strike, ILGWU photographer unknown; courtesy of the Kheel Center, Cornell University. *Lower left*, cover of the Remember the Triangle Fire Coalition's calendar newspaper for the 2011 Centennial featuring Uprising of 20,000 organizer Clara Lemlich and Kalpona Akter, executive director of the Bangladesh Centre for Worker Solidarity: Esther Cohen (creative director), Laura Tolkow (designer), Mark Solomon/PHILMARK (printer); courtesy of the Remember the Triangle Fire Coalition. *Lower right*, *Die Fire Korbunes*, 1911 sheet music, performed by Eve Sicular and Metropolitan Klezmer at the Triangle Centennial concert in the Great Hall of Cooper Union, March 25, 2011, photographer unknown; courtesy of the Library of Congress.

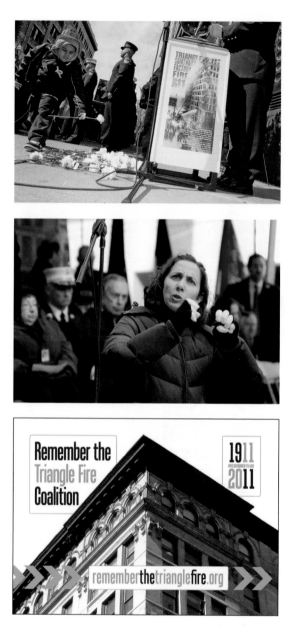

Centennial. *Top*, children laying flowers for the Triangle Workers at the Brown Building, photograph by RJ Mickelson; courtesy of Workers United. *Middle*, American Sign Language Interpreter Jessica Ames, Workers United Triangle Fire centennial commemoration, March 25, 2011, © Nathan Farb; reproduced by permission. *Bottom*, Remember the Triangle Fire Coalition postcard, design by Drew Durniak.

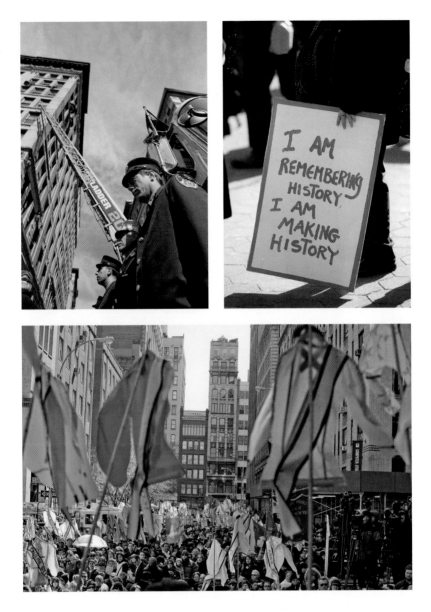

Centennial. *Top left*, fire ladder raised to the sixth floor. *Top right and bottom*, Triangle fire centennial commemoration, March 25, 2011, photographs by RJ Mickelson; courtesy of Workers United.

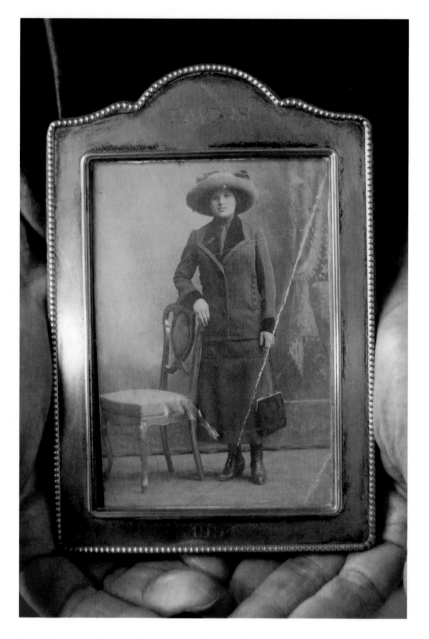

Rose Weiner. The hands of Suzanne Pred Bass holding a photograph of her great-aunt Rosie Weiner (20), who died in the Triangle fire. Courtesy of photographer Gabrielle Bendiner-Viani/Buscada.

RADICAL TOLERANCE

Be of good cheer, sisters, you are not alone in the struggle. Your fight is our fight, your cause is good, your fight is brave, your victory will be glorious!

—Morris Hillquit[1]

The philosopher Mary Midgley has a great description of how we might conceive the relationship between our interior consciousness and the world at large—not as two separate entities battling over borders and boundaries, but as an atlas. To understand the whole we need to see the same ground through a profusion of layers: the topological map, the political map, natural resources, population, and so on. Each layer adds to both our general and our specific understanding.[2]

The Triangle fire is a kaleidoscopic story of origin. It is a tale of the Jewish and Italian American immigrant experience, women and the labor movement, an impetus for the New Deal and the establishment of fire and safety laws. The more communities who share their stories, the more layers we have for our atlas of the Triangle fire and its legacy. Only when seen together is the whole revealed.

The Coalition became known for the diversity of communities involved. A quick glance at our roster and you'll find everyone from the American Society of Safety Engineers to the New York State Communist Party, the Stanton Street Shul to the New York State Department of Labor. Schools, theater companies, fire marshals, unions are all part of the mix of over 250 partners nationwide.[3] How that came to be was anything but chance.

Creating an environment in which a multiplicity of voices can comfortably engage in the conversation takes careful design and a kind of radical tolerance—a welcoming of people of all stripes on their own terms. We had to craft as many avenues of entrée as we could find to offer diverse communities organic paths to participation. There is a constant happy challenge to stretch forward yet one more arm's length to invite all aboard. It's a wild ride, as you never know who is going to show up or when you will hit the wall of your own prejudices. As Dr. Bernice Johnson Reagon of Sweet Honey in the Rock has said, "If you're in a coalition and you're comfortable, you know it's not a broad enough coalition."[4]

In theory, practicing tolerance should be easy. But if it was, then everyone would do it. One flash of road rage or an argument with someone close to you is all it takes to realize how quickly we can all go down the rabbit hole. When we open ourselves to others there is a kind of sandpaper to our nature. All of us get our edges rounded a bit. I used to have a sculpture teacher whose classroom was always filled to overflowing with students. Sometimes we implored him to set some limits so there would be enough space for all of us. "I can't do that!" he would shout. "What if I turned away the next Michelangelo?" And it's true. People are so surprising you never know what they might come up with. It's a much stronger organization if it is open to everyone.

There is nothing radical in collaborating with people who hold the same views as you, no matter what those views are. The experiences that expand us occur when we are confronted with contradiction. The mix of people involved in the Coalition has always been our greatest strength. The healthy tension of working just beyond what was comfortable led us to be much more effective, expanding all of us in unexpected ways. Core members of our community came from different work and organizing backgrounds. Some people had spent their entire lives in extremely hierarchical environments; others live a bit outside the law. Some issues touch my heart more than others, so that is where my work leans; but I'm deeply grateful that others find their meaning elsewhere. All of

us had to stretch and expand ourselves in order to fully participate. That kind of personal leap often pays off in unexpected ways. Through our interaction my palette is expanded, and together we cover a lot of ground.

The criteria for participation in the Coalition was straightforward. All one needed was a passion for the Triangle fire. Beyond that, there were no definitions or demands. What brought people to the Triangle fire was so diverse, it would have been false to pretend that we were all there for the same reason. Rather than dumbing down everyone's contribution to something simplistic, we kept the bar high by encouraging bold engagement while explicitly not dictating how that would be done. Our trust was in the participants.

For every path into the Coalition, I tried to create loops of positive feedback so that new members would quickly feel welcome and included. The Coalition had a mix that could be roughly broken down into communities of identity (labor, women, Jewish, Italian American, fire and safety, Triangle family, neighborhood) and communities of participation (educators, artists, activists, first responders). Overlaying this was a generational divide between people who had grown up in a digital world and an older generation often with decades of organizing experience. Using both live and virtual tools, the goal was to find means for each of these different groups to collaborate in every possible combination.

Even before the Coalition was much of an organization, we had a website that formed the nucleus of our growing ecosystem. Much of our technical savvy was made possible because I had the good fortune to study at ITP (Interactive Telecommunications Program) at New York University.[5] It was there that I learned the skills to build our technical infrastructure. The site began simply, displaying only our mission statement and contact information. A resource page with a constantly updated list of books, lesson plans, films, and other creative responses to the Triangle fire. The map from Chalk, charting the homes of the Triangle dead, was included with easy instructions so others could embed it on their own sites. We soon expanded to feature a running list of the technical tools we were using to create our network so that others could access these free or low-cost resources if they found them to be effective. On our homepage we proudly listed the growing roster of partners.

The process to become an official member of the Coalition illustrates the positive loops of experience that were constructed for our members. We had three levels of membership: Participating Organizations ($20 fee, which was

waived if it hindered), Supporting Organizations ($100), and Change Agents ($1,000 and above). The sign-up procedure was the same for all the groups. New members filled out a simple online form that asked what they were planning for the centennial and if they had or were seeking any particular resources. Once I received their registration, I immediately launched a series of welcome actions. I added their names to the roster on our home page and gave them a personalized shout-out on our Facebook page and Twitter. A short while later I sent the new members a personal email welcoming them to the Coalition and pointing them to their place on our roster and the enthusiastic welcome they were receiving from the community on Facebook. If any were seeking resources, I put them in touch with other partners who might be able to pitch in. Sometimes the only need was financial. Since we had almost no money ourselves, I offered letters of support for grants or possibilities for networking that might reduce costs.

One of the inducements to join the Coalition was that all our partners could post events to our popular online calendar. The Coalition was formed at a moment when many organizations knew they needed an Internet presence, but the tools for small groups were still quite challenging. Even organizations that had websites were often unable to update them without outside support. In this moment, the Coalition was able to help bridge the technical gap. Our online calendar contained permalinks and a map and linked to the originating organization. Members could see what was already scheduled and find good dates for their own actions. As events neared, we happily publicized them on our Facebook page and promoted them in our monthly email blast, providing an organic cross-pollination of publicity among all the participants.

Access is a civil rights issue on par with any other. Discussions of our fundamental interdependence directly challenge the fantasy of rugged individualism. We were happy to open up a conversation on the topic. The Coalition wrapped the discussion of accessibility into the procedures for posting on the calendar, our most heavily used platform. The calendar submission form required information about event access. We asked if the venue was wheelchair accessible and if interpreters were available upon request. Many times organizations want to do the right thing but don't exactly know what that might be. What makes an event accessible to a person who uses a wheelchair is different from what makes it open for a blind person and different again for a person with developmental disabilities. We were fortunate to get some great tips from

blogger Emma Rosenthal. One of the things she encourages is pretty easy: if you don't know—just ask! With clear channels of communication, people can ask for what works for them, but it is the organization's responsibility to initiate the conversation. Rosenthal suggests adding contact information for a specific access point person within the organization and this wording to all forms of publicity:

> This event is wheelchair accessible and dis-ability affirmative. If you need additional accommodations, please contact us 72 hours prior to the event.

What worked for the Coalition is surely outdated by now. The technology changes with startling rapidity, but the underlying assets that make things work or not are the age-old precepts of good organizing. It's important to personalize interactions, create concrete objects together, enable people to see their participation as part of a greater whole. Social networking simply provides another means of movement building.

New technologies are simply the tools of the moment. The fantasy that technology or the tech community will save us is like believing in the tooth fairy. Religion has been replaced by science, which has been replaced by technology. We hope that the techies will do no evil and save us. But like the robber barons of old, you get what you pay for. They are not doing it for us; they are doing it for themselves. There is no reason to trust them simply for their skills.

While technology evolves quickly, we humans remain pretty much the same. Even a cursory look at history teaches us that we just keep repeating the same human impulses with new tools. Today it's Facebook Friends, yesterday it was *cartes de visite*, business cards printed with small photographic portraits left at the homes of friends. Households would proudly show off their collection of these cards in large leather-bound books. We're always looking for a way to demonstrate our popularity. We worry about how many friends we have or don't have or who is a real friend. Somehow our human vulnerability and hunger for creativity and meaning, work and love remain pretty solid throughout.

With our limited resources, the Coalition sought to make the most of what we had to offer, constantly reassessing what we could do to be more inclusive. Often when tensions arose, it was about control rather than inclusion. This came to a head when an art project was proposed that some people felt was disrespectful to the Triangle dead and their families. The artist listened to the criticism and came back with changes intended to address the community's

concerns. Unfortunately by that point, this particular piece of work had become a focal point for a lot of fears. It was a moment when people began to think that control would make them safe. They insisted that the Coalition not support this work.

Art is often one of the first things attacked when individuals are seeking to exert power. Somehow people feel entitled to pronounce judgment and censor in a way they wouldn't in any other situation. If the Coalition was to welcome everyone, then the rules had to apply equally to all. The only criteria we had for participation was a passion for the Triangle fire. This artwork clearly surmounted that hurdle. Every year at the union commemoration there are politicians on the dais. Some of them speak well, and others preach a bunch of hogwash. If we don't like what they're saying, we can boo or ignore them. But they get to speak. It is completely inappropriate, as so often happens, to single out artists for special censorship; so I insisted on our continued support.

I didn't know if I would hit a line I felt couldn't be crossed, but in fact we never did. My taste is limited. Ultimately there were events for the centennial that were not my personal cup of tea, and some of these were the most popular all around. We had to trust that if a person was passionate enough to do the enormous amount of work to create a commemorative project, there would be someone who would find the work compelling. Since we wanted folks from all walks of life to participate in the centennial, it made perfect sense to have many different kinds of people creating it. I'm in favor of voting with your feet. If you think you'll be offended by a project or won't like it—don't see it. Problem solved.[6] As it happened, in the end the art piece was performed, and there wasn't a single complaint.

Every now and again you hit a wall with someone who does not act in good faith, and the issue of tolerance becomes more complex. There is one individual who takes an enormous amount of the Coalition's time and energy. We'll refer to him as *the one who shall remain nameless*. Every step I take, he tries to find fault. At first it was disconcerting, but it turned out that even a bit of craziness can sometimes be turned into something useful. Because he is always nitpicking, he sometimes finds things that actually do need improvement, and it's kind of great. Where people who like us might give us a pass, this guy gives me fodder to improve the organization. That's the positive side. The negative is that he often veers into a lunatic land of obsessive harassment. Once someone

is in his sights, he is seemingly unable to control himself, unleashing a deluge of rants and vague threats. His rabid attacks left many people feeling unsafe and bullied into silence. People began to censor themselves in order to try to avoid his wrath. Over the years an astonishing amount of time has been spent, mostly by women, attempting to accommodate and placate this individual, giving him a lot of power. This leaves the many people he has abused feeling alone and delegitimized.

The best strategy turned out to be a little organizing. First, I reached out to other folks leading organizations. Suzanne Wasserman, director of the Gotham Center for New York City History, regaled me with her own experiences of this kind. Her stories and those of others made me realize this is simply part of leadership and I was in great company. Their humor and insight gave me the confidence not to join the nameless one in his mania but to keep my focus on the real work at hand. At some point the nameless one stopped attacking me directly and shifted his focus onto others. He would find some member of the Coalition to harangue in an obsessive and unfortunate manner with phone calls, emails, and obscure threats. I soon learned that the best response was simply to put the latest victim in touch with the previous person he had harassed. Those two could compare notes on their experience and were assured that the attack was not personal to them but a problem inherent to the nameless one. It was much more effective than anything I could have ever said. It took some time, but over the years, the nameless one created his own loss of credibility among our many partners, and my time was free to spend on constructive work for the Coalition.

Virtual organizing is a great tool, but there's nothing like getting in a room together. As the community grew, we created a regular schedule for our boisterous open monthly meetings. One table was always kept free for people to share their fliers and postcards. Often there were donations of cookies and snacks. It can be intimidating to walk into a room full of strangers. To make welcome everyone who was bold enough to take the chance, we had to shift the structure of the meetings and ensure that everyone in the room spoke at least once. We started with a round-robin. People who had already attended a meeting would simply state their name, affiliation, and any general announcement. Newcomers were encouraged to be more expansive, to share what they were planning for the centennial and what resources they might have or need to realize their project. We cheered and howled at will. As our membership

grew, these introductions soon took up a large part of our meeting. What time remained was used to break into working groups that gave people the opportunity to brainstorm and exchange contact information. The energy of these encounters acted as a fast-forward version of the process that the steering committee had engaged in over our first year. It's not that a lot of practical work got done; there wasn't time for that. But people did get the more important message: an expansive and expanding community was organizing for the centennial, and everyone was invited to pitch in.

There is an exhilarating beauty in folks who are not embarrassed to be passionate. It was intoxicating, as we began to get a sense of the breadth of what was being created. One of the reasons I love making work is that it gives me the excuse to interact with people I might not usually get to know. At the Coalition we have a contingent of history stalwarts. These folks show up regularly at public events. They can quote dates and addresses, and they're not shy to correct the purported "experts." It was also an opportunity to honor the unacknowledged pioneers. Often the folks who blaze trails have difficult personalities. You have to be kind of nuts to be bullheaded enough to knock through prejudice. We depend on these people to foster change, but later they are often discarded for being difficult. These women and men have a lot to teach us, and their presence can do much to keep a group honest.

My absolute favorite thing is to hang out with people who are really obsessed with something. It doesn't much matter what: it can be a lost craft, a political ideal, or a scientific theory. All of it is fascinating when seen through their eyes. Because they are so focused, they often live a step outside the mainstream within an unspoken self-reliance. The independence of their viewpoint is deeply inspiring. I always learn a lot.

The meetings celebrated people acting as intelligent, committed, and fiery as they actually are. The university professor who brought her entire class, a theater company based in Kentucky, engineers in ties, and reps from local unions—all gathered to honor the memory of the Triangle fire. It felt like a party of a secret army uniting for action.

What the Coalition had to offer was humble, but what people need is often quite modest; an encouraging word, a brainstorm for the next concrete step to take, or simply an acknowledgment of the hard work required in staking an independent path. As a supporter, I can't know what will help, but I can act as a sounding board while they find their way. What I saw in the faces of people

new to the Coalition was a shyness bursting with hope. Being presented with an environment of mutual support creates a radically different context. It's a bit bittersweet to see how much people can accomplish with the slightest encouragement. It makes clear how little true sustenance we receive in our daily lives. With even modest backing, people were glowing with possibility.

Within the Coalition I found that my voice was often extremely happy and enthusiastic. Part of that was simply truthful—it was thrilling to see it all unfold. But it is also because positive feedback is an extremely powerful tool. One of the subtle controls in our life is the lack of constructive reinforcement. Do anything that challenges the status quo, and it's stunning how acute the costs can be. There is a hurt done to people, a way that they are pressed into conforming. If you stand up, you might get left out of the pack. A kind of ugly permission is granted for a strange viciousness toward the one who breaks out. It's no wonder that it's so much easier to just blinker ourselves.

When we first stand up for our own point of view, we often stumble, and that can snowball into a sense of embarrassment or shame. We forget that no one actually stands alone. There is a web of (sometimes unacknowledged) support. People with the benefit of privilege have their wildest claims given the benefit of the doubt and find their mistakes easily forgiven. They have the luxury of the calm and time that come from being the normative model. For the rest of us, there's the constant battle to assert our own experience of reality. It takes an enormous amount of individual force just to get to the starting gate.

We have to set up our own systems for rewarding dissent. We can construct environments in which people are safe to let their imaginations roam wildly, trying out possible selves, dreaming a different kind of future. Everyone gains immeasurably by knowing there is a witness to their truth. There is a fierce beauty to the practice of speaking out loud what we want and asserting our ability to get it, no matter what the odds.

As the centennial loomed, the open meetings grew into a thrilling collective action in themselves. We had come a long way from our modest early days. Still, as I left each meeting and walked toward home, I was often disappointed in myself. There were always moments that I had missed. Something I hadn't put together quickly enough or been able to find the right words to address. Sometimes if I work on a project long enough, I get lucky. Someone will describe what I am doing more clearly than I could ever explain it to myself. It's only then that some of the terror abates, and I realize the work is taking

on a life of its own. One day I got a call from a woman in Boston who asked me what the Coalition was doing. A bit startled by such a direct question, I stumbled through what felt like a not very coherent response. After a while she piped in, "Oh, I get it, it's anarchist organizing!" Somehow she had distilled the sensibility of the entire project.

GUIDE TO ACCESSIBLE EVENT PLANNING

1. Progressive communities need to begin (BEGIN!) the dialogue on inclusion.
2. All events have a designated accessibility coordinator to make sure aisles remain clear and unblocked and to support people with dis-abilities, should problems arise.
3. Ridicule and humiliation of people with dis-abilities must be treated like all hate speech and appropriate action be taken to assure events are not hostile environments.
4. Where "special" entrances are necessary, specific signage and staffing must be provided so that people with dis-abilities have the agency to come and go with the same liberty as all other participants, not having to wait until someone becomes available to assist them.
5. Add the following statement to all publicity for your events:

 This event is wheelchair accessible and dis-ability affirmative. If you need additional accommodations, please contact us 72 hours prior to the event.

Then be ready to provide sign language interpretation and other accommodations as needed.

My biggest pet peeve is otherwise accessible venues where the stage is inaccessible. It is a very strong reminder: "You are welcome to be here, but we don't feel that you have anything to say!"

Emma Rosenthal is an artist, writer, educator, Reiki practitioner, farmer, and human rights activist living in Southern California whose work combines art, activism, education, and grassroots mobilization. As a person with a disability, she is confined—not by her disability but by the narrow and marginalizing attitudes and structures of the society at large.

We are one! Chinatown ILGWU Local 23-25 strike, 1982. ILGWU photographer unknown. Courtesy of the Kheel Center, Cornell University.

FAIR EXCHANGE

For every girl that is slugged in this strike a cop ought to be sent to the hospital.

—Big Bill Haywood [1]

The passion ignited by the Triangle fire has inspired many people to independent research. As our organizational presence took hold, the public began to share family photographs, old newspaper clippings, and historical documents on our Facebook page. It was thrilling to see these bits of history rising to the surface but also disconcerting, because Facebook is ephemeral. It quickly became clear that someone should be ensuring the preservation and future accessibility of these materials. Then I realized that someone was probably us.

The Triangle Fire Open Archive is a collectively created repository. It was established as an immediate response to a need demonstrated by the community. The development of the project reflected my growing realization that the defining role of the Coalition was not so much to initiate but to constantly seek ways to support opportunities for interaction between our partners. The

community was organically churning up fascinating material. The Triangle Fire Open Archive used these discoveries as the basis for expanding the conversation between people who might not have otherwise found common ground.

The digital revolution has had a profound impact on the role of the community-based artist. It has subtly shifted the roles of maker and subject. In the past, an important part of our work was to mitigate the cost and technical complexity of the tools needed to preserve and amplify the voices of outsider communities. Today with only a cell phone and Internet access, people have the capacity to expose their own story. But the cacophony of easy broadcast does not necessarily mean one will be heard. Ironically, as these tools became readily available, the power of the broadcast was revealed to be extremely limited. We are oversaturated, pummeled by a sensory overload of data streaming across our many screens.

Often projects focus on collection as an end in itself with little thought to the practical use of the materials in the future. As a result a lot of busy work goes into acquiring large amounts of data that are never touched again. There is a necessary shift before us to develop more sophisticated tools to recontextualize, amplify, and give back what we collect and to find ways to draw those outside the original community into meaningful dialogue. Thoughtful curation shifts the focus from the commodity of the collection itself to the kinds of conversations that are made possible.

A seemingly subtle but critical difference exists between collaborative acts that are created out of genuine exchange and those that are exploitive. You will often find corporations or well-financed large institutions co-opting people's impulse for creativity. Flash mobs are used to sell mobile phones, and paid staff use images contributed by the public to promote their own institutional brand. Corporations and news organizations ask people to share pictures and eyewitness accounts with no return in remuneration. The line of exchange has to be extracted and seen explicitly. Is it a fair exchange? Who is being paid, and who is working for free, and to what end?

With a start-up grant from the Metropolitan chapter of the Victorian Society in America, I began to look for collaborators; and I was fortunate enough to be put in touch with Gabrielle Bendiner-Viani and Kaushik Panchal of Buscada. They had a history of making place-based projects that create an environment for dialogue. They quickly focused on the importance of placing the images and texts, the "objects," in the context of shared memory.

Everyone is welcome to submit to the archive, and contributions came from the Triangle families, educators, artists, and union members. The Triangle Fire Open Archive contains all the juxtapositions of our community: a period fire sprinkler, a family photograph from one of the male victims of the fire, ILGWU keychains, and other memorabilia. All the objects donated by the public are virtual, as we had no capacity to care for physical items. Each object can be a gallery of images, a video, an audio recording and includes a written description by the contributor. Often included are links to resources both within the archive and from external sources. Some objects are accompanied by commentary from historians and others with specialized knowledge. The entire collection is searchable by key word or topic. With over two hundred contributed items, the project demonstrates community-defined history.

Participation in the archive reflected our other organizing efforts. We immediately established multiple points of entry. Our website featured a simple online submission form. We also reached out to other archives to ask for contributions. This helped us to develop the collection as a stepping-stone for people to discover the fine resources of the Kheel Center and other repositories. We spread the word about the Triangle Fire Open Archive at our open meetings and in regular postings to Facebook with an "Object of the Day." To support those who might not have the tools to digitize their contributions, Gabrielle and Kaushik, armed with camera and audio recorder, staked out Coalition open meetings, garment workers' retiree groups, and Triangle-related events to collect materials.

Gabrielle's deeply sensitive photography placed the contributions in the context of memory. She often photographed not simply the object but the person who had donated it: the hands of Suzanne Pred Bass holding the framed photograph of her great-aunt Rose Weiner or longtime union member Norman Saul proudly wearing his re-creation of a period button that states We *Still* Mourn Our Loss.

New research was bringing to light the experience of the Italian American community. Stories were being uncovered leading back to the villages in Italy where many of the Triangle workers had been born. At a meeting of educators hosted by Cecilia Rubino at the New School, we were introduced to Mary Brown, who had done extensive research in the archives of Our Lady of Pompeii, the Greenwich Village church that lost eighteen young parishioners in the fire. She translated and digitized documents that had never before been in the public eye. These included handwritten listings of private masses and a note by the priest declining payment for a mass for the Triangle dead. She

was also able to provide a list of the churches the rest of the Catholic Triangle workers probably attended based on their home addresses. This invaluable information could have been unearthed only by a community insider. Now, through the Triangle Fire Open Archive, it is available to all and lays the groundwork for future discoveries.

On our original website Andi Sosin had taken on the daunting task of updating our resources page, which included an ever-expanding list of teaching plans, books, films, and art projects related to the fire. While researching, she dug out a long-neglected song—*Die Fire Korbunes* (The Fire's Sacrifices)—from the Library of Congress.[2] In the era of the Triangle fire there was a thriving Yiddish music scene, and sheet music was often printed quickly to keep up with current trends. Immediately after the Triangle fire at least two songs, both based on earlier works, were produced. *Mameniu* is a ballad that is commonly associated with the fire. *Die Fire Korbunes* had been largely forgotten.

Andi brought the song to the attention of Eve Sicular, bandleader of Metropolitan Klezmer. With the support of the Sparkplug Foundation, Eve oversaw a multifaceted reconsideration of the song, including a new orchestration and a translation of the Yiddish lyrics. She wrote an essay situating the song in the context of the early twentieth-century Yiddish music scene and parsed the lyrics and sheet music artwork to clarify the references that would otherwise be lost on contemporary audiences.

With the generous support of Cooper Union, we scheduled a free concert on the night of the centennial. In the Great Hall where Clara Lemlich launched the Uprising of 20,000, Rob Linné curated a program of art and activism. It was there that Eve and Metropolitan Klezmer performed *Die Fire Korbunes* for the first time. One hundred years after the fire, the aching refrain "Korbunes fun doler-land" (sacrifices of Dollar Land) rang out. Their performance, with haunting resonance, created a bridge to one hundred years earlier. The concert was recorded, and now the performance, sheet music, new translation, and critical essay are all available in the Triangle Fire Open Archive.

After the success of the Labor Day parade, Workers United had generously offered us desk space in their office on Fourteenth Street. It was fascinating to be in the midst of the day-to-day conversations between the business agents and visiting garment workers. Sherry was organizing materials from the ILGWU to send up to the Kheel Center. Sometimes I would sneak a peek at the publications and banners before they were packed up. Seeing the broadly humanistic

support the ILGWU had offered its members sparked me to consider anew our collaboration with the union. In some sense, through our social and creative organizing, the Coalition and our partners were fulfilling some of the cultural tasks that unions had provided in the past. While working with organized labor was new to me, I soon began to understand how we fit into their historic sense of broad worker support.

Through my time in the office I kept hearing tantalizing bits about garment workers' strikes that followed the Triangle fire. The needle trades have served as a stepping-stone for successive generations in New York. In the 1950s and 1960s the labor pool was predominantly women from Latin America; by the 1980s the industry was centered in Chinatown. Soon I began to hear references to a 1982 strike in Chinatown. Every time the subject came up, people got really happy and excited. Clearly the discussion evoked a deeply passionate and proud memory.

When I told Ed Vargas that I had been hearing rumors about the Chinatown strike, he got a big smile on his face. Ed has been organizing the union Triangle commemoration for more than thirty years now. This is how he told me the story of the 1982 Chinatown strike.

An early morning in Columbus Park, in the center of Chinatown in lower Manhattan.[3] Union officials are waiting nervously. Many of the workers have been locked out by the bosses. The union has called for a strike, hoping the workers will come out. Not unlike the Uprising of 20,000, a lot of people don't believe that the women will stand up for themselves. Many of the factories are owned and run by male relatives. The appointed hour for the strike arrives. No one shows up. Ed says not to worry, they will come. But in his heart of hearts he is not sure. Five minutes past the hour, still no one. Ed is thinking, it's time for a backup plan. Ten minutes past the hour, and the women begin to stream into the park. Like a wave, more and more appear until there are thousands in the street. "We are one!" rings out, and the strike is on. In the coming days the momentum is infectious. The joy of standing up and claiming power spreads throughout the community. Workers and even owners march together.

It was a watershed moment both for the workers who rose up to create this movement and the leaders that emerged, including Alice Ip, Katie Quan, and Shui Mak Ka. Any fantasy of Chinese American women as passive victims was utterly obliterated.

The Coalition collaborated to host a panel on the 1982 Chinatown strike that was held at the Chen Dance Center, a locus of art and activism. May Chen intro-

duced the speakers. As the story of the strike unfolded in English and Chinese, the excitement in the room was palpable. People who had been a part of the strike were bouncing out of their seats, bursting to shout out once again, "We are one!"

In the hallway Gabrielle set up a collection center. Many of the women brought with them photographs, old newsletters, and memorabilia. Each item shared came with its own story. Camera and audio recorder in hand, Gabrielle raced to capture everything. The women painted a picture of a union that played a central role in their lives. By organizing, they had been able to create a well-respected day care center and a very popular singing chorus, as well as classes in English and countless social events. In 1982 the garment workers of Chinatown carried forth the proud legacy of the Uprising of 20,000 and the ILGWU. By including the Chinatown strike in the Open Archive, we contextualized the action as a link from the Progressive Triangle era to 1982 Chinatown to the workers of today.

Once you have a tool like the Triangle Fire Open Archive, you always find more uses for it. Gabrielle and Kaushik created a pop-up museum in collaboration with the Brooklyn Historical Society. For one weekend physical objects that were represented in the archive were put on display. Several of the contributors were on site to answer questions, and visitors were welcome to bring their own items to be digitized. The following year Gabrielle and Kaushik made an open museum, setting vitrines with Triangle objects in five locations across the city.

As we neared the centennial, we invited our partners to recognize their own contribution to the centennial as historic. We put out a call encouraging the community to plan for the documentation of their own events to ensure they were preserved as a part of the permanent record. The response was enthusiastic. Class projects, fine art, and performances were documented and are now preserved through the Triangle Fire Open Archive as a part of the legacy of the fire.

Since the Coalition had no capacity to preserve actual physical items, we were especially delighted when we heard from the Kheel Center that they were interested in collecting physical memorabilia related to the centennial. With our network in place, it was something we could easily organize. We immediately put out the call. Soon stacks of packages began to arrive at our office. Programs from academic events, postcards from exhibitions, DVDs of performances, fliers from political actions. We packed up boxes and sent them off to the Kheel Center for permanent preservation. We were thrilled to be able to give back to the institution that has given so much to all of us.

MAKING SPACE FOR CONVERSATION:
THE TRIANGLE FIRE OPEN ARCHIVE

When people ask what we do, we say that we work to create spaces for conversations that can't be had anywhere else.

Our first Coalition meeting consisted of a heady series of conversations: first, looking through family photographs with a woman who had both a Triangle fire survivor and a victim in her family; turning around to talk with a union shop steward about the issue that today so little organizing happens between unions; talking with a performance artist about why Triangle has inspired so much of her public work; and winding up the evening by talking with a safety engineer who saw his job as making it safe to go to work, so that "you don't come home in any worse shape than you came in." As a born and bred New Yorker, I had known about the Triangle fire, but in one night, I had come to see it as a lens through which we could see so many of the city's current concerns, as well as an event that had shaped the city I know and love.

Those meetings were an extraordinary feat of bringing together in one room often-divergent perspectives for a common cause. And they led to extraordinary but ephemeral conversations. Wanting to allow these conversations to live for longer was what spurred us to create the Triangle Fire Open Archive—an online collection of people's objects that has become another space to foster unusual conversations.

To create this space, we asked people (like those we spoke to at our first Coalition meeting) to contribute "objects" accompanied by a short, often personal, statement explaining how she or he perceived the object's significance for the history of the Triangle fire and its bearing on today. These objects helped to ground us in the present when talking about making links to the past—and their juxtaposition was also able to make surprising connections. To allow people to contribute however they felt most comfortable, we made it possible to contribute online; but we also met people at Coalition meetings and sought them out at other public events, interviewing them in person and photographing their objects, often held carefully in their contributors' hands.

With the Open Archive project we sought to honor these contributions both by keeping them safe and by sharing them, enabling them to spark new

conversations about social justice; workers', immigrants', and women's rights; and why the past is such a crucial part of the present.

Buscada is a collaboration between Gabrielle Bendiner-Viani, an environmental psychologist and photographer, and Kaushik Panchal, a designer. Together they create projects that explore critical questions of place, dialogue, and visual urbanism. Buscada's practice incorporates curation, design, research, and photography to create multifaceted projects that bridge the online and physical worlds, as well as the expressive and the practical (www.buscada.com).

Pauline Newman, *left*, and Clara Lemlich. Courtesy of the Schlesinger Library, Radcliffe Institute, Harvard University.

LEADERSHIP

You do like to argue some, don't you little girl?

—Defense lawyer Max Steuer to sixteen-year-old Ethel Monick, survivor[1]

Being the founder of an organization is a tricky business. You're always trying to find a form of guidance that reflects the broader goals of the project. The kind of leadership I practice often brings up an internal tension. I'm split between a very raw and receptive way of being in the world and the force-of-nature drive necessary to propel the work into being.

In order to make these projects successful, I have to listen very intently. I shift into an open sensory state to feel out what is around me. I call it living in my eyeball, when I kind of float around the room trying to get a sense of what is actually going on with everyone. How people are leaning in or away from each other, if they are engaged or spacing out, who seems to be struggling. At the same time in order to move the project forward, I have to be quite pragmatic and strategic. Leadership requires a bit of arrogance, a kind of pig-headed belief in oneself to drive the whole thing onward even when you're not even

sure where you're going. Both the open-receptive and driven-ambitious sides are true parts of me, and I'm always a bit taken aback when people perceive only one or the other.

In the wake of the ninety-ninth anniversary of the Triangle fire, issues of power and leadership of the Coalition came to a head. Suddenly our small operation ballooned. After another public event at Judson Church—this time focusing on performance work being created for the centennial—came a rush of new members, articles in the press, and a rapidly growing list of participating organizations. Overnight our open monthly meetings became so large we had to seek out larger meeting rooms. It was thrilling to witness the growing confirmation of everything we had dreamed.

The rush of attention and new people pouring in was like a tidal wave through our small group. Internally there was growing sense of unease. A rash of irate phone calls and emails began to circulate. Accusations and secret meetings took hold. Prior to this, we had functioned largely by happy consensus. But now the lack of a clearly delineated decision-making process made people wary. It was particularly uncomfortable for those who had already personally invested in the organization. After committing so much of themselves, people understandably wanted assurances that they would continue to have a voice as we plunged forward with many newcomers involved.

Up until this time, we had been such a small group that creating an organizational structure seemed wishful thinking more than anything else. I had resisted the establishment of a more official hierarchy too early, as it can put decision-making power in the hands of people who happen to be there or who talk a good game. If the assigning of specific roles can be postponed a bit, you have time to discover who is actually doing the day-to-day work to keep the organization running. There is always a need for great ideas—but who stays after the public event to clean up, and who is willing to pitch in on the drudgery of data entry and the other monotonous tasks that are so necessary to community building? These are the people who have the most realistic sense of where we stand as an organization. Firmly placing the decision-making power in their hands will create a much stronger, effective, and efficient human machine.

Once a group grows large, an external structure becomes absolutely necessary. To pretend that there is no hierarchy only hides what everyone knows is there and forces people to try to operate in a murky world of personal favors.[2] It excludes people who don't have the time or social skills to navigate those

mysterious waters. Setting up a working order gives everybody the opportunity to be heard. They may or may not get what they want, but at least there is a defined process. With the ninety-ninth anniversary we reached that tipping point. We had organically grown large enough that it was time to establish a formal decision-making body.

In response to the group upheaval, I scheduled a meeting to discuss governance. As the evening approached, I was nervous, deeply exhausted, and a bit curious. It wasn't clear to me what our options were or even if I would continue with the Coalition. The rage and vitriol that had been unleashed had been stunning and not a little disheartening. But it was reassuring to find that just by calling for the meeting to address the issue explicitly, many of the people who had made the loudest complaints were immediately much calmer. As long as their concerns were being taken seriously, they were open to many possible solutions.

My experience with critique for art projects is that feedback has to be used carefully. People often have an uncannily accurate sense for when something is not working; and it's very important to listen closely to what they find problematic. At the same time, the solutions they offer, coming from the outside, are often off the mark. It's up to the person who has the central vision to find ways to address the problem in a manner that is true to the heart of the work. With the Coalition, I was the leader, but it was also a particular type of collaborative project. It wasn't clear to me how we would find a path forward or if the meeting could constructively address the problems in a way that would both fulfill the needs of the people participating in the organization and still remain true to the sense of open-ended inquiry that felt fundamental to me. I was being forced to take a risk and trust the process I had been promoting. I wasn't fully convinced it would work.

At the start of the meeting, we began with a simple brainstorm of possible decision-making structures. People tossed in ideas from their experience in academia, unions, activism, and collaborative art projects. Rose leapt up and began to make a list on a big piece of paper. I was surprised and touched to discover that many people whose opinions I wasn't sure of felt strongly about our undertaking. For the first time I began to realize that they were not just passionate about the Triangle fire but felt strongly about the Coalition and this form of memory and engagement. There was a generosity of spirit in the room, as most people wanted the organization to succeed.

After a dynamic start, the conversation began to stall. One individual rejected every option, and the discussion started heating up. We were going in circles trying to address his concerns. What was ultimately revealed was that he didn't want a healthy decision-making process: he wanted control—and he definitely didn't want me to be the boss.

A tension often persists just beneath the surface of communal works. Poet Audre Lorde describes how "we fear the very visibility without which we also cannot truly live."[3] Negotiating that visibility comes in many forms. It can quickly get dicey if these issues are not explicitly addressed. What happens if the effort is collective but only a few do the bulk of the work? Will there be individual credit for the work performed, and is anyone getting paid? Who gets credit if one person hatches an idea but someone else does the tasks to bring it to fruition?

Some people simply don't see the communal aspects of our individualistic society. There can be a willful or unexamined blindness to leadership models that don't fit into a hierarchical norm. When attempting to be inquisitive and open to others, it can be disconcerting to suddenly have someone barrel over and try to take charge without any comprehension that there is already leadership in place with a meticulously crafted environment. In general, these individuals don't really want to get their hands dirty. They want to dictate. Treat them simply as equals, and they lose it. They genuinely expect that others will do the work, and they can be the boss. Part of my job was to keep bringing the focus back to supporting the worker bees. Great ideas are fairly common, but it's the follow-through that actually gets us somewhere. If someone has a wonderful proposal, the next question always is, what are you going to do about it?

Conflict provides an important opportunity. It forces us to clarify our own ideas. Often we have a misguided fantasy that an ideal coalition would be polite and we would all ultimately agree on everything. That is far from the truth. Organizations often stumble when they try to please everyone. In fact, that kind of politeness only reduces us to our lowest common denominator, where we fall back on dysfunctional models that don't really represent us.

As my internal dialogue was revving up, I heard Annie call out her suggestion for a governance model: "I have an idea! Ruth does most of the work, so let's just leave all the decision making to her!" It was hilarious and immediately threw off the balance of the entire discussion. Her comment and the general support in the room woke me up. I wouldn't be truthful to myself or the orga-

nization if I didn't explicitly own my role as leader. It was the moment for me to act without apology. So I did. Instead of simply listening, I pushed hard for the organization to move forward and released the difficult individual to his own spirals. You can't please everyone. I was the leader, and since no structure was going to give him control, he wouldn't be happy with any option. It was time for the organization to vote for its future.

We elected to form a board of seven people.[4] Members of our loosely knit steering group could nominate themselves or vote on the selection. We established some very basic bylaws that covered attendance, voting rules, and responsibilities. We arranged to send out an email of the minutes and voting instructions to our entire steering committee—and with that, the governance meeting wrapped up.

The organizational structure we came up with was something that almost everyone who had been involved felt they could live with. It was simple and clear enough to ensure transparency. We required a commitment of five hours a week from each board member. In this way we kept the decision making with the people doing the work. A couple of folks were still unsatisfied, but they were not doing the day-to-day work of the Coalition; while their loss was unfortunate, it wasn't damaging to the organization. The people who stepped up to be on the board were an amiable community who had already demonstrated their gifts and commitment to the Coalition. Moving forward, we declared ourselves the Execuvistas and reveled not only in our accomplishments but also in the joys of creating community with unexpected others. Over countless work sessions and potluck dinners, the board grew into a warm, extended chosen family.

Looking back, I realize I made some key mistakes at this juncture. While I was careful to ensure representation from communities historically linked to the fire, I missed something important about including contemporary groups. Carmelina Cartei pointed out to me that if you don't have everyone in from the start it's hard to recover, and that has proven to be true. By the time I realized my mistake, what would have been organic growth—if we had begun from the right base—became an uphill battle. Not impossible, but certainly more difficult.

The Coalition was made stronger by going through this reorganization. We now had a structure that made our decision making transparent, but I also grew through the process. I find that when I lead a project I'm often forced to act braver than I actually am. It's a great side benefit to me personally. As we left the meeting that night and gathered on the sidewalk to say our good-

byes, Sheryl Woodruff, our treasurer, howled, "Yes! You claimed it!" Sheryl is a tough cookie. Her words made me recognize another layer to what we were creating. I had to think more explicitly not just about the role of leadership but how it is perceived. Having a female leader certainly wasn't a requirement, but it added to the sense of people claiming their own power.

When I look back, it's astounding how much of my education and work life have been wasted managing the impact of other people's sexism. The internal strife at the Coalition rose up for a variety of reasons, but the form it took was shaped by the usual difficulty with female (or any kind of "other") leadership. When I worked in the film industry, I was often the only woman technician on set. I quickly learned that I had to start each gig on a new team with a verbal shove. If I started by being nice to everyone, I would be demolished. Instead, I had to take down the first guy who tried to tell me how to do my job. There are a lot of strategies, and one often leaps on instinct. Sometimes I was lucky in hitting the right response. Sometimes I was pretty funny. Other times I would cry in the darkroom.

Today conditions are a bit better, but not as much as one would have expected. I am still consistently confronted by people who assume that someone else (male) did the technical aspects of my work or that intricately conceived and executed projects miraculously just happened. If you begin to add up the time all of us have had to waste overcoming these last-millennium mentalities, you begin to get a sense of the massive loss to our society as a whole. Sometimes you find a quick way to stride past sexism; sometimes it knocks you for a loop—but the goal is to not sweat the small stuff and keep moving onward.

I was greatly influenced in this process by my mother, Judith Treesberg. Her experience in the women's movement led to my own feminism, as well as my good fortune to be a student at schools created by visionary pedagogues Caroline Pratt (City and Country)[5] and Red Burns (ITP, New York University). The focus of their educational model was on process, self-direction, and collaboration. We were taught not rote content but how to act on our own natural inquisitiveness and hunger for learning. These educators made evident that a good part of leadership is searching for ways to set up situations in which people can act as their own best selves. It is most successful when it is relatively invisible. As with any good educator, a lot of my work goes into preparing an environment that appears effortlessly supportive. For a teacher it might be tubs of paint, plentiful paper, and mounds of clay. For the Coalition it meant

agitating and inciting, then being adaptable enough to create new platforms responsive to the community's needs as they arose. It's a form of leadership in which we don't tell people they should be empowered but create the conditions in which they are supported in the practice of acting on their own agency.

In order to pull off complex social projects we have to be bold enough to fight for the time and space to organically and truthfully develop the process. Growing an organization is rarely about setting up a perfect model. It takes time to develop the warm and flexible conditions that can constructively address issues as they inevitably arise. Developing as an artist, one learns to be both brutal and kind to oneself. There is a need to constantly throw out work, even if it took huge effort, if it doesn't fulfill the needs of the project. One figures out early on not to place too much value anywhere. You get a lot of experience in failure, and that imparts a great kind of freedom.

When building a collective project, we are always creating a story of community. Part of it is real, and part of it is what we hope will become true. I was constantly looking at who was doing the work and who was simply talking. The role of leadership is to act for the project as a whole, not for any individual or interest group. If you start to compromise and attend to individuals, you will be lost. An atmosphere is created that encourages people to become more concerned with fighting for their own piece of the pie. The decisions always have to be made on your best bet for the project as a whole. It's easy to forget that most folks are pretty vulnerable. They will willingly step up and donate time, energy, and creativity for little personal return, but the exchange has to be fair and equal. If the organization can keep its eye on the prize, most times people can step past small hurts and stay engaged. It assures everyone that the best ideas will move forward, and it takes the steam out of competition for favors that so often dogs groups and can be particularly draining in organizations that are trying to address social change. We succeed not by control but by being the most rocking bandwagon.

Today the Remember the Triangle Fire Coalition appears inevitable, but it was created out of thin air. For a long time it was in constant danger of simply ceasing to exist. For much of the project all I had was a stubborn belief in something I couldn't even properly describe. We started with no physical space or money or institutional support. For every meeting we bounced from one donated room to another. It could have failed at any moment. In fact, it did fail—all the time. What made our eventual success possible was the quiet

dedication of a very small group of individuals who stuck with it. We had to be willing to stumble a bit, trust in each other's point of view, even if we didn't fully understand or agree with it. To have enough faith to move forward on our points of agreement and let the conflicts rest. It was important that the actual organization, the people working together, came before the external structure so that the form honestly reflected who we already were.

ANCESTRAL IMPERATIVES

Stories drive us. People ask me, "Why are you involved with Triangle?" "My grandmother worked in the factories. Not that factory, that day, but those young girls that died are as much our children as they are our ancestors."

I learned about the Triangle fire through Chalk. Chalking on sidewalks was something I did as a kid with scraps of plasterboard we found in the trash. Chalk—the project—called to my childhood sensibility of claiming the sidewalks, curbs, and streets, and of the aesthetic of clotheslines, telephone wire rings, throwing Spaldeens at stoops, homeplate sewercaps in stickball, perching on corner mailboxes to tell each other stories, and carving our names with a stick in fresh cement. Acts of memory, all. I "Chalked" for a few years, then I met Ruth and got more involved with Triangle. As an artist I had a job to do. For the ninety-ninth memorial, we were invited to march in the Labor Day parade. I got a phone call from Rose Imperato, "We need an image, something visual for the parade." I was on retreat in the woods, near a bend in a creek where the energy flowed, reading Whitman out in the sun. I practiced emptying out, praying, strumming my guitar, running my dogs, listening to spirit. Empty, ready for listening. An afternoon nap and the spirit transmission came. "Make 146 shirtwaists like kites and hold them up in the sky." Ancestors speak with commands. I telephoned Rose back. "We gotta make 146 shirtwaists like kites and hold them up in the sky." A handful of coalition members in NYC made the first prototype. The project mushroomed into a community arts project, which eventually rooted at the home of artist LuLu LoLo, our new shirtwaist factory. A hundred years after the fire, a cadre with glue guns, ribbon, and donated cloth decorated shirtwaist kites to fly the message of justice out to our generation. The shirtwaist kites became an emblem for education and awareness.

I wrote a song for the fallen girls. I directed the crowd to look up at the top of the building where the workers had been trapped and sing "Thanks, Joe!" in honor of the elevator operator who'd saved 150 workers. I didn't know until the next day that Joe Zito's granddaughter was in the crowd. On Facebook she thanked me, "In all the years I've been coming to commemorations, no one ever thanked my grandfather. They've always focused on the victims."

I told my mom, "Joey Zito is truly an unsung hero," and as those words left my mouth I felt I had the power to "sing him"; and so I wrote "Ballad for Joe Zito," which I performed at the centennial commemoration.

Sacred acts of memory and obeying spiritual imperatives—this is my life as an artist.

Annie Rachele Lanzillotto is the author of L Is for Lion: An Italian Bronx Butch Freedom Memoir *(Albany: SUNY Press, 2013) and* Schistsong *(New York: Bordighera Press, 2013), a book of poetry. Her albums* Blue Pill, Eleven Recitations, *and* Carry My Coffee *are all available on iTunes (www.annielanzillotto.com).*

The Triangle bosses, workers, and visitors, 1910. Photographer unknown. Courtesy
of the Kheel Center, Cornell University.

DIFFICULT MEMORY

There will come a time
When your time will end, you golden princes.
Meanwhile,
Let this haunt your consciences:
Let the burning building, our daughters in flame
Be the nightmare that destroys your sleep,
The poison that embitters your lives,
The horror that kills your joy.
And in the midst of celebrations for your children,
May you be struck blind with fear over the
Memory of this red avalanche
Until time erases you.

—Morris Rosenfeld, *Jewish Daily Forward*[1]

Memory is slippery. I once knew a young man who was struggling to complete a documentary about his grandparents. They were Holocaust survivors, and in

his family the admonition to *Never Forget* was fierce. He felt an acute responsibility. One day he told me a story. When he was a boy of about nine years old, his father took him to a shopping mall. After completing their purchases, the father and son returned to the parking lot. As the boy crossed behind the vehicle and reached for the door handle, the car pulled away and left him. In a family so deeply committed to remembering the past, a father completely forgot his young child in a vast parking lot. I love this story because it so poignantly reveals how oddly fallible we humans are. Despite our most committed attempts, much is beyond our control. Something in memory flits round us. Even the most cruel and acute loss can never be passed down whole to the next generations.

One of the clues to the resonance of the Triangle fire lies in the open wound left when an injustice is not met with accountability. It creates a dizzying sense of dissonance. We experience that today with the almost unfathomable economic inequality surrounding us. While we are mesmerized by the specter of terrorism, it's difficult to focus on the more common crimes in our midst. Whether it's too-big-to-fail banks ripping people's homes out from under them or the 2013 Rana Plaza building collapse, which took the lives of over 1,100 garment workers in Bangladesh, it's galling to see time and again the guilty get away with it. The lack of legal accountability leaves us having to constantly reassert the humanity of the victims of these crimes. It's not a new story, but one we know only too well. We have all had the experience of being treated as if we were invisible. Those with money and power, like the Triangle bosses, regularly get away with murder.

The owners of the Triangle Waist Company, Max Blanck and Isaac Harris, were in many ways the embodiment of the American dream. They had arrived as part of a wave of immigration just slightly earlier than most of their employees. They had worked hard to build a thriving business, which afforded them their luxurious lifestyle. The shop they constructed was modern, and many of the employees were from their extended family. But step by step these two men made choices that led to the deaths of 146 people.

The aftermath of the fire began with justice deferred. There was a trial. At the center of the case was the question of whether or not the door on the ninth floor Washington Place side had been locked at the time of the fire. Blanck and Harris hired Max Steuer, an expensive and highly skilled lawyer. Some claimed that the owners were offering to pay individuals if they would change their testimony and gave raises to those who would speak in their defense. Despite

this, witness after witness at the trial testified that the door had been locked. Steuer skillfully denigrated the immigrant workers, who often struggled to testify clearly in English. In advising the jury, the judge instructed that the owners would had to have known the door was locked at the specific moment of the fire in order to be found guilty. As so often happens, those with money walk. With 146 people dead, Max Blanck and Isaac Harris were acquitted.

As the Triangle owners slinked out of the courthouse, David Weiner, who had lost his sister in the fire, chased after them, shouting, "Murderers! Not Guilty? Not Guilty? Where is the justice?"[2] then collapsed on the sidewalk. The debilitating experience of powerlessness that he expressed is all too familiar. The crushing sense that no matter how hard we push for accountability we will never achieve justice. The legal system is set up to protect the privileged. Blanck and Harris never took responsibility for their part in the fire. In fact they continued their unscrupulous and myopic behavior. They collected insurance money at a profit and immediately opened a new factory. They were later fined for a chain on a door and for illegally sewing union labels into their goods. A fire inspector invited to visit their new facility reported that he had difficulty concentrating on what was being said as he was distracted by a six-foot pile of refuse on the factory floor.

One evening as I was wrapping up a talk about the Triangle fire, I was approached by a woman who was extremely agitated. She wanted to know why I had brought up the fact that Blanck and Harris were Jewish. At first I couldn't understand what was upsetting her, but as we spoke it became clear that she had come to the event because she wanted to celebrate a lineage of women rabble-rousers. I had shared the story of the Uprising of 20,000, but it is also true that the owners were, like many of their workers, Jewish. So if you connect to the Triangle fire through your identity as a Jew, you get both visionary organizers and the Triangle owners to your credit.

Her question raises an important discussion about the kinds of stories we are brave enough to tell. The fact that the owners were also Jewish makes the story difficult but also more useful. When we imagine history, we'd like to believe that we would have acted well, even heroically, in the same situation. We dream that if we were alive at the time of the Triangle fire, we would have been out on the picket line with the likes of Clara Lemlich, and perhaps it's true. Yet every day we encounter situations in the streets, at work, or in our homes that cry out for action. The best clue to where we might have stood in

the past is to look ourselves squarely in the eye today. The line to cross from being one of the Triangle workers to a boss is not necessarily so distinct. Many of the contributing circumstances that led to the fire came about not because people acted in an intentionally evil manner, but because they did not act at all.

There can be a seduction in identifying as a victim, but it is rarely all of the story. To see oneself only in this light can be a mask for profoundly insensitive or aggressive behavior. It's a tricky moment when one traverses from victim to perpetrator. We've all seen it. Heck, we've probably all done it—used the shield of victimhood to avoid something we'd rather not face up to.[3] One can easily fall into the ugly comfort of lashing out as if helpless, without thought about how to actually achieve the desired goal. It's like in the old black-and-white movies when the woman pounds on the chest of a guy, then collapses into his arms. A lot of show. We have to be rigorous about picking apart what is truthful and what is simply a ruse. There is a discipline in keeping the focus on what we actually want to achieve and how best to get there.

Public humanities projects that promote a fantastical notion of perpetual progress mask the central question of our own complicity. We have to be rigorous in challenging ourselves to determine if we are actually moving anything or simply keeping communities very busy "remembering" without ever translating those memories into something of use. The projects that we create, using history as a platform, construct possible past realities and evoke what might be sparked today. Are we independent enough to propel the conversation outside the dominant state-corporate discourse, or do we simply recycle within the same confined range provided us? Are we co-opting genuine passion and hunger into a system of control, or are we busting out the status quo?

It's unpleasant to imagine what we might have to venture in order to get things on track. We know change is necessary, but how much are we actually willing to risk to make it happen—an hour? A dollar? A broken bone? What should we have the strength to walk away from? Buying a cheap piece of clothing made in the Triangle-like factories of Bangladesh? There is a constant stink of war hysteria. In my lifetime it was the tail end of the War on Communism that became the War on Drugs that became the War on Terror. It is never-ending war, and at some point we have to step outside and question the purpose of it all. Because it certainly isn't to keep us safe. It keeps us docile.

Grief can be a deeply radicalizing experience, forcing us to reconsider our values and choices. It has the power to forcefully jolt us out of com-

placency. An unexpected tragedy explodes everything that seemed part of an ordered universe. Like a force of nature, it will lift you up, smash you down, then do it all over again and again and again. The vulnerability of the experience is profound, and our culture is particularly bad at holding people through it.

A trauma like the Triangle fire can split a life in two. Forevermore, time is measured on either side of the pivot point of this one horrible moment. There is a particular dissonance to the death of a child, a young friend, or a sibling. These deaths upend our sense of how things are supposed to operate, where parents die before their children in a natural passing of the generations. Mourning is properly imagined as a series of stages that one goes through, hopefully quickly, on the way to closure. Anyone with actual experience of grief knows how facile that idea is. Even years later, a smell, a texture can trigger memories so intense we are brought to our knees yet again. Over time, the rest of one's life might grow large enough to make the loss appear smaller, but it is never fully absent.

It is an existence a step outside your past life—both painful and emancipating, as we recognize that, like it or not, we might now have more in common with those who have been through similar life experiences than with friends or family. There is a particular knowledge of fragility and wonder at the harsh beauty of a world that keeps spinning no matter what one's personal despair. People are laughing, falling in and out of love, worrying about seemingly inconsequential things. For others, there is a life apart.

Public tragedies often resonate in powerful ways with these more personal scars. Emotions that have been thwarted can sometimes come out in extravagant displays over people we don't personally know. One can see it in the mountains of flowers left for Princess Di or John Kennedy Jr. The unexpressed grief finds an acceptable public outlet. Rather than being dismissive of this outpouring, we have to ask, if this happens so often, then how are we not addressing the real sense of loss in people's lives?

One evening I was listening to a radio program discussing a demand the September 11 families were making. The newscaster was reporting the story as if the families were silly difficult children. My mom stormed into the kitchen fuming. "Who wouldn't be crazy? Everyone is telling them how important they are, what heroes their children were, but they're only being used. Nobody is really listening to them!" And of course she was right.

No matter how most of us remember the Triangle fire, for the families it is always personal. At the time of the centennial it was a generation of mostly great-nieces and -nephews of the Triangle dead. Carrying forward the family stories, they are the last link to relatives who have a living memory from the time of the fire.[4]

The centennial focused a lot of attention on the Triangle families. Perhaps it was a good instinct, to personalize the tragedy. But it also conveniently depoliticized the Triangle fire even as the economic crisis made it most pertinent. It seemed a kind of willful erasure. The Triangle fire is known because of its public face; historically it was the ILGWU that spearheaded the commemoration. Without the union and Leon Stein, the Triangle fire would be largely invisible in the public realm. It was inspiring to see many of the family members jolt the conversation out of maudlin complacency with passionate calls for workplace justice.

At the Coalition we were thoughtful about how to carve out a safe space for family members. The most obvious was to support the families organizing themselves. The Maltese brothers established the Triangle Fire Memorial Association decades ago and are warmly welcoming to anyone who wants to participate. In 2006, I had put together the Triangle family panel at Judson Church as an outgrowth of Chalk. In 2010 the Coalition collaborated with NYU and the producers of the HBO documentary *Triangle: Remembering the Fire*[5] to host a Triangle family coffee before the annual union ceremony. As we went around the room, people spoke of their family remembrances. I was impressed by a relative of the lawyer Max Steuer. She openly and bravely acknowledged the financial benefit her family had received from the trial. For the centennial, the Coalition worked closely with the union and sent the families a list of events that might be of particular interest to them and what to expect at the union ceremony.

In historic commemoration, all of us are on some level conflating other unresolved traumas and injustices. We can't fully know how this tragedy resonates with other more personal losses, and in the end it doesn't much matter. As outsiders, we can't untangle that for each other, but we can have compassion for each person seeking a path forward. The more we can remain centered, respectful, and straightforward, the better. The hope is that by supporting the public memory of a traumatic event, we create space for individuals to hold the private memory in the manner they find best.

The language we use for commemoration—*We Will Never Forget* and *Never Again*—has a kind of poignancy because we are always forgetting in ways both personal and political. And perhaps in a certain sense, that is a good thing. Memory alone can keep us stuck in past wrongs without a way forward. We have to be able to hold the past while staying firmly rooted to live in our own time. Natalia Ginzburg, whose husband was tortured to death in the last days of World War II, writes, "When we are happy, our imagination is more dominant. When miserable, the power of our memory takes over."[6]

We need to create stories that build united movement instead of regressing us into a constant tit for tat. Complex narratives that can traverse generations and hold flawed humans and misguided attempts. Stories broad enough to bind us but not so superficial that they quickly collapse under their own weight. The Coalition created a new story, weaving together memory and imagination. It is a tale of how our own generation stood together to look back, not only to honor the Triangle workers and organizers, but also to turn our despair and rage toward constructive action for the future.

IN MEMORY

In my mother's world to cross a picket line was to sink to the lowest rung of humanity. I knew before I knew much else that a scab was a traitor, a criminal, a dishonorable human being.

On March 25, 1911, two of my great-aunts—my mother's aunts and grandmother's sisters—were working on the ninth floor of the Triangle Shirtwaist Factory. Rosie Weiner was twenty, and Katie Weiner was seventeen. Rosie perished in the fire. Katie was the last person to leave the ninth floor; she bravely swung herself onto the elevator cable of the last descending elevator and survived. My family was traumatized, bludgeoned, devastated by this avoidable massacre of mostly very young women immigrants, girls dreaming and struggling to forge a better life for themselves. The pain doesn't leave; and I can still siphon off the sadness that blanketed my grandmother. But the heroic spirit of Katie fed me as well. And indeed she was full of vitality, prolabor, married to a union president, and feisty until her death in 1974.

How do these different strands shape and form us? How does a tragedy of this magnitude come to bring us strength and gifts? For myself, my brothers, and our children, it was through the heightened sensitivity to social and political injustice that permeated my family, stemming from the fire, and the need to find ways to speak out, to fight for change. In the 1990s I began to go to the yearly Triangle Factory fire commemorative ceremonies. I was always deeply moved, but it wasn't until I met Ruth Sergel and began to get involved in the growing community of victim families and others for whom this fire resonated that I began to find my voice and place.

With Ruth Sergel's brilliant creation of the Chalk Project and the subsequent formation of the Remember the Triangle Fire Coalition community, an invaluable berth was given to me. The Remember the Triangle Fire Coalition became a nationwide force focused on the 2011 centennial of the Triangle Shirtwaist Factory fire. The innumerable ways it inspired art, music, theater, and political action should be the stuff of legends. It was and still is a place to join with others to be a force against the recurring workplace tragedies occurring in our own country and around the world, most glaringly and painfully the recent Bangladesh factory fires. At present the Coalition is planning for

a permanent Triangle Factory fire memorial, to be situated on the site of the fire, now NYU's Brown Building, that will finally give voice to the struggles and unsung heroism of women workers then and now.

The enormous gift of being part of the Coalition's dedication to seeking to make the worker's world a safer, better place has nurtured me in untold ways. The tragedy my family has indelibly suffered has also taught me to never give up on the notion of repair, to ourselves and to the pain and injustice around us. The Coalition provides a base from which action can generate hope and change.

Suzanne Pred Bass is a long-standing member of the executive committee of the Remember the Triangle Fire Coalition. She is a psychotherapist in New York City, as well as artistic director/producer of Todd Mountain Theater Project, which is dedicated to the development of new plays.

Top, Caterina Maltese (age 39); *middle*, her daughters Lucia (20) and Rosarea (14). *Bottom*, the engagement photo of Daisy Lopez Fitze (26). All died in the Triangle fire. Courtesy of Serphin and Vincent Maltese and Diane Fortuna.

MEMORIAL

It comes right down to dollars and cents against human lives no matter how you look at it.

—Fire Chief Crocker, 1911[1]

In his autobiography Gabriel García Márquez writes, "Life is not what one lived, but what one remembers and how one remembers it in order to recount it."[2] On the facade of the Brown Building are three modest plaques that acknowledge the Triangle fire and the landmark status of the site. Below are a row of concrete flower planters. Each Triangle anniversary, people leave tokens: flowers, a note. Yet every day thousands of New Yorkers stream past this corner on their way to Washington Square Park or Broadway or to a class at NYU. Most of them have no idea what took place here.

With preparations for the centennial well under way, the time was ripe to launch the creation of the Triangle Fire Memorial. I set out to establish a process which, like the Coalition, would provide a platform for multiple communities to collaborate. With the momentum of the centennial, I dove into the ambitious venture.

In a sense the first act of commemoration was by those who gathered in the street to bear witness to the fire in 1911. The public meetings in the immediate aftermath and then the historic memorial march were the initial organized actions. For many in the Progressive Era, including Frances Perkins, Clara Lemlich, Pauline Newman, and Rose Schneiderman, the fire became a touchstone, which they credited as an ongoing impetus to their later work for social and economic justice.

Today, the annual union ceremony at the Brown Building is the central Triangle commemoration each year. But other tributes could be considered as living memorials as well. One man I met from Penn South, the large affordable housing complex sponsored by the ILGWU, felt strongly that this vibrant community was the best memorial possible. An association of trial lawyers, the Triangle Shirtwaist Factory Fire Memorial, annually awards scholarships to the children of workers disabled on the job. The Triangle Fire Memorial Association was founded by the Maltese family and hosts an annual dinner and awards ceremony. Chalk stands as a part of this tradition as well.

A permanent memorial does something very different. It becomes the vessel that shapes the future conversation. Its purpose is not only to commemorate but also to set terms about who counts in our culture and in the legacy of the city's past. Looking at the statues and monuments around New York, you'll find almost none are of women. The few that do exist are mostly metaphoric; Lady Liberty and Justice. In the garment district is a statue of a male tailor. Women who act on their own agency are largely invisible.

Memorials regularly reflect the power relationships of the moment in which they are created. I was eager for the Triangle memorial not only to honor the dead by insisting on their visibility but also to serve as a platform for contemporary discussion. It was important to me that the memorial not fall into the trap of presenting the Triangle fire as a symbol of the regrettable past that we have now overcome.

Constructing a permanent public artwork was an entirely new undertaking for me. I knew that the process had to reflect our larger goals of inclusion, but I had no practical experience in how to put together this kind of project. Although I'm a big believer in DIY culture, it can also sometimes be self-defeating. We end up actually disempowering ourselves by not bringing in the people who have expertise. For the memorial I was grateful to have the guidance of public art administrator Kendal Henry. Heated debates were already cropping up

over what the memorial should look like. Kendal's first act was to immediately reframe the discussion. He encouraged people to focus on what they wanted the memorial to accomplish, not on its appearance. This immediately released some of the reactive panic that had been setting in and kept the focus precisely on all the contributors doing what they did best. People were encouraged to express and refine what was important to them in the memorial, after which the artist would be entrusted with realizing that collective vision.

We scheduled an open meeting in New York for a group brainstorm. Mary Anne Trasciatti, firebrand and Hofstra University professor, was traveling to San Francisco, where in collaboration with LaborFest she hosted a West Coast meeting. At the gatherings, we all tossed out every idea we could think of for what was important to us in the Triangle Memorial. The lively discussion covered how a memorial might start a conversation rather than finish it, if it was possible to create something that would have an emotional impact on future generations, and the pros and cons of corporate financial sponsorship. From these meetings we culled a list of ideas and began to build community around the project.

We held an open call for artists to design the Triangle Memorial and asked our partners to spread the word as widely as possible. Again Kendal provided invaluable guidance as he purposefully shifted the application process away from preconceiving the Triangle Memorial and toward the act of collaboration. He encouraged us to specifically *not* include a proposal for the Triangle Memorial design in the call. It would have subverted our intent if the artist visioned the work before engaging with community input. By keeping the focus of the application on past projects and the artist's history of working with communities, Kendal ensured that the overall process reflected our broader goals.

The artist selection committee was made up of about sixteen people, all representatives from the many stakeholders directly connected to the fire or participants with special expertise in areas that would be useful to the effort. New York University, which now owns the Brown Building, graciously collaborated. We had representatives from the Triangle families, the Jewish and Italian American communities, the union, and historians. We asked each committee member to be a liaison to their broader constituency in the hope that we could have as many viewpoints as possible brought to the table. Because it was such a large group, no one person could hold too much sway, but we did hear from a lot of points of view.

The artist selection committee looked carefully at every application. Over a long afternoon we fastidiously narrowed the field to determine our three finalists. These artists were provided additional resources on the history and legacy of the fire and asked to create a short presentation for the selection committee. Emotions were high when we met to choose the Triangle Memorial artist. Everyone felt the weight of our impending decision, but by the end of the day it was unanimous. One artist had demonstrated sensitive and responsive design combined with a broad palate of materials. She had examples of how she worked with communities to develop her designs and ideas on how she wanted to move forward with this project. Janet Zweig was selected to design the memorial.

The Eldridge Street Synagogue hosted our first community meeting to introduce Janet to the Triangle community. We were pleased with the turnout and the remarkably in-depth conversation that took place. Janet presented some of her past work and her research into the Triangle fire, then opened the floor to the public. What followed was an animated discussion on everything from what various people wanted the memorial to achieve to how to make the project appeal as widely as possible, in particular to young people who might not know of the fire. Debate was spirited as some people in the room insisted that the memorial carry a list of the Triangle dead. Equally adamant was another contingent that pointed to the lack of emotional engagement of a simple list of names. It was thrilling to watch as both sides fought forcefully for their point of view yet also listened very carefully. As the conversation progressed, the two sides came together over common ground. They carefully worked their own way toward a clearer stipulation that the names be included but in an emotionally compelling and integrated manner. Toward the end of the meeting Serphin Maltese, who lost three family members in the fire, rose to address the artist. "This is so hard—I'm glad I'm not you!" He brought the house down. It was a deeply hopeful meeting. Working together, we appeared on track at last to establish a permanent Triangle Memorial on the Brown Building.

Because the Triangle fire inspires a lot of passion, it was incumbent on us to create a process for the public to have direct communication with the artist that was constructive rather than overwhelming. The open meeting was followed by a series of smaller gatherings between the artist and different Triangle communities. Included were a visit to a contemporary garment factory

with the union and conversations with people with specialized knowledge, such as the Landmarks Commission, historian Daniel Walkowitz, and Ellen Wiley Todd, the art historian whose earlier writings had so influenced me. A meeting was held with Triangle family members, who were being asked to take the biggest leap of faith. Their thoughtful support was critical to the project. Everyone was welcome to participate in open meetings or as part of the smaller groups. If people did not live near New York, I was happy to take written comments that I could collate and share with the artist. In this way we ensured that she would hear the voices of our broad-based community but not be inundated by a barrage of individual suggestions. The one who shall remain nameless made his appearance, but besides his momentary flare-up, everyone seemed to understand that a safe and fair process was necessary for the artist to attend to her work.

We spent one memorable evening with a group of fire marshals, engineers, and first responders, organized in collaboration with the American Society of Safety Engineers.[3] Many times issues of building codes and fire laws seem a bit dry to me. But the evening we shared with these men was one of the most moving Triangle events I have ever attended. With great openness they shared story after story of arriving at buildings in flames, knowing that there are people dying inside but that little can be done because inside—defying all building and safety codes—is an impossible maze of ad hoc partitions and locked doors. They named fellow firefighters who had perished due to conditions eerily reminiscent of the problems at the Triangle Factory. September 11 was very present for many of them.

The conversation that evening at the New York City Fire Museum shifted how I understood the circumstances that led up to the Triangle fire. By law, the Asch Building was required to have three staircases. The architect was granted an exception when he claimed that two staircases and a fire escape were an effective equivalent. The fire escape was installed on an inside court and ended over a skylight. The doors to both stairwells opened in toward the factory floor rather than out for quick egress. Fire sprinklers were available but not installed. Not a single fire drill was ever conducted. The fire department had long been concerned about its lack of capacity to fight a fire in the new "skyscrapers." Just four months before the Triangle fire, a similar conflagration in a Newark garment factory burned nine young women to death while another sixteen were killed when they leapt out the fourth-story windows. Fire Chief Crocker

had warned that the same circumstances existed in New York and that "a fire in the daytime would be accompanied by a terrible loss of life."[4]

The fire marshals and other safety workers we met with that night spoke fiercely of the human cost of greed. They had all lost friends and colleagues. In many ways their direct talk was the most radical of any I had heard linking avarice to loss of life. Walking out of the meeting, Janet and I were stunned. I had been comfortable seeing the Triangle fire through my eyes, as a woman, as a Jew, as a worker. How I understand the Triangle fire was forever changed by the stories I heard that night.

I was pushing hard for Janet to come up with a design for the memorial that we could unveil at the centennial. At some point, while running to all the meetings we had scheduled for her, she insisted that she needed more time to integrate the large amount of community input. She emphasized that we could either have a fast memorial or one that was truly responsive. She was exactly right. With so many competing demands, I had broken my own rules about giving projects their proper time. We were faced with forcing a centennial deadline for practical and financial reasons or supporting the real time needed to come up with an engaged design. We agreed to postpone.

As we neared the centennial, I felt the memorial slipping through my fingers. I had been working 24/7 for the Coalition for as long as I could remember. What we lacked in funding I was trying to make up for in sweat equity, but I was reaching a breaking point. Even though Mary Anne Trasciatti stepped in to take on many of the memorial responsibilities, there just weren't enough hours in the day to do everything. In the end I had to face that I had reached my limit. I could either focus on the centennial effort or the memorial, but I could not do both. I made the choice to stick with the impending centennial and trust that in the future we would still be able to pull off the memorial.

After good faith efforts by the Coalition, community, the public art administrator, and the artist, the memorial didn't come to fruition at that time. And that sometimes happens. We can do what is seemingly right on every front, but it still does not bring about the intended result. Sometimes there are variables beyond our control; sometimes it's a lack of resources; sometimes we've made too many small mistakes along the way. Often it is a combination of all these factors. It's disappointing but not uncommon. All we can do is try again another day. As of this writing the effort to erect the Triangle Memorial on the Brown Building continues. Perhaps by the time you read this, the

memorial already stands—but if it doesn't, you might need to get involved to make it happen!⁵

If you look out the window of the ninth floor of the Brown Building, the height to our modern eyes seems modest. The building across Greene Street is not so far away; in a movie the hero would be able to take a running leap and jump from roof to roof. The stairwells are narrower than one would imagine. The building is now filled with New York University science labs. It seems somehow oddly appropriate to see the students, many of whom are just a bit older than the Triangle workers, bustling about. In the streets below, a river of young people flows back and forth between classes, mingling with the rest of the busy city. A professor stops by, and we begin to chat. He mentions that at the start of the semester he always tells his new students the story of the Triangle fire. Each of us passes the story down in our own way.

AT THE CORNER OF WASHINGTON PLACE AND GREENE

We need a Triangle memorial. Something permanent, attached to the building, impossible to ignore. A way to tell the story of the fire and remember the dead on days when no one is marching in the streets, no shirtwaists are fluttering in the air, no names are being chalked on the sidewalk. The small historic plaque that currently marks the building is utterly unremarkable and too easily over-looked. We need a poignant, powerful work of art that draws people to the neighborhood and calls out to casual passersby on the corner of Washington and Greene, "Hey! A terrible thing happened here on March 25, 1911. One hundred forty-six people died. Countless others suffered tremendously. And you should know about it."

New York City is filled with memorials to the achievements and sacrifices of men. We need to do away with the idea that public space is a male domain. Once and for all. Most of the Triangle dead were young immigrant women and girls. On behalf of all the women who have toiled in obscurity for millennia, we cannot let the women of Triangle remain invisible and their names remain unfamiliar. It is time to claim space for women.

We want to transform the Asch Building from the site of a historic tragedy into a space for political action, not just during the commemoration on March 25 but every day of the year. The Triangle fire was a line-in-the-sand moment that inspired workers, politicians, and activists of all kinds in New York City and the United States to rise up and demand that working women and men be treated with justice and dignity. Their stubborn refusal to be laid low by tragedy and accept oppression continues to inspire people around the world. We want a Triangle memorial to remind us that the struggle for social justice transcends space and time and that whatever their apparent differences, good people everywhere are united in their work to make a better world.

Mary Anne Trasciatti is associate professor of rhetoric at Hofstra University and chair of Remember the Triangle Fire Coalition. She is writing a book on the free speech work of labor organizer Elizabeth Gurley Flynn.

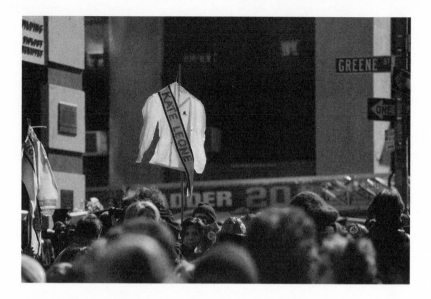

Kate Leone (14) was one of the youngest who died in the Triangle Shirtwaist Factory fire. Photograph by RJ Mickelson. Courtesy of Workers United.

SUSTAINABILITY (A RANT)

I had a right to protect my property.

—Max Blanck, Triangle Waist Company boss, 1911[1]

There is a myth going around—that if you are talented enough and work hard enough you will be rewarded. But it's a lie. I know plenty of people of exceptional abilities, brave of heart, who never got a fair shake. They slip beneath the surface. Their gifts are lost to the world.

I want to talk about money.

I want to talk about how much of the creative and political work we depend on is done by people who are not paid. Sometimes it's called a labor of love, as if that would erase the inconvenient fact that we still need to come up with the bucks for rent, groceries, and medical care. I want to talk about what happens in an ecosystem in which only the young, the rich, or the very lucky can opt to live a creative life in New York City. The rest of us can be there temporarily, but over the years most are winnowed out. It becomes a sharply narrow niche of people who are making what is termed culture. I want to talk about who

is complicit: the friendly monsters of universities and arts organizations who enable this dysfunctional system. I want to agitate for a conversation about how to blow up this beast and rewire the entire scheme.

It's impossible to fully share a project without being up front about the financial conditions under which it was created. We have to be transparent about our budgets to uncover how the system is actually functioning. Who is getting paid and how much and who isn't getting any money at all? We have to be honest so that the pressure is on the system that needs fixing instead of on individuals struggling to get by. If we clearly define how funding (or lack of it) impacts the content and longevity of our projects, we might be able to collectively improve the situation.

For every project I've ever done, someone along the way told me it was impossible. My work tends to be large and complex. If it's a film, it's shot in 35mm; if it's an oral history project, it has to be video, with more than five hundred participants; if it's a Triangle Fire Coalition, it has to be national. It's the way I work. So in a sense the warnings are true. My projects are never fully funded, and they come into being only if a large number of people are willing to contribute a superhuman effort. I am able to pull off these projects through a mix of my technical skills with a ferocious amount of time, stretching every resource to its absolute limit. For years I kept a quote from dancer/choreographer Bill T. Jones pinned to the wall above my desk: "It was impossible for it to succeed, but it did not fail."[2] I almost never get paid to make my work. In fact, it's a happy occurrence if I don't end up in terrible debt. Working in this manner produces a brutal tension, as at any moment the entire endeavor might simply collapse in on itself.

It's constant guesswork trying to figure out if it is more efficient to try to raise the funds to pay people or more practical just to do the work myself or with the donated skills already present within the community. Even with reasonable-sized grants I have never come even close to having enough money to pay everyone. A large part of my work is corralling people into committing and following through in all the busy tasks necessary to keep us afloat and functioning. When running on human capital, how far can you actually go? Pretty far, in turns out. But it requires extraordinary effort at pulling in sweat equity for each step of every project, taking away from all the other things one could be doing for the work.

The first year of the Coalition was manageable; but by the second I was utterly overwhelmed. Even though the steering group pitched in as much as

possible, the workload was unrelenting. With no office or funding or support staff, I was working seven days a week, and I could never keep up. We regularly applied for grants and were just as regularly turned down. This flawed model fosters a tendency to lose self and give more than is sustainable or healthy. I did that. I see others do it all the time. It's thrilling and addictive to work at such a manic pace. But it also ultimately constrains the project. No one should be giving up a sense of self, including economic self, to participate. A misconception seems to be flying around that folks without a lot of money have time. The truth is just the opposite. When you're broke, it takes a huge amount of time and energy to keep afloat. When we don't have money to pay people, we lose many of the voices necessary to grow the project to its fullest potential. Certain types of work tend to get compensated, even when there is little to go around, while others are expected to work for free or to donate large amounts of unremunerated hours.[3] Unsurprisingly, the split often falls along traditional male and female roles.[4]

Although one of the first places many people seek funding is through grants, that is a very tough route unless you have a personal connection with a foundation. Government funding continues to be negligible for individual artists. Since digital technology has brought down the technical barriers to participation, the pool of applicants has grown wildly larger. You might get lucky and get a significant injection of funds, but the odds are against it. Even for those who get support, I almost never see a budget that includes a living wage for all participating artists, including what we would expect for other types of workers such as health insurance and retirement.

Stepping outside the United States, the picture is very different. I have a young friend from Denmark. There, a number of artists who reach a certain stature are guaranteed a living wage by the government. Though not a ton of money, it's enough to live on and keep the focus on making the work. If they become financially successful beyond a specified level, they're bounced from the program. Plenty of other well-off countries have models of support for their artists. It is the United States that bucks the wider trend.

What is shocking about the situation here in the United States is not just the lousy reality of it but the fact that it's not even contested. Somehow everybody drank the Kool-Aid and doesn't even consider that a person should be paid reasonably for creative labor. How did that happen? Maybe because we're all so exhausted from working day jobs, paying off student loans, writing yet

more grant proposals, doing the laundry and grocery shopping, and somehow managing to find the time to make a little work. We don't have the energy to also fight this junky system.

Sometimes the lengthy process of applying for grants feels like up-the-down-escalator. The odds of getting any particular grant are so low that to ask artists to complete long involved applications only ensures a huge number of wasted artist hours that could have been spent more productively elsewhere. Some of this is unavoidable, but there seems to be a lack of pro-portionality between the overall amount of money on offer and the amount of time required. Some organizations helpfully require a two—or more—step process so that the number of hours required increases only with the chances of actually receiving the grant. My pet peeve is when foundations try to tell me that writing the grant will somehow be good for me. Let me tell you, the time spent on grant proposals is precious energy taken *away* from the project. I've been fortunate to receive some very generous grants, but if I add up all the hours I've spent on applications compared to the total amount of money raised, the whole system is thrown into question. There is an irrationality to putting in so much effort for what will never provide reasonable compensation.

We look to arts organizations to help us sort through all this muck.[5] They are often beleaguered, staffed by artists just getting by themselves. They provide useful services such as fiscal sponsorship (a way for individuals and groups to operate under nonprofit status) and aggregated information on other resources. They often offer workshops and panels: Meet the funders! Learn how to write a winning proposal! Much of the emphasis is on being a better super-deluxe-cherry-on-top applicant, as if that would result in the pot of gold at the end of a rainbow. Supposing it is simply a question of the individuals' lack of dedicated hard work that prevents them from raising funds. If we could only make better documentation video or social network with more finesse, then somehow we would break through. But the reality is that no matter how perfect the application, the odds are against you. You might be better off buying lottery tickets.

Some of us used to be able to sell the technical skills we use for our work to commercial interests to fund our art. But with digital technology, the middle realm of production has dropped out. Commercial entities don't want to pay an experienced craftsperson—a composer or cinematographer—a full pro-

fessional rate when they can get by with cheaper product. The difference in quality is not meaningful to them.

Others turn to crowdsourcing for funding. It's a cumbersome system for creating professional paid artistic work. A successful campaign takes a huge amount of effort, unrelated to the actual creation; and underlying it is something more insidious. These campaigns contextualize art as product and the artist as entrepreneur. I am not against commerce, but it is obviously not the only measure. We know that much of what we require for a meaningful life cannot be bought. But if we treat art as simply another consumer product, we end up with crap entertainment. What is missed is not simply the end product but the model of a different way of being in the world. To me it's simply another effort to chain us into the consumer culture instead of valuing what artists actually provide. The writer Jeanette Winterson asks,

> How much can we imagine? The artist is an imaginer. The artist imagines the forbidden because to her it is not forbidden. If she is freer than other people, it is the freedom of her single allegiance to her work. Most of us have divided loyalties, most of us have sold ourselves. The artist is not divided and she is not for sale. Her clarity of purpose protects her although it is her clarity of purpose that is most likely to irritate most people. We are not happy with obsessives, visionaries, which means, in effect, that we are not happy with artists. Why do we flee from feeling? Why do we celebrate those who lower us in the mire of their own making while we hound those who come to us with hands full of difficult beauty.[6]

Another myth is that because artists don't make a lot of money, we are somehow foolish about finances. It is just the opposite. To survive economically and still be making work, we have to be very, very smart about every penny and willing to live the consequences. By necessity I regularly move forward on projects even when they still aren't fully funded, hoping I will be able to figure it out along the way. If I didn't do it that way, I'd never get anything made. It often means I am juggling many projects at once, inching forward wherever I can. There have been times I've ended up tens of thousands of dollars in credit card debt and sleeping on friends' couches. It makes a good story; but the reality of living it—and digging out—is not so great.

In recent years, academia has stepped into the fray. First they told us we needed MFAs; and I guess those degrees can be helpful. It's always great to

be around smart people. More recently they've started studio PhD programs. What do you get from that? I guess if you're early in on those things, you can get hired to teach others. But pretty quickly that pyramid scheme dries up. The rest of those graduates are coming out with debt and no improved job prospects. I don't understand why we can't recognize creative expertise without a degree. I've never met an artist who presumed to be a historian or anthropologist, but I've met plenty of academics who profess to be artists. As if picking up a tool, a camera, or a keyboard bestows that title. Again it's a consumer model. Buy the equipment, dabble—and you change who you are. As if craft and apprenticeship, time and practice had nothing to do with it. What if we put those thousands of dollars going to universities, backed by government-insured student loans, into support for artists: studio space, materials, subsidized insurance, paying a living wage, retirement funds.

The result of this topsy-turvy situation is that lots of people who would be making art are left with crippling student loan debt. They're working the crazy hours of day-job wage slaves, trying to stuff a serious arts practice into the gaps. I can't imagine a situation more well designed to curtail bold creativity. It forces a devolution of artist as outlaw. It's a denial of the living proof that there are alternatives to our fast-food culture. There is a great quote from Jonas Mekas when he was asked if he was going to be a part of a planned Museum of the Counter Culture:

> I object! . . . We are not counterculture. We in the East Village are the culture and everything around us is the opposite of culture. Counter is the mass that is called culture, but it is really the shopping-counter culture. I'm very much opposed to this term counterculture.[7]

I'm not saying arts organizations and academia are intentionally bad. Quite the opposite. I loved grad school, learned a lot. Will probably be paying off my student loans until the day I die. I've gained valuable support from artist organizations. They are doing their best in a mucked-up system. But shouldn't we all be questioning and confronting and organizing for something better, not just hoping to get our crumb of luck from it? Or are we simply too desperate to notice that our participation is at a cost? This is a road to nowhere, and the result is a mass silencing of artists who could be visioning us out of the mess we're in.

Over the years, although I've seen some people break through to financial success, most of those still making work into their middle or late years have

independent financial means. We used to flock to cities for the combustion that happens when the artistic community hits a critical mass—the ping pong of ideas and resources only possible in a physical community. Now those cities are playgrounds for the wealthy. As if art were not a necessity of life, to be nurtured by our society as a whole.

When I was growing up, we lived in an old warehouse in the Washington Market area (now TriBeCa). There was plenty of space and light. Our neighbors were dancing, making jewelry, building geodesic domes on the roof. My stepfather's darkroom was the size of my last NYC apartment. If we wanted groceries or to get to my school, we had to hop the subway. Almost no one bought in. It wasn't just a question of not having the money; it was a question of culture. We were a community of creators, not consumers. Over the years most got pushed out, to Brooklyn or upstate. Now I live in Berlin, and my neighbors here are friends from the old hood. The commute home just gets longer and longer.

At the Coalition our initial funding came from modest grants of at most about $1,000 and from individual donors. We had fiscal sponsorship from the beloved neighborhood institution City Lore. Without proper funding the Coalition never had the resources to support the many worthy projects that were proposed: the union member who hoped to remake the commemorative button, the theater companies from Kentucky and San Francisco that wanted to bring their Triangle shows to New York. We simply didn't have the funds to stake these good efforts.

Even the projects we were able to realize were deeply constrained by financial limits. We managed to raise the money to build the website for the Triangle Fire Open Archive but not to pay to maintain it past the centennial. Although Triangle-related treasures continue to be uncovered, only through the donated labor of Gabrielle and Kaushik of Buscada are new items added to the website. A similar fate has befallen the Procession of the 146. LuLu LoLo generously stored and organized the rebuilding of the shirtwaists for each public outing—in addition to performing her own one-woman play about the fire.[8] Her sensitivity and knowledge of the Triangle families are irreplaceable. LuLu received a very modest amount of money for the centennial, but everything else she did was donated labor. Joel Sosinsky continues to donate his time to insure that the shirtwaists show up at events around the city. Because public projects usually take so many years to unfold, even

in the best of circumstances the true work of the project will often extend far beyond any grant period.

Other losses are more subtle to define: the many good seeds of ideas that we didn't have the means to nurture to fruition. We will never know what they might have become. We dreamed of creating a Teachers' Pledge to encourage teaching labor history every Triangle anniversary, but our resources were too stretched to act on this plan. Although some of this is, of course, inevitable—all projects walk the tension of dream and reality—chronic underfunding leads to inevitable burnout. We push every resource so hard because we see all the beauty just on the other side. It's a constant heartache imagining all that will never come to be.

An organization created to honor the Triangle dead should have a strong commitment to contemporary workers, including the people working for the Coalition. For three years, from our founding through the centennial, the Coalition hosted the ninety-eighth and ninety-ninth anniversary events at Judson Church; created the Procession of the 146 for the Labor Day parade, centennial, and many smaller events; built our website and the Triangle Fire Open Archive; organized a centennial commemorative concert at the Great Hall; funded the recovery of *Die Fire Korbunes*; printed postcards and ten thousand centennial calendars; and launched the creation of the Triangle Memorial—all for about $70,000. It was a lot of activity for very little money, and it was made possible in large part by in-kind donations, an enormous amount of volunteer labor, and the eagle eye of our treasurer, Sheryl Woodruff, who made sure we were absolutely precise and careful with every penny spent.

It was our friends from the labor movement who stepped forward to get the Coalition on the right track. I was running out of money and had begun charging groceries to get by. One day Ed Vargas, May Chen, Lana Cheung, and Sherry Kane of Workers United took me out to lunch. They suggested the Coalition contact the 21st Century ILGWU Heritage Foundation for support. Ed ribbed me that they weren't being nice, they just needed me to keep doing whatever it was I was doing. For those of us who come from the arts and nonprofit world, it was a great eye-opener. These experienced organizers had a clear view that workers should be paid.

We applied, and the 21st Century ILGWU Heritage Foundation became the Coalition's first substantial funder. Their generous support was a great wave that lifted everything the Coalition was attempting to accomplish. For the first

time I was paid for my work as founder and director of the Coalition. Rose was hired to work part-time, but in fact put in more than full-time hours. All the Execuvistas and interns and volunteers continued to donate their time. It was a huge relief to me, because without their support I would not have been able to afford to continue with the Coalition through to the centennial. I was deeply honored and liked to brag (almost truthfully) that at last I was working as an organizer for the ILGWU!

THE TREASURER'S LAMENT

As the treasurer of the Remember the Triangle Fire Coalition, I had the privilege—and the stress—of managing the finances for the organization. As happens with many start-up nonprofits that depend primarily on volunteer labor, my title sounded much more glamorous than the duties I shouldered. Besides ensuring that my fellow board members were fully aware of the organization's financial status, I processed all incoming donations, received invoices from contractors, submitted deposits and invoices to be paid to our fiscal sponsor, and prepared thank-you letters for donors. I also took part in development work for the organization, volunteering with a team of my fellow board members on several grant proposals and leading an annual campaign in December 2010.

One of the biggest challenges of this role was finding the time to complete everything I needed to do in addition to my full-time job working for a—you guessed it—small nonprofit. Another challenge was cash flow. As you can see from the organization budget, the largest part of our income stream was from foundation grants. The organization frequently had to wait for a second installment of a grant payment, while expenses for a project had already accrued. Payments to contractors often had to be put on hold; and I was the person who had to tell them. I regularly took more cautious stances than my fellow board members when it came to making decisions of when and how to embark on projects and even began to resent my board colleagues who pushed for more. It was an outsized source of stress during my tenure. I believe, whether for staff or volunteers, these financial pressures can sidetrack all small nonprofit organizations, forcing them to make decisions based more on fear than good practice. However, I did have the extraordinary opportunity to stretch my skills and broaden my experience with a group that always believed in my abilities.

A few notes about the organization budget. The timeline reflects the start of the group as an organization (March 2008) through the transition between the organization's focus on the Triangle Centennial to creating a permanent Triangle Memorial (October 2011). By October 2011, all grant monies for the centennial programming had been received and memorial expenses begun.

The budget reflects a particularly flush time in the organization's history, but expenses quickly ramped up again in 2012, and cash flow issues arose once more.

Sheryl Woodruff is a nonprofit professional with over fifteen years of experience working in history and cultural institutions. She is a founding member of the Remember the Triangle Fire Coalition and served as its treasurer from 2008 to 2013.

INCOME		AMOUNT
Foundation Grants		$55,964.00
Participating Organizations		$3,177.00
Individual Contributions		$17,478.00
Memorial Contributions		$5,049.00
TOTAL INCOME		**$81,668.00**
EXPENSES		
Personnel Total		$36,080.00
	Ruth	$20,000.00
	Rose	$16,080.00
	Sheryl (bookkeeping and fundraising)	in kind
Memorial Total		$3,250.00
	Personnel	$3,250.00
	Venues (public meeting space and memorial jury space)	in kind
Centennial/Procession Total		$3,084.00
	Personnel	$2,250.00
	Procession dancers and musicians, shirtwaist and sashes rebuilt, musicians at commemoration	in kind
	Supplies	$685.00

	Fabric, ribbon, and buttons, hangers, fabric paint, buttons, scissors, stilts. Labor for construction of 146 shirtwaists and sashes, space for construction and rehearsal	in kind
	Transportation	$149.00
Centennial Event Calendar Total		$4,000.00
	Personnel	$4,000.00
	Publication, distribution	in kind
Great Hall Concert/Die Fire Korbunes Total		$6,758.00
	Personnel including translation, orchestration, research, audio engineer, and supplies	$6,758.00
	Great Hall, performers, additional tech crew, video documentation, programs	in kind
Triangle Fire Open Archive Total		$5,000.00
	Design	$5,000.00
	Uploading contributed "objects," social networking, outreach to other archives, venue, and personnel for public digitizing events	in kind
Coffee for Triangle Families (2010) Total		in kind

99th Anniversary Judson Church Total		$636.00
	Supplies	$464.00
	Transportation	$172.00
Labor Day parade 2009 Total		$448.00
	Transportation and fire truck	$348.00
	Video documentation	$100.00
98th Anniversary Judson Church Total		$807.00
	Supplies	$807.00
	Musicians and MC, Shirtwaist banner, food and drink, programs, documentation, cleaning and set up	in kind
Website/Design Total		$1,200.00
	Personnel (logo design and coding)	$1,000.00
	Website design and maintenance	in kind
	Hosting (one year donated)	$200.00
Occupancy Total		$150.00
	Office space	in kind
	Shirtwaist storage	in kind
	Monthly meeting space	$150.00
	Monthly meeting space	in kind
Marketing/Promotion Total		$2,080.00
	Postcards, communication, marketing	$2,080.00

	Coalition banner and photographs of Triangle workers at cost, additional postcards	in kind
Supplies Total		$744.00
	Office supplies, hard drives	$744.00
	Computer, software	in kind
Postage/Delivery Total		$566.00
Fundraising Total		$420.00
Financial Fees Total		$3,283.00
	Credit card processing	$233.00
	Fiscal sponsor	$3,050.00
TOTAL EXPENSES		**$68,506.00**
NET INCOME		**$13,162.00**

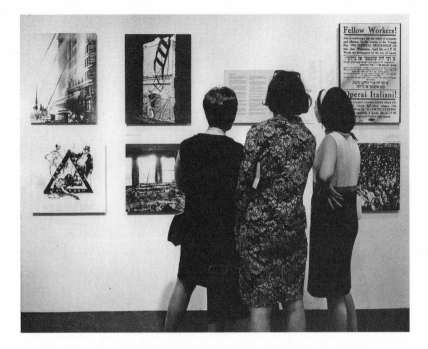

1960s Triangle fire exhibition. Photographer unknown. Courtesy of the Kheel Center, Cornell University.

ACTS OF RETURN

The way to honor the memory of the dead is to build up a strong and pow-
erful organization that will prevent such disasters as that of two years ago
and serve as a monument to the dead. Lest we forget!

—Pauline M. Newman[1]

About six months before the centennial, I realized that I would be leaving the
Coalition. The creation of the organization had been for me a creative act.
What drove me were its ephemeral, experiential, and experimental qualities.
With the centennial, that artistic project would be complete. It would be time
for me to move on to new work.

Planning my exit from the Coalition was bittersweet. It was hard to think of
going just at the moment we were reaching the culmination of our collective
dream. It was seductive to consider continuing on, but I knew that wasn't the
right thing for me or the organization. I was exhausted, and I didn't have the
stamina to continue working at that intensive pace. Looking ahead, the focus
of the Coalition's work would be on the memorial, which required an entirely

different skill set from what I had to offer. I suspected the organization would be better off with new leadership.

I also had more personal reasons for leaving. I was starting to feel stirrings of discontent within. I wanted to be making more intimate work, and even beyond that, I felt somehow my personality was changing. Big public projects necessarily mean constant contact with a large number of people, but in an odd way they leave me somewhat disconnected. I was so often being the cheerleader that I was losing more subtle real connections with people, both in and out of the Coalition. I was driving so hard I couldn't find a way to just be anymore.

I was never sure if the Coalition was art or activism or an amalgam of both. In recent years there has been a push to recognize social practice art. It's a bit of a conundrum to me. Perhaps it is similar for people who work in public humanities. I don't really know where the lines fall, but I do feel a kind of uncomfortable tilt. My purpose is not to do good. I am here to tell the truth. My own individual corrupted truth. If others tell you something else, they might be subverting their own creative want to make it prettier, more socially acceptable. It's not that the intent is to lie; it's just extremely hard to make work. Even harder to get support. We are rewarded for doing good, not for having agency. But it is in finding our voice that transformation becomes possible.

As the Coalition was gearing up to shift focus from the centennial to the memorial, the balance of art to activism began to swing too far for me. I was desperate to get back to my own work, to explore new territories. I was becoming more involved with new interactive technologies and excited about what opportunities they might offer for the audience's physical participation. I longed to be a bit quieter; and as painter Chuck Close describes,

> for me, the most interesting thing is to back yourself into your own corner where no one else's answers will fit. You will somehow have to come up with your own personal solutions to this problem that you have set for yourself because no one else's answers are applicable.[2]

I had begun to create projects that use interactive technologies to invite the audience to physically engage with objects, image, and sound. In the interactive documentary *Al*, based on the life of homeless vet and painter Al Carlo, the viewer picks up a blank piece of paper. The movement of the physical paper is mirrored by the motion of a projected handwritten note that Al had given me. Pick up a pincushion, and scenes from his prickly interaction with a prostitute

play out. At the time I began the Coalition, I was working on *Alchemy of Light*, which melded nineteenth-century illusionist tricks with current interactive technologies to depict the life of legendary magician Torrini. Live performers led the audience through the tale of the magician, who put his own child in the infamous bullet-catch trick. After a tragic accident, Torrini spent the rest of his life trying to conjure back his lost family. Through magic and live and virtual interactions, *Alchemy of Light* guided the audience to explore the seduction and limits of our human connection through technology.

Emerging technologies have the capacity to unhinge what we thought we knew about how the world operates; and in that moment of confusion a rush of possibilities both wonderful and terrifying appears. We are offered the opportunity to reinvent how people move from an individual and passive experience to a communal and participatory engagement that more fully represents the spirit in which these projects are created.

We can now create environments where the audience has to physically move in order to experience the work. Interactive art requires the audience to risk. In an immediate and physical manner the individual has to choose to engage. No longer separating the body from the rest of our being, form and content are aligned to bring the audience into a public and active arena.

My final contribution as director of the Coalition was to release it from "founder-itis." It was time for the organization to stand on its own. If I had remained, the effort would have been constrained by my limitations. Now I had to trust in the community that had been created to see the memorial effort through. I was a bit nervous about how to transmit what was crucial to me and what I would do if things were done that were different from my original vision. But I also realized that by releasing my role, I would demonstrate my belief in all the principles by which we had built the Coalition. The more clearly I could do that, the better for everyone.

Through the growth of the Coalition, I had been able to clarify three general rules of engagement. At moments when I felt lost or unsure, these ideas helped to center me and keep me on track. Over time I had discussed them so often that I felt they were built into the DNA of the organization.

All are welcome because the mix is always strongest.
Decisions would be made by the people doing the work.
The Coalition would be beholden to no one.

After the centennial, I organized files and wrote up how-to documents for many of the technical tasks. I did a few more grant applications, hoping that the organization would have a little money to move into the next phase. Rose agreed to keep the day-to-day organization running. Her passion for Triangle and the Coalition created a safe space for me to step away. I was thrilled that the dynamic Mary Anne Trasciatti was willing to take on the role of leader. It's a tough gig, and I was deeply grateful to be able to leave the organization in her capable hands.

To facilitate the transition, the board organized our first retreat at the country home of board and Triangle family member Suzanne Pred Bass. Over a weekend we looked at past materials, hashed through current issues, discussed restructuring and the transition process, and had a few margaritas to celebrate the passing of the torch. Two days after that last gathering, I got on a plane and moved to Berlin.

I was a bit stunned and didn't exactly know what I would do. That summer, I was invited to the Obama White House to be a part of the Community Leaders Briefing Series. It was a fascinating glimpse into another world. Afterward I met with a nice guy from the Department of Labor and proposed that they hire me as the DOL's artist-in-residence. He almost fell out of his shoes he laughed so hard; that will never happen, he told me. You have to give the guy credit for being honest.

In the funny way things sometimes work out, the notoriety of the Coalition gave me the juice to approach the institutions that held *Voices of 9.11*. With the support of Steve Brier of the September 11 Digital Archive and Jennifer Schantz at the New-York Historical Society, I was able to get permission to make my own copy of the *Voices of 9.11* hard drives and to create a website that included all the testimonies in time for the ten-year anniversary. It was a madhouse labor of love with many of the people who had worked on the original *Voices of 9.11* almost ten years earlier.[3] Anniversaries are charged, and we felt a commitment to make the collection accessible to all who had participated. For the first time we were able to watch and log all the five hundred plus video testimonies. Once the site was up and running, I tried to find as many of the participants as I could, but the contact information for most of them was long out of date. To those I did reach, I offered a copy of their testimony and the opportunity to contribute a written update to their posting.

Over time people are finding their recordings, either through word of mouth or by searching for themselves online. Most were glad the project had finally

come to fruition. A few asked to be removed from the site. Others wanted copies of their testimony for their children. A few people have requested copies to be used in memorial services.

Both the *Voices of 9.11* website and Chalk exist outside institutional support in a state of constant fragility. I keep up *Voices of 9.11* and respond to participants' requests. At some point I will have to give it up; the website will break; and the public will no longer have access to the testimonies. I tried to raise funds to formalize some aspects of Chalk with an eye to being able to pass it on to continue without me. Despite enthusiastic public participation year after year and lots of great press, I was unable to raise any money. Chalk will one day no longer exist.

In September 2011 Suzanne Wasserman organized panels for us to present *Voices of 9.11* to the public at CUNY's Gotham Center for New York City History. During the Q&A, it took only one person sharing a September 11 story to trigger an avalanche of personal narratives. One could feel the surge of emotion that was suppressed in 2001, as each story created the space for more to be shared. In a peculiar way it felt as if we had spent the last ten years in a kind of suspension. It was similar to the moment after the first plane had hit but before the second—when we could still believe it was simply an accident and not a new reality that we would have to learn to live with. Now, by sharing our stories, we could begin to step past the shock into a fuller contemplation of what had happened and our responses to it.

The first year after I left the Coalition had its agonizing moments. No matter what I said or intended, it was extremely difficult to let go. Every move the Coalition made I second-guessed. I could easily stay up all night obsessing. I would write epic emails that I carefully compressed from twenty-five absolutely critical points to only three before realizing that, of course, I wasn't sending the email at all. I had to let it go and walk the walk if I really believed the organization would thrive without me. With a little more time, I gained some perspective, and it slowly became kind of great. They made decisions that were utterly surprising to me, but in the end those choices were true to who the organization is now; and that is exactly how it should be. The first year was a bit rough, as transitions often are, but they soon found their own footing. A new design competition for the memorial was won by Richard Joon Yoo and Uri Wegman for "Reframing the Sky." As the Coalition moves forward, I am happily cheering them onward from the sidelines.

ART IS THE PATH FROM REALITY TO THE SOUL

All through history, artists with their creative spirit have highlighted historic events and the many injustices in the world by creating art. The Triangle Shirtwaist Factory fire is no exception. In the wake of the fire, stirred by the catastrophe, creative works appeared to mourn the victims and condemn the injustice that led to the tragedy. The Yiddish poet Morris Rosenfeld's poem "Memorial to Triangle Fire" appeared on the front page of the *Jewish Daily Forward*. The artist John Sloan's symbolic illustration "The Triangle Shirtwaist Factory Fire" was printed by the *Call*, and the sheet music ballad "Die Fire Korbunes—The Popular Fire Song—An Elegy for Fire Victims" was published to lament the victims.

One hundred years later for the centennial of the Triangle Shirtwaist Factory fire, artists were once again creatively inspired to highlight the tragedy with theatrical productions, poetry readings, music, song, dance, street performances, and visual art. All these works honored the victims of the fire, telling their immigrant stories, conveying the hopes and dreams of the 146 mostly young immigrant Jewish and Italian women, and drawing attention to deplorable working conditions and the need for strong fire safety laws.

The Centennial Commemoration was a gathering force of artistic spirits. Like the anonymous builders of the cathedrals of old, volunteers banded together to create 146 shirtwaists and named sashes for each of the victims, working with dedication, artistic enthusiasm, and camaraderie amidst talk of factory working conditions and with pauses to remember all the victims of the fire by name, noting their ages, where they lived, and if they perished alongside their sisters or mothers.

On the day of the centennial, March 25, 2011, the Procession of 146 Shirtwaists and Sashes took place, as volunteers and family members carried the shirtwaists and sashes high aloft on bamboo poles and, led by drum beats and mournful dancers, proceeded down Broadway to the site of the Triangle Factory, replicating the mourning procession of April 5, 1911, when two hundred thousand people marched in the pouring rain.

At the end of the commemoration, the shirtwaists were placed resting on a blue cloth on the sidewalk across from the site of the fire. This became our "Triangle Shirtwaist Factory Fire Memorial."

A worldwide appeal went out to churches, firehouses, and individuals to sound a bell on March 25 at 4:45 P.M. to mark the moment the fire bells sounded at the Triangle Shirtwaist Factory. A gathering of poets, musicians, artists, and activists rang bells and called out the names of the 146 victims at the site of the Triangle Factory as bells were heard throughout the city and all over the world.

Art is the path from reality to the soul. It adds legend and spirit to what has happened in the past.

A New York–based playwright/actor and international performance artist, LuLu Lolo has written and performed eight one-person plays off-Broadway that evolve from her passion for historical research and social justice, especially with regard to the dramatic struggle of women in New York City's past (www.lululolo.com).

Sisters Bessie and Civia Eisenberg worked at the Triangle Waist Company. Civia, just 17 years old, jumped to her death. Bessie was ill and did not go to work that day. She went on to have a family and lived in Atlanta, Georgia, until her death at age eighty-five. Photograph courtesy of their great-niece Phyllis Zuckerman Kestenbaum.

THE CENTENNIAL

We must live. How shall we live—in the factory or on the street?

—Anna Shaw [1]

Despite the cold, thousands of people are in the street. For the one-hundred-year anniversary of the Triangle Shirtwaist Factory fire, a broad swath of communities is represented. At the union-led commemoration, family members of the Triangle workers are seated in a sea of young students from the city's public schools. Onstage labor leaders and politicians shout out to the crowd. It's all being streamed live online and ASL (American Sign Language) interpreted. The crowd stretches back toward Broadway but can still see the action on the giant Jumbotron. Up in Union Square, drummers and dancers performing stylized rituals of mourning lead the Procession of the 146. High in the air the shirtwaists draped with the names of the Triangle dead accompany family members, retired garment workers, union members, students and teachers, artists and activists. All are on the march. They carry outsized photographs of Rose Weiner, Daisy Lopez Fitze, Caterina Maltese, and her daughters Lucia

and Rosarea. Banners quoting agitators and organizers Clara Lemlich and Rose Schneiderman are proudly held aloft. A shofar calls the marchers to join the crowd by the Brown Building. Songs of memory and protest ring out in the canyon between the buildings. "Open the door, open the door" curls over us.[2] The crowd is loud and bold. No one will be silenced.[3]

The weeks leading up to the centennial bring a growing sense of euphoria. Across the nation people are organizing. Grade school classrooms, universities, and union halls are hosting events; theater groups are creating new plays and musicals. Yiddish and Labor choruses are singing out. Jazz, new music, and folk musicians are composing and performing Triangle-inspired works. Art exhibitions are cropping up in a Fifth Avenue gallery, the New York Fire Museum, and alternative spaces. Video projections illuminate the Brown Building. Drawings made from smoke, detailed needlework, and a Triangle fire pop-up book are meticulously crafted. New documentaries are airing on national television. Synagogues and churches are holding services. An award for unsung women activists in their eighties, nineties, and beyond is inaugurated. There are poetry and book readings, walking tours and academic symposiums, craft actions and workshops, Clean Clothes and Sweat Free campaign teach-ins. The dead are being honored, and the fight for social and economic justice celebrated.

Kalpona Akter, head of the Bangladesh Centre for Worker Solidarity, is touring the United States, educating the public on current garment-factory conditions in Bangladesh. A jolt of energy is injected from the unexpected uprising in Wisconsin, as thousands of workers take over the capitol to stand for their rights. When the Coalition was founded, it seemed our project was out of step with the moment. Now, in the odd way it so often happens, we are completely in the zeitgeist. Triangle actions are cropping up in Philadelphia and San Francisco, Chicago, Los Angeles, Minneapolis, and Washington, D.C., Michigan, Massachusetts, Kentucky, North Carolina, and Iowa. Every state seems to be finding a way to honor the Triangle workers.

In a last forceful push, we reach across language and distance to build the Coalition. Our postcards are being distributed all over the city with invitations in English, Spanish, and Chinese. American Sign Language interpreters are hired for the union commemoration and the free concert in Cooper Union's Great Hall. For its commemorative exhibition, NYU's Grey Art Gallery has asked for thousands of our Labor Day handouts. In Coalition style, the call

to join the centennial is in Italian, Chinese, Spanish, Russian, and Hebrew.[4] They're going like hotcakes, and we have to print more. We put out a newspaper print edition of our calendar.[5] It is filled with page after page of actions from across the nation. A physical testament to the collective commitment to the commemoration. On the cover, the image of Kalpona Akter is mirrored with Clara Lemlich. In a world where capital is global, our organizing has to be as well. Adding to the visibility of activists like Akter is one way to assist in keeping them safe in the dangerous environments in which they often work.[6]

A couple of weeks before the centennial, we began to hear from people who wanted to participate but whose communities had no organized event. In response we quickly pulled together Bells, a participatory project that could be performed in any location. A call was put out inviting everyone to ring a bell at 4:45 P.M., March 25, 2011—exactly one hundred years after the first alarm for the fire was sounded. The response was immediate. From South Dakota down to Oklahoma and Texas, from Alabama to Arizona, and on both coasts, people signed on to ring bells. We posted a map to our website and added a marker for each participant. As the map filled, one could read the pledges from around the country. Some vowed to ring in honor of garment worker relatives or current labor struggles in their local areas. We used the language of the labor movement to thank them for organizing their communities and sent shout-outs through social media. Fire houses, universities, and churches all pitched in. Hull House in Chicago, St. John the Divine in New York, a police officer in Queens, a radio station in Missouri, a group of children in Kansas. One woman rang her doorbell for all those who didn't make it home that day. We even had a bell ringer in Brazil. It was a joyful collaborative act in which anyone and everyone could participate.

Our open monthly meetings swelled into regular festive occasions of eighty people or more. Overcrowded and joyful, we celebrated the cornucopia of offerings. LuLu organized sewing circles in her home to rebuild and repair the shirtwaists for the Procession of the 146. Working in close collaboration with the union, the Procession became a centerpiece of the commemoration. As we planned for the live webcast of the event, we met with NYU Security and the Office of Community Affairs. Just before the anniversary, the head of security sent out an email to the NYU community warning of the anticipated crowds and street closures. He unexpectedly closed with a heartfelt call for people to consider not simply walking around the commemoration—but joining in! As

so often happens, the people who are passionate about the Triangle fire show up in the most unexpected places.

The Triangle fire boomerangs with the past to make it possible to have a different kind of conversation about ourselves as workers and our hopes for the future. It's easy to see the injustices of 1911, the dangerous working conditions, and the disregard for human dignity. It can be more difficult to be as clearheaded about our own moment. The systemic oppression that leads to financial insecurity is often oddly invisible. The shame and stress are placed on individuals. The Coalition inspired us to look at present-day economic struggles with the compassion we usually reserve for the workers of the past. Once the curtain is pulled back, it is hard not to see the rampant inequality. Those who are ruled by greed act with brute force; but when we can step outside their constraints, we often find unexpected wells of power.

The success of the Remember the Triangle Fire Coalition reminds us of what is possible when we insist on the world we want to live in. The creation and development of the Coalition were not obvious. Building an organization that was entirely dependent on so many individuals taking a public stand entailed an element of risk. We stuck to our principles through momentary setbacks and pressure—even from well-meaning friends—to conform to more traditional structures. The realization of our project was the union of thousands of people from across the nation and all walks of life who insisted on remembering the 146 Triangle workers.

The work of the Coalition was to set up a process that invited participation while respecting autonomy. What people created for the centennial was not nearly as important as the experience of trusting an internal passion, turning it into an action, and seeing that action through to fruition. A perfect event or artwork doesn't matter. The problems of the world are not going to be solved by a single act. What will see us through is an engaged citizenry. Boisterous, speaking their mind, and boldly acting. With the Coalition we found a way to channel our individual dissatisfaction with the status quo into a broad conversation. Taking a stand after lying fallow is enormously thrilling and not a little addicting. Once you've done it, it's hard to remember why you ever lived any other way.

By the time we reached the centennial, I was racing from a puppet opera to a new music concert, exhibitions uptown and down, performances in the streets, talks at CUNY and FIT, documentaries airing on HBO and PBS, and

a special edition of the *Forward*. All around me other people were similarly busy. There was a sense of plenty—a growing tidal wave as symposia, political actions, plays, religious services, music, and exhibitions all came to fruition. Each event lifted the air between us. Resources had been pooled. We had built mutual support and appreciation among organizers. Together we had achieved a broadly based collective action. We claimed a possible world in which we could act as engaged, passionate, and joyful as we are. By stepping forward, and seeing so many others do so as well, we affirmed our secret hope—that we are many. Between us, a resonating hum of energy grew to a roar as we gave proof to the words of Suzanne Pred Bass, great-niece of two Triangle workers, as she shouted out to the crowd,

> Let this Triangle fire centennial be a call to all of us to rededicate our energies, raise our voices, and become more active in the pursuit of justice for all working people. Let it be known loud and clear that we stand for workers' safety, collective bargaining, for the strengthening of unions, for a working democracy. We stand with those struggling for their rights across the country and around the world. We stand with you from Wisconsin to Bangladesh. In solidarity![7]

Behind each Triangle centennial action is a person with a hunger. Someone who found a book, saw a film, heard a lecture that formed a thread to the larger story of the Triangle fire. We all started out this way, believing that our voice, our actions could have impact before it was schooled or socialized out of us. With the Coalition we found a way to set up the conditions to celebrate each person doing their part. Just a few days before the centennial, I got a call from Adrienne Cooper of the Workmen's Circle, where we had held some of our earliest meetings. At the time we had been so tiny and befuddled that it hadn't really been possible for the connection to develop. Now, just days before the centennial, Adrienne shouted out her happy disbelief at how far we'd come. "You're changing the world!"

RIDING MEMORY

Stories shift the relationship between those who tell them and those they recall. By the very end of the one-hundredth-anniversary commemorations, I was unexpectedly elated, aware that something quite extraordinary had happened. Our unquiet dead had become visible again as interlocutors. People marched with individual sashes bearing names. Lives had started to take shape—not just the awful moments of collective death. A century later, in remembering the Triangle fire's dead by name in the places where they lived, walked, and perished, the dead had assumed an individual solidity. A dialogue had emerged: as Edmond Jabès wrote in the aftermath of World War II: "You are silent; I was. You speak; I am."

We resurrected them because we needed them. Yet, by that Sunday evening I started to feel fingers peacefully withdrawing to the tunes of kaddish and other melodies. Our dead signaled that we had given them something else they had demanded beyond mourning or organizing. They gave something back. There are personal and unexpected ways in which storytelling and memory transform all those involved. I remember that sense of elation precisely because I never expected to feel it. I don't believe it will happen again.

Earlier that week I had seen Elizabeth Swados's production in which cast members ask, "Will you promise to remember us?" After the rallies, I went to a mass for the first time, ran a synagogue service, and wore a shirtwaist and long black skirt to conduct a Triangle fire history tour with a friend. By Sunday afternoon stories circulated, bouncing between past and present. Then the crescendo: Caraid O'Brien's "Triangle Walk," where mourners marched with a cantor to announce to the beat of a drum the return of the dead, declaiming each person's name at their address, bringing them home.

By trumping conventional history, we had touched the extended fingertips of individual hands and then felt them retract. We could feel those fingertips in the Lower East Side, where stories of the fire dead smolder like a subterranean fire. The words "Catherine Maltese, we return you to your home" have stayed with me, not least because I've met her elderly descendants and learned about the three women in that family who died together.

When claiming that the fire's dead did not die in vain, we make a promise to the future in their names and ours. We sense that both we and they live

on, and perhaps live best in memory, a sentiment seemingly expressed about a hundred years ago by the president of the immigrant Ponevezher Shul. He wrote then of his comrades: "They do everything . . . to prevent the name of a member from being erased from the memory of the living."

Long-time resident of the Lower East Side Elissa Sampson is currently a PhD candidate in geography at UNC Chapel Hill. She unabashedly thinks that history and memory are part and parcel of how we understand place and belonging in the construction of urban identities—both with respect to living communities today and in hearing and retelling narratives of the past.

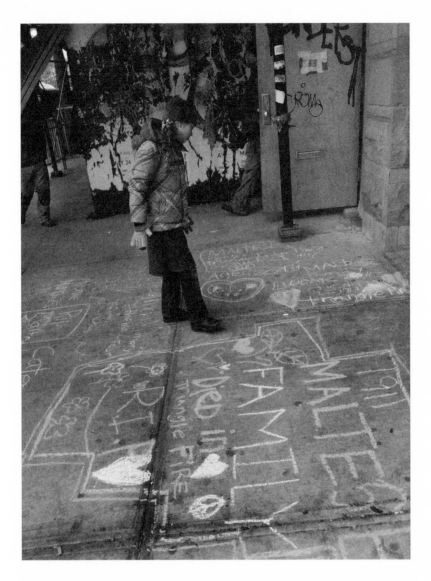

Zoe Boo Meister, great-great-niece of Triangle worker Annie Starr (30), participating in Chalk. Courtesy of Gary Meister and Vivian Sorenson.

SEE YOU IN THE STREETS

Just before the centennial, I was walking down the street with my partner, pummeling the pros and cons of some Coalition decision, when he finally blurted out, "Do you want a revolution or don't you?"

And yes I absolutely do.

Revolution as a refusal to accept the world as it is presented to us. Revolution as an insistence on our right to shape what is defined as history. The Triangle Shirtwaist Factory fire is a forceful reminder of the cost of silence. We are living in dark times. Don't let anyone tell you it's not so bad out there, because it is. We are starving for meaning, for connection, for impact. The daily practice of passivity is at a huge cost to each of us as individuals and to society as a whole. Recognition of the corrosiveness of our era makes the practice of a radical engagement all the more necessary. It is not that one person alone can do everything; many of our problems are deeply systemic, but we can be a part of the collective body that reimagines the world. And I know I am not alone. In the future, we will be measured not by what we hope but by what we do. We will have to risk our comfort, our bodies, our

fantasies of ourselves. But we can nurture a different story. The world is full of unexpected beauty.

Looking forward to seeing you in the streets.

Ruth Sergel
Berlin, 2015
www.streetpictures.org

ACKNOWLEDGMENTS

It is totally fabulous when you do something you love doing, and people love it and benefit from it also. I think that is the core, and if you are lucky enough to find a spot in the ethos where those things line up even once in your life, you should get down and kiss the ground.

—Nathan Farb[1]

A written thanks seems wholly inadequate in expressing my joyous appreciation for collaborators near and far. The sheer pleasure of a life in communion with the people listed below has sustained me in ways both personal and professional. I am deeply indebted to their wisdom, good humor, and generosity.

First, thanks to the beautiful chalkers who, as of this writing, have taken to the streets for over ten years to ensure that the lives of the Triangle workers are made visible. Your creativity and passion defy all cynicism. You are my hope.

Thank you to the beloved Remember the Triangle Fire Coalition Execuvistas, both titled and entirely unofficial. You made this impossible dream come true: Suzanne Pred Bass, Gabrielle Bendiner-Viani, Roy Campolongo, Carmelina Cartei, Esther Cohen, Diane Fortuna, Rose Imperato, Sherry Kane, Rob Linné, Annie Lanzillotto, LuLu LoLo, Kaushik Panchal, Andi Sosin, Joel Sosinsky, Mary Anne Trasciatti, and Sheryl Woodruff.

Thank you to all the postcard writers and photographers, many of whom are mentioned above but also including Marjorie Ingall, Gary Meister, Shelley Jacobs Mintz, Ileana Montalvo, Emma Rosenthal, Elissa Sampson, Vivian Sorenson, Ellen Wiley Todd, Kevin Walter, Al Guerriero, and the Young Historians at PS 126, as well as Scott Jackson and his students at Brooklyn International High School, who generously shared their work.

Thank you to the Coalition partners and friends, including Kevin Baker, Robin Berson, Meg Browne, Steve Greenhouse, David Greenstein, Hannah Grif-Sleven, Eliza Ladd, Daniel Levinson-Wilk, Ernesto Martinez, Gary Parker, Daphne Pinkerson, Cecilia Rubino, and John Schimmel. Thank you to historians Annelise Orleck, Richard Greenwald, Danny Walkowitz, Marci Reaven, Suzanne Wasserman, and Steve Zeitlin. Thank you to Coalition interns Nora

Daly, Becky Herman, Stephanie Schwartz, Anna Shelkin, Olivia Wise, and Ashley Perry.

Thank you to the good folks of the Kheel Center: Curtis Lyons, Cheryl Beredo, Patrizia Sione, Kathryn Dowgiewicz, Melissa Holland, Barbara Morley. Thank you to Workers United, who introduced me to May Chen, Lana Cheung, Ed Vargas, and Edgar Romney. Thank you to the Triangle family members, some of whom are listed above but also Vincent and Serphin Maltese, whose open-hearted welcome sets the example for all of us. Thank you to the Kestenbaum family, whose grace and warmth inspired much of my early work on these projects. The support of the 21st Century ILGWU Heritage Foundation was crucial to the Coalition's accomplishments. Many thanks to Jay Mazur and Muzaffar Chishti for their kind support.

Thank you, David Von Drehle, for being the spark that ignited all of this.

Thank you to the *Voices of 9.11* project managers Pamela Griffiths, Laura Doggett, Andrea Star Reese, and Vicki Warren. Thank you to all at Here Is New York: A Democracy of Photographs for their support of *Voices of 9.11*. Thank you to Susan Faludi, whose sage words gave me new insight into the project.

Berlin is made brighter with the friendship and probing conversations of Antonia Humm, Dino, Sanija, and Seid Kulenovic, Helmut Tausendteufel, and Saudia Young. Thank you to Mark Coniglio, Catherine Duquette, Xenia Leydel, and, from afar, Dawn Stopiello. I am fortunate to have grown up in an amazing, opinionated, and bold family. Thank you, Judith Treesberg, Nathan Farb, Kit Howard, Kathleen Carroll, Esme Farb, Kate, Seth, Lola, Elias, and Lark Buncher.

There is a core group who have seen me through many of the projects mentioned in this book, a chosen family of touchstones and fellow travelers. Heartfelt thanks to Amy Auchincloss, Dorothea Braemer, Jude Calder, Tricia Clark, Jörg Fockele, Nicole Franklin, Fay Greenbaum, Pamela and David Griffiths, Nina Haft and Nancy Fishman, Holly Heinzmann, Tyler Kim, Michael Montes, Manfred Reiff, Claudia Sidoti, Keena Suh, Markus Waschewsky, Paul Weathered, and Jeri Zempel.

Sections of this book were developed through a fellowship at the John Nicholas Brown Center for Public Humanities and Cultural Heritage at Brown University and in an essay for the *New York University Journal of Legislation and Public Policy*, whose editor, Meg Brown, patiently led me through the

process of academic publication. While writing this book, I had the good fortune to have a residency at Yaddo, where the inspiring environment and good company spurred me forward.

Thank you to Peter von Salis, first reader and comrade. Thank you to Nina, Jude, Kit, Pam, Gabrielle, and May for reading the manuscript and providing valuable feedback.

Heartfelt thanks to the University of Iowa Press and editors Catherine Cocks, Teresa Mangum, and Annie Valk, whose lively encouragement pushed me onward. I am so grateful that you took a chance on me and guided this ship to shore. Thank you for the great patience and support of James McCoy, Susan Hill Newton, and production manager Karen Copp.

This book is part of a broader dialogue being held in the streets, in our kitchens and cafes, online, and in the work we create. Final thanks goes to you, dear reader. Thank you for spending time with this book.

Looking forward to continuing the conversation.

APPENDIX A
WANT TO LEARN MORE?

Want to learn more about the Triangle Shirtwaist Factory fire? Of course you do!

Books

The Classics

The Triangle Fire by Leon Stein

Triangle: The Fire That Changed America by David Von Drehle

Extra Credit

Common Sense and a Little Fire: Women and Working-Class Politics in the United States, 1900–1965 by Annelise Orleck

The Triangle Fire, the Protocols of Peace, and Industrial Democracy in Progressive Era New York by Richard Greenwald

The New York City Triangle Factory Fire by Leigh Benin, Rob Linné, Adrienne Sosin, and Joel Sosinsky

Websites

Everything you ever wanted to know about the Triangle fire (including Leon Stein's papers and the ILGWU archives): http://trianglefire.ilr.cornell.edu/.

The Remember the Triangle Fire Coalition: http://rememberthetrianglefire.org/. (Be sure to check out the Triangle Fire Open Archive and the resources + education pages.)

Street Pictures is the home for Chalk and everything else I do: www.streetpictures.org/chalk.

APPENDIX B
THE REMEMBER THE TRIANGLE FIRE COALITION

Participating Organizations

A Besere Velt (A Better World): Yiddish Community Chorus of Boston Workmen's Circle • Adelphi University • Alta Gracia Apparel • American Experience, PBS • American Labor Museum/Botto House National Landmark • American Labor Studies Center • American Society of Safety Engineers • Anabella Lenzu/DanceDrama • Ann Maria Bell • Annie Lanzillotto • Archbishop Carney High School • BAAD! • Babcock Galleries • Barre Historical Society • The Bay Ridge Historical Society • Timothy Beaty • Berkeley City College's Arts and Cultural Studies Department • Boston College Department of Theatre • Bread and Roses Centennial Committee • Bread and Roses Heritage Committee • Brooklyn College Alumni Assoc. Mid–New Jersey Chapter • Brooklyn Historical Society • Brooklyn Women's Chorus • Brotherhood Synagogue • Jane Bugnand • Caraid O'Brien • Carolina Center for Jewish Studies • Center for the Study of Labor and Democracy • City Reliquary Museum & Civic Organization • Coalition for a New Village Hospital • College of Staten Island/CUNY • Dean's Circle, NYU • Def Dance Jam Workshop • Department of Romance Languages/Hunter College, CUNY • Diane Lutz • Dianich Gallery • Downtown Art • Drama Bookshop • Duane Cook • East Harlem Preservation Inc. • Education & Labor Collaborative • Elaine Ocasio • Eugene Lang College, The New School for Liberal Arts • Experimental Geography in Practice • First Class PR Agency—Hofstra University • *The Forward* • Frances Perkins Center • Friends of the Bowie Library • Gettysburg Stage • Global Education Motivators • Gotham Center for NYC History • Greater Astoria Historical Society • Greater New York Labor-Religion Coalition • Greenwich Village Society for Historic Preservation • Grey Art Gallery, New York University • Hebrew Free Burial Association • Hudson Valley Area Labor Federation • Cynthia Impala • Injured Workers Unite Coalition of ConnectiCOSH • Institute for Global Labour and Human Rights • International Labor Rights Forum • IS 190–Class 002 • Italian American Writers' Association • J. Tay-

lor Finley Middle School • JCC CenterStage • Jewish Community Action •
Jewish Labor Committee • Jewish Women's Archive • Jews for Racial and
Economic Justice • Joyce Gold History Tours of New York • Juan Morel
Campos Secondary School • Judea Reform Congregation • Kavana Coop-
erative • L Cunniff Productions • La Fuente: NYCPP and LICPP • Labor
and Working-Class History Association • LaborArts • LaborFest • Lallan
Schoenstein and Gary E. Wilson • Latinas Against FDNY Cuts • Levy's
Unique New York • Looking for Lilith Theatre Company • Los Angeles
LaborFest • Lower East Side Jewish Conservancy • Lower East Side Tene-
ment Museum • LuLu LoLo Productions • Lyric Stage • Manhattan Choral
Ensemble • Memory Melody • Merchant's House Museum • Metropolitan
Chapter of the Victorian Society in America • Metropolitan Klezmer •
Meyer London Family • Microrevolt • Mount Sinai–IJ Selikoff Center for
Occupational & Environmental Medicine • Murphy Institute for Worker
Education/CUNY • Museum at Eldridge Street • Museum of the City of
New York • My New York City Tours • Nassau Reading Council • National
Labor Committee • New York City Fire Museum • New York Labor History
Association • New York Society for Ethical Culture • New York State De-
partment of Labor • Roger Newell • NewFilmmakers • Next Generation Bay
Area • Nina Haft & Company • NOW-NYC • NYS Communist Party • NYS
Immigrant Action Fund • Occupational and Environmental Health Center
of Eastern NY • Open Ink Productions • Parachute Project • Philadelphia
Jewish Labor Committee • Pipe Nozzle • PS 65 Bronx, NY • Remember
the Women Institute • Rory Lancman, NYS Assembly • Safety Priority •
San Francisco Mime Troupe • Sheep's Nose Farm • Sisters in the Building
Trades • Society of Fire Protection Engineers–Metropolitan NY Chapter •
Brian Spaulding • St. John the Divine • St. John's University–Staten Island
Campus • Stanton Street Shul • Staten Island Democratic Association •
Staten Island OutLOUD • Street Pictures • Street Vendor Project • SUNY
Albany School of Public Health, CPHCE • Suzanne Beahrs and Dancers •
SweatFree Communities • Tellers2 • The Actors Company Theatre • Theater
for the New City • Theorizing Women's Activism • Ti Piace Italian Amer-
ican Presentations, Inc. • Todd Mountain Theater Project • Tottenville
High School Women's Chorus • Triangle Concert • Triangle Jazz Project •
Triangle Letter Project • Triangle Project LLC • Triangle Shirtwaist Factory
Fire Memorial • United National Anti-War Committee • United University

Professions/Stony Brook • University of Iowa–The Labor Center • University of Iowa Theater Department • Annie Schneiderman Valliere • W4 New Music Collective • West End Synagogue • Widener Triangle Centennial Committee • Women and Gender Studies Program at Hunter College (CUNY) • Women's City Club of New York • Workmen's Circle/Arbeter Ring Michigan • Workmen's Circle/Arbeter Ring • Worksafe • Yeshiva University Museum

Sponsors

Albert Catalano • American Social History Project • Andrea Coyle–Lower East Side History Project • Andrew + Miriam Sanello • Annmarie Brown • Barbara Burrell • Barbara Campbell • The Bay Ridge Historical Society • Beatrice Vargas, in memoriam • Bill Russo • Blair Brewster • Bricklayers & Allied Craftsworkers Local 1 NY • Brindle-Khym Family • Burt Swersey • Carol & Harold Sader • Charles Levenstein • Chelsea Reform Democratic Club • Ching Wong + Mary Yee • CSEA • Cynthia Drew • David Kook • David Prouty • David Von Drehle • Diane Fortuna • Dianna Maeurer • Donna Nevel • Edgar & Gladys Romney • Elaine Ferranti-Kennedy • Ellen Wiley Todd • Ethix Ventures Inc. • Family of Rose Schneiderman • Fashion Institute of Technology • Gennaro Pecchia • Hal Tepfer • Hanna Griff-Sleven • H. Theodore Cohen • Harry Robbins • Henry Street Settlement • Heriberto Vargas • Italian American Writers' Association • Janet E. Garvey • Jo Ann E. Argersinger • Jo Hamilton • John D. Calandra Italian American Institute, CUNY • Joyce Mendelsohn • Judith Polson • Judith Stonehill • Kate Bostock Shefferman + Jesse Shefferman • Kevin Foley • Labor-Religion Coalition of New York State • Labor and Working-Class History Association • League of Women Voters of the City of New York • Lee Feuerstein • Lynn Steuer • Maria Elena Capaldo • Maria La Russo • Marian Gray • Marise Hausner • Martha Fleischman • Mary Hirsch • May Ying Chen • Nancy Lorence • Nassau Reading Council • Natalie Sosinsky • National Consumers League • New York Committee for Occupational Safety and Health (NYCOSH) • New York State United Teachers • Norman Reisman • NY/NJ Regional Board Workers United/SEIU • Paradiso-Parthas Press / Feile-Festa • Rekindling Reform • Robert Forrant • Rosemarie Ottomanelli • Rosina Cirrito Descendents • Roy Campolongo • Ryan Heffernan • Save Chelsea • Social Dem-

ocrats, USA • Socialist Party of New York City • Steven & Ellen Eshchuk • Susan Cowell • Susan Lee • Suzanne Wasserman • Tom Lansner • Turning Point Acupuncture • UNITE HERE • United College Employees of FIT • United Jewish People's Order • Veemin + Kitty Yee • Walter McClatchey, Jr. • Washington Square Hotel • Washington State Coalition of Labor Women • Women's eNews

Change Agents

21st Century ILGWU Heritage Fund • American Society of Safety Engineers • Rachel Bernstein • Linda Bertoldi & W. A. Bogart • Blowback Productions • Louis Blumengarten • Change to Win • Esther Cohen • Cooper Union • HBO • Evelyn Jones Rich • Judson Memorial Church • Sherry Kane • Kheel Center–ILR School, Cornell University • Labor Arts • Daniel Levinson Wilk • Metropolitan Chapter of the Victorian Society in America • New York City Central Labor Council • New York Council for the Humanities • New York University Community Fund • Sidney Hillman Foundation • Suzanne Pred Bass • Schwarz Family Foundation • Adrienne Andi Sosin + Joel Sosinsky • Sparkplug Foundation • Sheryl Woodruff • Workers United, NY-NJ Joint Board • United College Employees of FIT

NOTES

Welcome

1. Mike Elk, "The Texas Fertilizer Plant Explosion Cannot Be Forgotten," *Washington Post*, April 23, 2013, http://www.washingtonpost.com/opinions/mike-elk-the-texas-fertilizer-plant-explosion-cannot-be-forgotten/2013/04/23/48eb770c-ac26-11e2-b6fd-ba6f5f26d70e_story.html.

The Fire

1. Quoted in the epigraph to David Von Drehle, *Triangle: The Fire That Changed America* (New York: Grove Press, 2003).
2. This account of the Triangle fire is from Leon Stein, *The Triangle Fire* (Ithaca, NY: ILR Press, 2011).
3. Although popularly known as the Triangle Shirtwaist Factory, the firm was actually the Triangle Waist Company.
4. The Asch Building was later renamed the Brown Building. I use whichever name is correct for the time period being discussed.
5. Stein, *Triangle Fire*, 188.
6. For more on Joey Zito, see the Triangle Fire Open Archive (http://rememberthetrianglefire.org/open-archive/portrait-of-elevator-operator-joseph-zito/ and http://rememberthetrianglefire.org/open-archive/newspapers-tell-the-story-of-joseph-zito/).

Chalk

1. You can view the map here: http://streetpictures.org/chalk/. Please feel free to embed it anywhere.
2. For an extended discussion of the social meanings of crayon style, see Rebecca Zurier, *Art for the Masses: A Radical Magazine and Its Graphics, 1911–1917* (Philadelphia: Temple University Press, 1988), 129–132.

Craft

1. As quoted in Von Drehle, *Triangle*, 36. Jacob Klein died at age twenty-three, March 25, 1911, Triangle fire.
2. I was inspired in my understanding of this by Ann Cvetkovich's book *Depression: A Public Feeling* (Durham, NC: Duke University Press Books, 2012).
3. I had the great good fortune to study with Regina Tierney at the New York Feminist Art Institute and to attend model sessions at Spring Studio, founded by Minerva Durham.
4. *Bruce* premiered at the Los Angeles Independent Film Festival in 1998 (http://streetpictures.org/bruce/). Director/Cinematographer: Ruth Sergel; Editor: Juliette Olavarria; Production Design: Paul Weathered; Assistant Director: Kate Sergel Buncher; Camera Assistant: Tricia Clark; Second Camera Assistant: Peter Gabriel; Gaffer: Eric Neason; Best Boy: Alexi Williams; Stills: Pamela Griffiths; Props: Dominic Toto; Sound: Tim Mangin; Catering: Claudia Sidoti; Dancer: Bruce Jackson; Music: "We Are . . ." composed by Dr. Ysaye Maria Barnwell, performed by Sweet Honey in the Rock and available on Sacred Ground (http://sweethoneyintherock.org/albums/1996-sacred-ground/).
5. *Cusp* premiered at New Directors/New Film at the Museum of Modern Art in New York City in 2000 (http://streetpictures.org/cusp/). Writer/Director: Ruth Sergel; Producers: Pamela Griffiths, Claudia Sidoti; Director of Photography: David Griffiths; Editor: Lora Zaretsky; Music: Michael Montes; Costume Design: Suzanne Kelly; Production Design: Paul Weathered; Line Producer: Susan Forrest; Title Design: Steve Tozzi. Cast includes Alice: Sophie Mascatello; Mother: Marlene Forte; Eliza: Hannah Goldwater; Lila: Gina Maria Paoli; Becca: Audrey Gelman; PJ: Dylan Weathered; Sam: Jerry Hildebrandt; Lainey: Ashley Brichter; Candy store clerk: George Valencia; Candy store girl: Giselle Forte; Ring vendor: Alex Furth; Happy family: Kate, Seth, and Lola Buncher; Screaming couple: Elizabeth Canavan, Jared Shaw; Eliza's mother: Claudia Sidoti; Sam's new girlfriend: Aimee Gallin; Teacher: Beverly Crick; Kung fu boy: Brian Dolphin, Nicholas Forrest-Reynolds; School kids: Elizabeth Aguilar, Eliot Aronson, Chris DeLoach, John DeLoach, Anna Gribetz, Kate Gribetz, Antonella Lentini, Francesca

Lentini, Zach McDonald, Arianne Moore, Matt Moore, Claudia Maria Perez, Lucia Reynolds, Aliza Stone, Nick Turner.

6. *Belle* premiered at the Tribeca Film Festival in 2004 (http:// streetpictures.org/belle/). Writer/Director: Ruth Sergel; Producers: Pamela Griffiths, Nicole Franklin, Maya Montañez Smukler; Associate Producers: Jude Calder, Mei Szetu; Director of Photography: David Griffiths; Editor: Lora Zaretsky; Music: Michael Montes; Costume Designer: Suzanne Kelly; Production Designer: Paul Weathered; Sound Editor: Al Zaleski; Title Design: Steve Tozzi; Mr. Fix-it: Manfred Reiff; Production Manager: Carolyn Hepburn. Cast includes Belle: Ethel Greenbaum; Ladies of the boardwalk: Marion Baker, Hope Bernstein, Goldie Gold, Blanche Schreiber, Ruth Shapiro, Susan Spielman, Ruth Vogel; Pablo: George Valencia; Cashiers: Jennifer Poe, Jennifer Vilette; Gas station attendant: Juan Molinari; Dandy: Nathan Farb; Hussy: Deborah Schwartz; Store customers: Kate and Lola Buncher, Robert Castanos, Sylvia Cattan, Denise, Sarah, and Sylvia Grazi, Shannon Mincieli, Christopher Trudeau; Gas station customers: Kristen Carey, Molly Lariccia, Manfred Reiff; Boardwalk: Marsha Gildin, Franklin Perkins, Marilyn Silverman; Belle's neighbor: Shirley Seligman; Belle's son: Michael Shulan; Secretary: Vera Zelen; Pablo's wife: Candice Coke. Special thanks to Fay Greenbaum.

7. The LESGC is one of the best organizations on the planet. Please consider supporting their good works today (http://www.girlsclub.org/).

Voices of 9.11

1. http://www.hereisnewyork.org/.

2. September 11, 2001, was a historic day for the United States. In other years and other countries that date has also been significant. September 11, 1973, a US-backed coup led to the overthrow and death of the democratically elected president of Chile, Salvador Allende. To learn more, please check out Patricio Guzman's extraordinary film, *The Battle of Chile*.

3. Craig Braden, who contributed video to Here Is New York.

4. *This American Life*, episode 197, "Before It Had a Name." The recordings were made in 1946 by David Boder (http://www.thisamericanlife.org/ radio-archives/episode/197/before-it-had-a-name).

5. *Voices of 9.11*, 2001–2003 (http://hereisnewyorkv911.org/). Created by Ruth Sergel; NY Director: Pamela Griffiths; Washington, D.C./Pentagon: Laura Doggett, Vicki Warren, Lara McPherson; Pennsylvania: Andrea Star Reese; Booth Design: Tim Main; Tech Design and Support: Daniel Valdez, Juan Molinari, Paul Constantine. Additional support: Martha K. Babcock, Maggie Berkvist, Cynthia Dartley, Abigail Feldman, Kerin Ferallo, David Griffiths, Karen Jaronesky, Mary Liao, Brenda English Manes, Jay Manis, Christine McAndrews, Steve Robinson, Stephanie Schenppe, Deborah Schwartz, Nelly Sidotti, Fernanda Malarazzo Suplicy, Nancy Tongue, Aaron Traub, Mary Traub, Amy Wentz, Mandy Yu.

Special thank you to Michael Shulan, Mark Lubell, Charles Traub, and all at Here Is New York. Many people helped *Voices of 9.11* come into being. I apologize if I missed including anyone on this list. Please let me know and I will make corrections as I am able.

6. Martha Carden (http://hereisnewyorkv911.org/2011/martha-carden/).
7. Donn Marshall (http://hereisnewyorkv911.org/2011/donn-marshall/).
8. Vielka White (http://hereisnewyorkv911.org/2011/vielka-white/).
9. Daniel Hooten (http://hereisnewyorkv911.org/2011/daniel-hooten/); Kathy Dillaber (http://hereisnewyorkv911.org/2011/kathy-dillaver/); Anne Youngblood (http://hereisnewyorkv911.org/2011/anne-youngblood/); Jennifer Youngblood (http://hereisnewyorkv911.org/2011/jennifer-youngblood/).
10. Liza Murphy (http://hereisnewyorkv911.org/2011/liza-murphy/); her sister, Mary Adams (http://hereisnewyorkv911.org/2011/mary-adams/).
11. This quote is from Maryat Lee, founder of the Eco Theater. I downloaded and printed it many years ago, but I can no longer find the original source. If you have it, please let me know and I will correct.

Start Your Engines

1. Von Drehle, *Triangle*, 62.
2. Christa Wolf, *City of Angels: Or, the Overcoat of Dr. Freud*, trans. Damon Searls (New York: Farrar, Straus and Giroux, 2013), 309.
3. My understanding of these extraordinary women was greatly enhanced by Annelise Orleck's wonderful book *Common Sense and a Little Fire:*

Women and Working-Class Politics in the United States, 1900–1965 (Chapel Hill: University of North Carolina Press, 1995).

4. Annelise Orleck interviewed Pauline Newman extensively before her death. Her book *Common Sense and a Little Fire* provides a wonderful detailed portrait of Newman, Clara Lemlich, Rose Schneiderman, and Fannia Cohn.

5. Jacob Klein was twenty-three years old when he died of asphyxiation and burns in the Triangle fire. Von Drehle, *Triangle*, 276.

6. Since she spoke in Yiddish, accounts of her actual words vary—but the gist of it is correct: she made history!

7. The Occupy Movement erupted on September 17, 2011. In part inspired by the Arab Spring, it began in NYC as Occupy Wall Street but quickly spread to hundreds of cities across the country and around the world. *Wikipedia*, s.v. "Occupy movement," accessed April 14, 2015, https://en.wikipedia.org/wiki/Occupy_movement.

8. Thank you to Jimmy's No. 43, Veniero's, and Essex Street Restaurant.

9. Leon Stein, ed., *Out of the Sweatshop: The Struggle for Industrial Democracy* (New York: Quadrangle/New Times, 1977), 196–197.

Solidarity

1. As reported in Von Drehle, *Triangle*, 61.

2. Around the globe Labor Day is celebrated on May 1. Not so in the United States. After the Haymarket Massacre in May 1886, the president moved Labor Day to September so as not to seem to be commemorating that historic event. In New York in recent years the parade has grown steadily smaller, outflanked by the September 11 commemoration and the West Indian American Day Carnival parade in Brooklyn.

3. See Ellen Wiley Todd, "Remembering the Unknowns: The Longman Memorial and the 1911 Triangle Shirtwaist Fire," *American Art* 23, no. 3 (2009): 61–80; see also Todd, "Photojournalism, Visual Culture, and the Triangle Shirtwaist Fire," *Labor Studies in Working-Class History of the Americas* 2, no. 2 (2005): 9–27.

4. Excerpt from a lecture given September 30, 1964, by Frances Perkins at Cornell University, School of Industrial and Labor Relations, accessed May 31, 2015, http://trianglefire.ilr.cornell.edu/primary/lectures/

FrancesPerkinsLecture.html?CFID=640754&CFTOKEN=60869769.

5. Richard A. Greenwald, *The Triangle Fire, the Protocols of Peace, and Industrial Democracy in Progressive Era New York* (Philadelphia: Temple University Press, 2005), 138.

Radical Tolerance

1. Quoted in Von Drehle, *Triangle*, 82.
2. Mary Midgley, *Science and Poetry* (London: Routledge Classics, 2001), 81.
3. For a full listing of all the Coalition partners, see appendix B.
4. Quoted in Gloria Steinem, *Revolution from Within* (New York: Little, Brown, 1993), 162.
5. ITP is part of the Tisch School of the Arts at New York University, founded by the incomparable Red Burns (http://itp.nyu.edu/itp/).
6. Steve Allen taped an introduction for bringing Lenny Bruce on his show. He tells the audience that since they know who Lenny Bruce is, if they think they're going to be offended, they should just turn off the TV for the next ten minutes. It's a brilliant riff. The episode was never aired.

Fair Exchange

1. Von Drehle, *Triangle*, 85.
2. The transliteration can be either *Die Fire Korbunes* or *Di Fayer Korbunes*. I'm going with Eve Sicular's preference, as she has studied the song in great depth.
3. Columbus Park is also the location of the infamous Five Points in old New York.

Leadership

1. Quoted in Von Drehle, *Triangle*, 238.
2. Reading Jo Freeman's essays "The Tyranny of Structurelessness" and "Trashing: The Dark Side of Sisterhood" brought me a lot of clarity about these issues. Both essays can be found on her website (http://www.jofreeman.com/joreen/joreen.htm). I was clued in to Jo Freeman

by a wonderful article by Susan Faludi, "Death of a Revolutionary," in the *New Yorker*, April 15, 2013.

3. Audre Lorde, *The Cancer Journals* (San Francisco: Aunt Lute Books, 1997), 21.

4. Suzanne Pred Bass, Rose Imperato, Sherry Kane, Annie Lanzillotto, Joel Sosinsky, Sheryl Woodruff, and I.

5. When I was a kid, I had the good fortune to spend a few years at the progressive City and Country School, founded by Caroline Pratt. It was an exceptional place where we were encouraged to be bold actors in pursuit of our passions. The school was founded in 1914, just a few short years after the Triangle fire. Soon after the centennial, I made the wonderful discovery that Pratt's life partner, Helen Marot, had been one of the founders of the Women's Trade Union League and a member of the Factory Investigating Commission after the Triangle fire. I like to imagine Pratt and Marot's dinner table discussions about pedagogy, the Uprising of 20,000, the Triangle fire, and its aftermath. Somehow their conversations and dreams filtered down through the decades to reach us. And one of the results was Chalk and the Remember the Triangle Fire Coalition. Caroline Pratt wrote a wonderful book about her work called *I Learn from Children*—definitely worth a read!

Difficult Memory

1. Quoted in Stein, *Triangle Fire*, 146.

2. Quoted in Von Drehle, *Triangle*, 258.

3. A touchstone for me on this tangle is Adrienne Rich's essay "Women and Honor: Some Notes on Lying," in *On Lies, Secrets, and Silence: Selected Prose* (New York: Norton, 1980).

4. Clarity on this idea came from a conversation with the wonderful historian/folklorist Steve Zeitlin, founding director of CityLore (http://citylore.org/).

5. *Triangle: Remembering the Fire*, directed by Daphne Pinkerson (http://www.hbo.com/documentaries/triangle-remembering-the-fire#/).

6. As quoted in David Grossman, "Writing in the Dark," *New York Times Magazine*, May 13, 2007.

Memorial

1. Stein, *Triangle Fire*, 141.
2. Gabriel García Márquez, epigraph, *Living to Tell the Tale* (New York: Knopf, 2003).
3. The ASSE was founded in 1911 in response to the Triangle fire and is the oldest professional safety society in the United States. I first learned of the organization when Diane Hurns, their public relations manager, contacted me.
4. Stein, *Triangle Fire*, 27.
5. Find out how you can help: http://rememberthetrianglefire.org/.

Sustainability (A Rant)

1. Stein, *Triangle Fire*, 202.
2. Bill T. Jones, *Last Night on Earth* (New York: Pantheon, 1997).
3. An example of this was in full force at Here Is New York: A Democracy of Photographs. Even though everyone was ostensibly paid the same amount, the tech guys got up every evening at 6 P.M. and walked out, while the women overseeing printing and other tasks would work long into the night and weekends. This gender imbalance was never explicitly requested, nor was it specific to Here Is New York. But it is illustrative of many organizations that depend on volunteer labor to keep afloat.
4. When I visit public humanities programs, most of the students are vibrant young women. Passionate, alive, fiery. How do we best nurture them? How about teaching them to negotiate their salaries, take credit for their work, delegate, step away if they are not being properly treated? I am taken aback at the lack of technology training provided to them. It keeps them dumb and dependent, without the necessary skills to imagine projects fully formed. Not that everyone has to be a technologist, but some will—and the others will be able to collaborate more effectively. They need craft.
5. I am purposely *not* naming specific organizations because I see the problem as systemic, not specific to any particular institution. Many times the staff is underpaid and overworked doing their best under impossible conditions.
6. Jeanette Winterson, *Art Objects* (New York: Vintage, 1996).

7. Quoted in Julie Salamon, "Can a 60's Spirit Survive the Walls of Nostalgia?" *New York Times*, May 23, 2005.

8. *Soliloquy for a Seamstress* (http://www.lululolo.com/theater/soliliquy .html).

Acts of Return

1. Pauline M. Newman, "Lest We Forget!" *Ladies' Garment Worker* 4 (April 1913): 23.

2. Joe Fig, *Inside the Painter's Studio* (New York: Princeton Architectural Press, 2009), 42–43.

3. *Voices of 9.11* website (http://hereisnewyorkv911.org/). Ruth Sergel, Magnus Pind Bjerre, Jude Calder, Laura Doggett, Pamela Griffiths, Juan Molinari, Nancy Tongue, Aaron Traub. Translations by Lana Cheung, Sherry Kane, Peter von Salis. The 2011 project to bring all of *Voices of 9.11* online is made possible by the generous support of our donors. Thank you: Anonymous, Martha Ann Babcock, John Barnes, Suzanne Pred Bass, Therese Baxter, Mary Berke, Maggie Berkvist, Lou Blumengarten, Christina Campanella, Roy Campolongo, Nigel Chatters, Sybil Cohen, Theresa Curtin, Suzanne Epstein, Kerin Ferallo, Carol Fleming, Nicole Franklin, Lyn Gale, Brian Garrick, Marsha Gildin, Steven Harkness, Carol J. Howard, Rose Imperaton, Gloria Jacobs, Allison Kestenbaum, Peilin Kuo, Marvin Kupfer, LuLu LoLo, Laura Lomer, Jay Manis, Lynne McQuaker, Carla Meyer, James Miller, Susan Patner, Lewis Rothenberg, Deborah Schwartz, Eva J. von Schweinitz, Laura Shapiro, Andi Sosin, Mark Tabashnick, Judith Treesberg, Sheryl Woodruff, Ellen Yaroshefsky, Anna Yusim, Lori Zaumseil. Special thanks: Tricia Clark, Barbara Vyden, Vicki Warren. Thank you to Steve Brier and the September 11 Digital Archive and Marilyn Kushner and Jennifer Schantz of the New-York Historical Society for their support of this project.

The Centennial

1. Von Drehle, *Triangle,* 69.

2. From an original song by Trebella (http://www.trebella.us/).

3. This chapter is based on an essay I wrote for the *Journal of Legislation and Public Policy* 14, no. 3 (2011).

4. A tip of the hat to the call one hundred years earlier for the funeral procession, which was printed in Yiddish, Italian, and English.

5. Extra, extra! Read all about it! You can find a pdf of the newspaper calendar here: http://streetpictures.org/TriCo/.

6. In fact, a year later Akter's colleague Aminul Islam was kidnapped, tortured, and murdered under circumstances that have never been fully investigated. No one has been brought to justice.

7. You can see a clip of the centennial here: https://www.youtube.com/watch?v=VPz8iZDHLnE.

Acknowledgments

1. From an email my stepfather sent me. See his work here: www.nathanfarb.com.

BIBLIOGRAPHY

Arbus, Diane. *Diane Arbus: An Aperture Monograph*. New York: Aperture Foundation, 1972.

Arendt, Hannah. *Eichmann in Jerusalem*. New York: Penguin Classics, 2006.

Baldwin, James. *The Devil Finds Work*. New York: Laurel, 1990.

———. *Notes of a Native Son*. New York: Bantam, 1972.

Benin, Leigh, Rob Linné, Adrienne Sosin, and Joel Sosinky. *The New York City Triangle Factory Fire*. Charleston, SC: Arcadia, 2011.

Bogart, Anne. *A Director Prepares: Seven Essays on Art and Theatre*. London: Routledge, 2001.

Brox, Jane. *Brilliant: The Evolution of Artificial Light*. Boston: Mariner, 2010.

Carney, Ray. "Fake Independence and Reel Truth." *Movie Maker Magazine*, October 3, 1997. Retrieved February 8, 2015. http://www.moviemaker.com/archives/news/fake-independence-reel-truth-pt-1-ray-carneys-incendiary-film-criticism-feels-vital-today-15-years/.

———. *The Films of John Cassavetes: Pragmatism, Modernism, and the Movies*. Cambridge: Cambridge University Press, 1994.

———. "The Path of the Artist." Retrieved February 8, 2015. http://people .bu.edu/rcarney/indievision/pa1.shtml.

Cvetkovich, Ann. *Depression: A Public Feeling*. Durham, NC: Duke University Press, 2012.

Dick, Philip K. *The Philip K. Dick Collection*. New York: Library of America, 2009.

Dorfman, Ariel. *Exorcising Terror: The Incredible Unending Trial of Augusto Pinochet*. New York: Seven Stories Press, 2002.

Dorsky, Nathaniel. *Devotional Cinema*. Berkeley: Tuumba Press, 2003.

Doss, Erika. *Memorial Mania: Public Feeling in America*. Chicago: University of Chicago Press, 2012.

Faludi, Susan. *The Terror Dream: Fear and Fantasy in Post 9/11 America*. New York: Metropolitan Books, 2007.

Fig, Joe. *Inside the Painter's Studio*. Princeton, NJ: Princeton Architectural Press, 2009.

Freeman, Jo. "Trashing: The Dark Side of Sisterhood." Retrieved February 8, 2015. http://www.jofreeman.com/.

———. "The Tyranny of Structurelessness." Retrieved February 8, 2015. http://www.jofreeman.com/.

French, William F. *Maryat Lee's: A Theater for the Twenty-First Century*. Morgantown: West Virginia University Press, 1998.

Gilligan, Carol. *In a Different Voice: Psychological Theory and Women's Development*. Cambridge: Harvard University Press, 1993.

Ginzburg, Natalia. *The Things We Used to Say*. Manchester, UK: Carcanet Fiction, 1997.

Gourevitch, Phillip. "Memory Is a Disease." *Salon*. Retrieved February 8, 2015. http://www.salon.com/2012/09/26/philip_gourevitch_memory_is_a_disease/.

———. *We Wish to Inform You That Tomorrow We Will Be Killed with Our Families: Stories from Rwanda*. New York: Macmillan. 1999.

Greenwald, Richard A. *The Triangle Fire, the Protocols of Peace, and Industrial Democracy in Progressive Era New York*. Philadelphia: Temple University Press, 2005.

Grossman, David. "Writing in the Dark." *New York Times*, May 13, 2007.

Hedges, Chris. *War Is a Force That Gives Us Meaning*. New York: PublicAffairs, 2002.

Jay, Ricky. *Learned Pigs and Fireproof Women: Unique, Eccentric, and Amazing Entertainers*. New York: Farrar, Straus and Giroux, 1998.

Jones, Bill T. *Last Night on Earth*. New York: Pantheon, 1997.

Knight, Louise W. *Jane Addams: Spirit in Action*. New York: Norton, 2010.

Lanier, Jaron. *Who Owns the Future?* New York: Simon and Schuster, 2013.

Laurel, Brenda. *Computers as Theatre*. Reading, MA: Addison-Wesley Professional, 1993.

Lerner, Gerda. *Fireweed: A Political Autobiography*. Philadelphia: Temple University Press, 2003.

———. *The Majority Finds Its Past: Placing Women in History*. Oxford: Oxford University Press, 1981.

Le Sueur, Meridel. *The Girl*. Albuquerque: West End, 2006.

———. *Ripening: Selected Work*, 2nd ed. Old Westbury: Feminist Press at CUNY, 1993.

Lorde, Audre. *The Cancer Journals*. San Francisco: Aunt Lute Books, 1997.

Marot, Helen. *Creative Impulse in Industry: A Proposition for Educators*. Retrieved October 14, 2015. https://archive.org/details/creativeimpuseooomarogoog.

Márquez, Gabriel García. *Living to Tell the Tale*. New York: Knopf, 2003.

Marrin, Albert. *Flesh and Blood So Cheap: The Triangle Fire and Its Legacy*. NewYork: Knopf Books for Young Readers, 2011.

McAlevey, Jane. *Raising Expectations (and Raising Hell): My Decade Fighting for the Labor Movement*. London: Verso, 2014.

Meiselas, Susan. *In History*. New York: Steid/ICP, 2008.

Michaels, Anne. *Fugitive Pieces*. New York: Vintage International, 2008.

Midgley, Mary. *Science and Poetry*. London: Routledge Classics, 2001.

Morrison, Toni. *Beloved*. New York: Plume, 1987.

——, ed. *Burn This Book: Notes on Literature and Engagement*. New York: Harper, 2012.

——. *Playing in the Dark*. Cambridge: Harvard University Press, 1992.

Orenstein, Peggy. *Schoolgirls*. New York: Doubleday/Anchor, 1994.

Orleck, Annelise. *Common Sense and a Little Fire: Women and Working-Class Politics in the United States, 1900–1965*. Chapel Hill: University of North Carolina Press, 1995.

Power, Samantha. *A Problem from Hell: America and the Age of Genocide*. New York: HarperCollins Perennial, 2003.

Pratt, Caroline. *I Learn from Children*. New York: Harper and Row, 1948.

Quan, Katy. "Memories of the 1982 ILGWU Strike in New York Chinatown." *Amerasia Journal* 35, no. 1 (2009): 76–91.

Rich, Adrienne. *On Lies, Secrets, and Silence: Selected Prose*. New York: Norton, 1980.

Salamon, Julie. "Can a 60's Spirit Survive the Walls of Nostalgia?" *New York Times*, May 23, 2005.

Sante, Luc. *Low Life: Lures and Snares of Old New York*. New York: Farrar, Straus and Giroux, 2003.

Sergel, Ruth. "Remember the Triangle Fire Coalition." *Journal of Legislation and Public Policy* 14, no. 3 (2011): 611–623.

Shange, Ntozake. *For Colored Girls Who Have Considered Suicide When the Rainbow Is Enuf*. New York: Scribner, 1997.

Sherman, Tom. "Catching Up with the Present: Two Texts to Demonstrate the 'Future' Is behind Us." *Millennium Film Journal* 58 (2014): 168–173.

Simon, Linda. *Dark Light: Electricity and Anxiety from the Telegraph to the X-ray*. Orlando: Mariner, 2005.

Smith, Patrick L. "American Exceptionalism and American Innocence: The Misleading History and Messages of the 9/11 Memorial Museum." *Salon.* Retrieved February, 2015. http://www.salon.com/2014/06/09/american_exceptionalism_and_american_innocence_the_misleading_history_and_messages_of_the_911_memorial_museum/.

Solnit, Rebecca. *A Paradise Built in Hell: The Extraordinary Communities That Arise in Disaster*. New York: Viking Adult, 2009.

———. *River of Shadows: Eadweard Muybridge and the Technological Wild West*. New York: Penguin, 2004.

Stein, Leon. *The Triangle Fire*. Ithaca, NY: ILR Press, 2011.

Steinem, Gloria. *Revolution from Within*. New York: Little, Brown, 1993.

Sylvester, David. *Interviews with Francis Bacon*. London: Thames & Hudson, 1988.

Tashlin, Frank. *The Bear That Wasn't*. New York: Dover, 1962.

Todd, Ellen Wiley. "Photojournalism, Visual Culture, and the Triangle Shirtwaist Fire." *Labor: Studies in Working-Class History of the Americas* 2, no. 2 (2005): 9–28.

———. "Remembering the Unknowns: The Longman Memorial and the 1911 Triangle Shirtwaist Fire." *American Art* 23, no. 3 (2009): 61–80.

Ullman, Ellen. *Close to the Machine: Technophilia and Its Discontents*. New York: Picador, 2012.

Von Drehle, David. *Triangle: The Fire That Changed America*. New York: Grove, 2003.

Warner, Marina. *Phantasmagoria: Spirit Visions, Metaphors, and Media into the Twenty-first Century*. Oxford: Oxford University Press, 2008.

Watkins, Peter. "The Media Crisis." Retrieved February 8, 2015. http://pwatkins.mnsi.net/Intro_MedCr.htm.

Weber, Katherine. *Triangle: A Novel*. New York: Farrar, Straus and Giroux, 2006.

Williams, David. *Collaborative Theatre: Le Théâtre du Soleil*. London: Routledge, 1998.

Winterson, Jeanette. *Art Objects*. London: Vintage, 1996.

Wolf, Christa. *City of Angels: Or, the Overcoat of Dr. Freud*. Translated by Damion Searls. New York: Farrar, Straus and Giroux, 2013.

Wood, Gaby. *Edison's Eve: A Magical History of the Quest for Mechanical Life*. New York: Anchor, 2003.

Youngblood, Gene. "Secession from the Broadcast: The Internet and the Crisis of Social Control." *Millennium Film Journal* 58 (2014): 174–189.

INDEX

We're all human beings. We're all one. You have to keep your spirits up. Without love, a person cannot live. It's just beautiful to be here and see this crowd of people. Young ones and an old one like me and a middle-aged one and a baby that is the most precious thing of all. I see every color here, every nationality here, and that's what this world needs. Love in many many ways. You can love a husband. Partners can love each other. You can love an animal or an idea, but the basic thing of a life is to love and be loved by a human being and to love them in return.

—Ethel Greenbaum, 89 years old, who described herself as never a leader, always rank and file